AGAINST THE WALL

THE ART OF RESISTANCE IN PALESTINE
WILLIAM PARRY

Against the Wall

The Art of Resistance in Palestine

William Parry

Lawrence Hill Books

First published in Great Britain in 2010 by Pluto Press
345 Archway Road, London N6 5AA

This edition published in 2011 by Lawrence Hill Books
An imprint of Chicago Review Press, Incorporated
814 North Franklin Street
Chicago, Illinois 60610

ISBN 978-1-56976-704-7

Designed and produced for Pluto Press
by Tom Lynton
www.tomlynton.com

Printed and bound in the European Union by
Butler, Tanner and Dennis Ltd, Frome, England

5 4 3 2 1

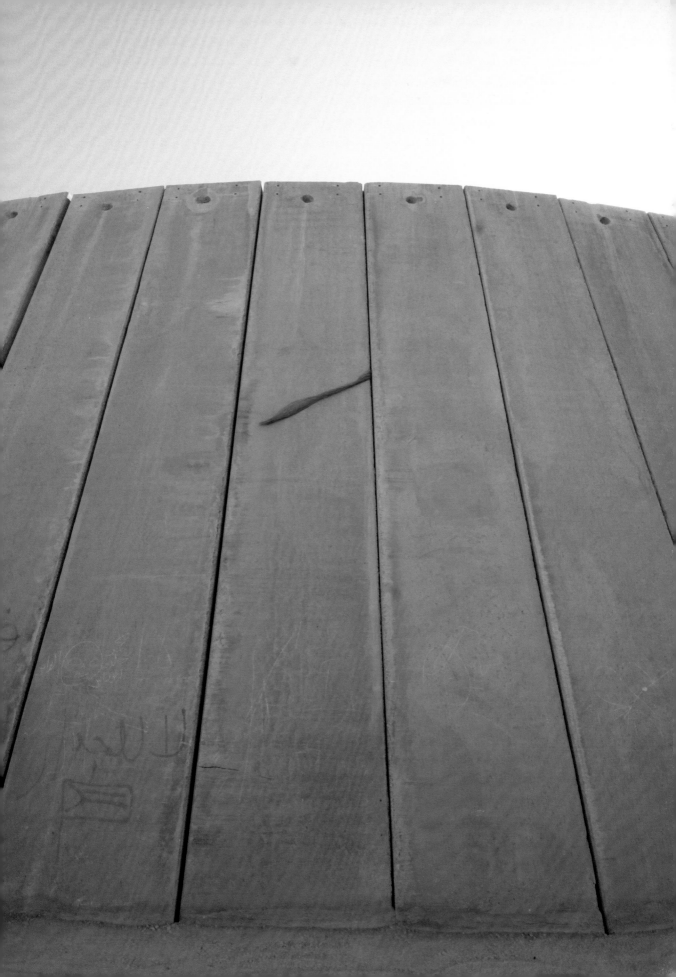

FOREWORD

The thing about a wall is that people tend to see only one side of it, the side they are on. And for those with enough distance from the wall, it's altogether out of mind. But these concrete slabs, as they rise, reverberate around the world like an iron butterfly, one or two beats of the wing away from triggering global catastrophe. So how do you bring a wall that's far enough away to ignore, close enough to see both sides? For me, the answer is simple. Paint it. Make it easier to see.

I'm not a politician, and I don't profess to know all the deep-set intricacies of this conflict, but as a person, an American, a world citizen, I don't think people can live like this indefinitely. And I don't think the world should permit it. We all have too much to lose.

In the mid 1980s, when I came of age, I made the sojourn to the Berlin Wall, where artists of my generation registered their visions, hope and anger on its facade. I spent three weeks there creating a seventy foot mural at Check Point Charlie, and I truly believe that the attention art focused on the situation contributed in some measure to the political sea change that eventually toppled the wall. Nearly twenty years later, when Banksy asked me to join him in his quest to bring attention to Israel's separation wall, I was more than happy to contribute, with the hope that this would be a step towards justice and, through this, peace.

By 2007, street art had galvanized the international press, and Banksy was its undisputed media star, drawing press like moths to a flame with his increasingly grand antics. Perhaps taking a cue from another famous Brit, John Lennon, who, with his partner Yoko Ono, decided to use his fame to draw attention to a larger, more pertinent issue, namely the war in Vietnam, Banksy organised the Santa's Ghetto project in Bethlehem, inviting some of the world's top street artists to create murals on the separation wall. He banked that the world press would follow, and he was right. Swarms of journalists filmed every stage of the project, but more than one told me candidly that although they were assigned to film, the footage would never air, especially not in America. The y were right.

Consumers of Arab and Muslim media see images of dead Palestinian children with American shell casings at their feet. The American people have had little or no exposure to this imagery and only a vague awareness of how our taxpayer money is funnelled into weaponry and logistical support for an extremely lopsided, endless conflict. I think we need to pay more attention to what's happening in this holy land because, to a large degree, we are responsible and because having an entrenched, uninformed and one-sided vision of the situation contributes nothing to the dream of peace for people living on either side of the wall.

I picked an area across from a refugee camp to work on my murals. As soon as I propped my ladder, children began streaming out from the seemingly uninhabited neighbourhood nearby, where the top floors of the buildings had been eviscerated by missile fire and the local factory sported a gaping truck-sized hole in its exterior. The rubble-strewn field between the camp and the wall, the no-man's land, was littered with piles of bloated dead sheep. The whole place smelled horrible.

The kids, accustomed to their playground, threw rocks at us and at each

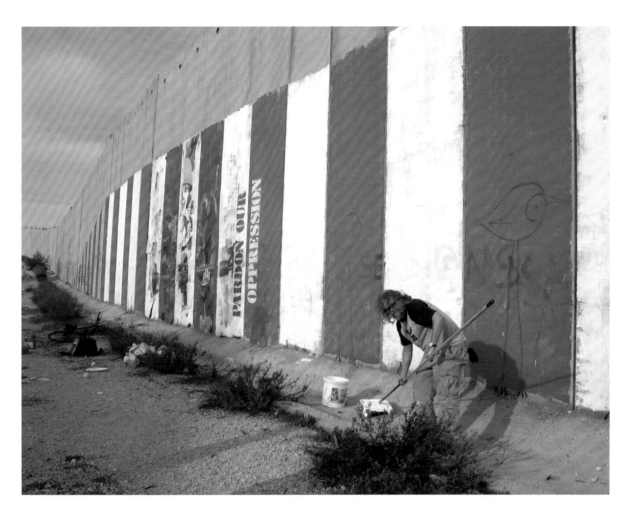

other, asked for money, and one, a preteen boy named Mohammad, pulled a knife and threatened my friend, Daniel, who had come along on the trip to help out. Daniel showed the kids some New York style handshakes and soon befriended them. The kids returned every day to hang out and help out. On our last day, Mohammad did an interview with a camera crew. He said that his dream was to protect his family, his country and to one day become an artist. We left him with some paint and a huge piece of canvas.

I have since wondered whether someday soon Mohammad will grow up and feel compelled to protect his family, his country, and what his actions will entail. I wonder if he will become an artist. Maybe it seems preposterous that art can change the world, but it can give a voice to silenced and oppressed citizens on the dark side of any wall. Think about it. If you had a choice between these two powerful vehicles of communication – a spectacular act of destruction, or a spectacular creation of art that spoke eloquently of your anger and alienation – which would you choose? Which speaks louder and longer? Violent resistance? A mural? Don't laugh. Little boys are making these decisions every day.

Ron English

Ron English painting 'Pardon Our Oppression'. See page 58
(photo courtesy of Ron English)

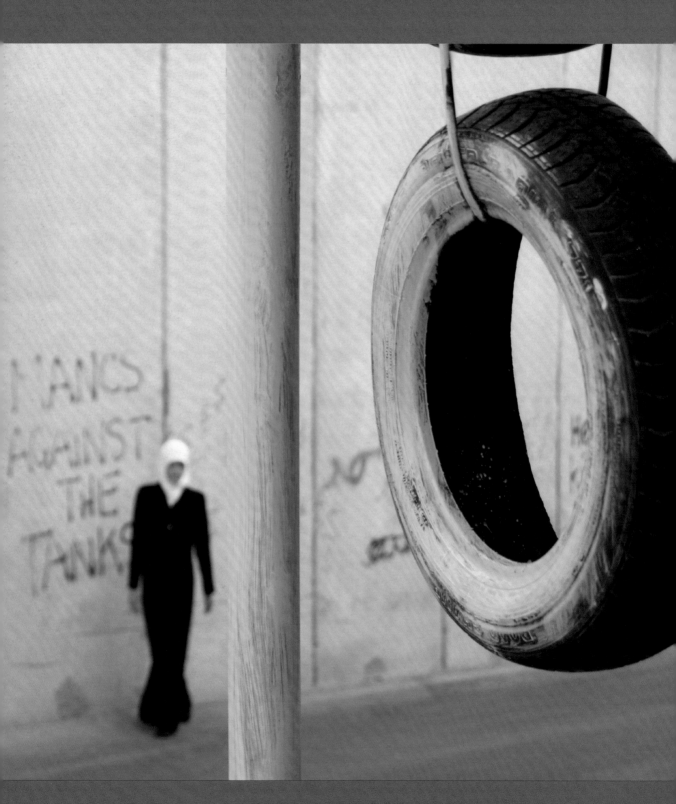

INTRODUCTION

❛ The Israeli government is building a wall surrounding the occupied Palestinian territories. It stands three times the height of the Berlin Wall and will eventually run for over 700km – the distance from London to Zurich. The wall is illegal under international law and essentially turns Palestine into the world's largest open prison. It also makes it the ultimate activity holiday destination for graffiti writers. ❜

Banksy, 2005

❛ Our children will be told what Israel has done. ❜

graffiti on the Wall in Bethlehem, opposite Aida refugee camp, 2008

Is the spray can mightier than the sword?

In December 2007, the celebrated and famously elusive British street artist, Banksy, and a London-based organisation, called Pictures on Walls, relocated their annual 'squat art concept store' called Santa's Ghetto from London to Bethlehem and invited 14 other international street artists along to work with Palestinian artists. The concept was simple: the artists would make artwork available for sale by auction to the public – but those wanting to buy an original work of art by Banksy or the others would have to travel to Bethlehem, witness Israel's occupation and checkpoints, and bid in person. The artists also used the opportunity to utilise the Wall as a giant billboard for their own political messages with some massive, stunning images – wall spaces throughout the city were also populated with work that challenged or subverted understandings about the reality faced by Palestinians under occupation. Within a few short weeks, Santa's Ghetto had raised over $1 million from art sales for local charities and brought Bethlehem and the Wall to the world's attention in a way that transcended language and engaged millions who wouldn't ordinarily take an interest in Israel's illegal occupation of Palestine. Just as important, it sent a message to the people of Palestine: you are not alone in your struggle.

The spray can hasn't forced Israel to stop building its highly controversial Wall, but in the skilled hands of a guerrilla street artist like Banksy, it's a formidable weapon in the struggle for hearts, minds and justice. Banksy's artwork cuts to the heart of a contentious issue with thought-provoking wit, immediacy and appeal. Banksy and co.'s street art in Bethlehem and in the suburbs of Jerusalem has engaged a Western audience and contributed to an awareness about the reality on the ground and the asymmetrical power struggle between Palestinians and Israelis. Banksy's images in particular communicate this to a mass audience via the media and internet with flabbergasting economy and efficiency. That ability to challenge Israel's narrative and to influence the Western public's perception of the Wall and the broader conflict is as rare as it is invaluable.

Although Banksy and the Santa's Ghetto collective account for a modicum of the artwork on the Wall and generate the most attention, interest and influence, there are thousands of other anonymous people from around the world who have

travelled to Palestine to mark their individual protest against Israel's Wall and their own governments' complicity, and to lend their idiosyncratic support, through words and images, to a people penned in by the Wall. The Wall has become an enormous visual petition, an ephemeral forum, a pictorial rant and reprimand, calling for resistance, justice, freedom and solidarity, and a plea for understanding and humanity. There are moving murals depicting a dove being nailed to the Wall and a snake consuming all life in its path. There are numerous depictions of Jerusalem, Palestine's spiritual, religious, cultural and economic capital, now inaccessible to 3.6 million Palestinians from the West Bank and Gaza because of the Wall. There are poignant, rhetorical questions to Israel's Jews, many of whom endured inhuman suffering, asking how they and their descendants can now dispossess and imprison another people. There are quotations from Shakespeare, the Bible, and freedom fighters like Gandhi and Nelson Mandela, used to challenge the inhumanity of Israel as occupier and oppressor. And there are symbols central to Palestinian identity, denoting resistance, liberation, affinity to the land, Palestinian refugees' 'right to return' and national unity. Some of the artwork is beautiful and moving; some conveys more spirit than artistic talent. Humour is often used to assuage or deflect the pain and naked barbarity of the Wall. And there is no shortage of inane dross. One defining message that runs up and down the Wall in the West Bank, however, is this: 'To exist is to resist.'

Can the Wall ever be beautiful in the eye of the beholder?
Some Palestinians have objected to 'beautifying' the Wall and believe it is best left in its plain, oppressive form as a reflection of Israel's nature. Banksy records one memorable conversation as he painted the Wall in Palestine in 2005:

OLD MAN: You paint the wall, you make it look beautiful.
BANKSY: Thanks.
OLD MAN: We don't want it to be beautiful. We hate this wall, go home.

Swoon, a street artist from New York, put up two main works on sentry towers in Bethlehem as part of the Santa's Ghetto project. She told me: 'I wanted to show to people living behind the Wall, in the best way that I know how, that people in the world care about what's happening to them.'

Like many of the artists, she hadn't anticipated that her efforts might not be welcomed by all: 'The enthusiasm from kids [from Aida refugee camp] while we were working was awesome. I was later told by one of the elders from the refugee camp that they don't necessarily want the kids to start viewing that area positively, and so they see the work as a thing of beauty, but in a place where beauty shouldn't be. It's an interesting view because I think that we as internationals were coming in, thinking of painting on the Wall as a way to create something for the people trapped behind it, as well as creating an international symbol that would be broadcast around the world. This man wasn't speaking about international symbols, but about what it means to live in the shadow of an 80 foot guard tower, and it's these kinds of things that we could not have imagined before we went there and talked to people.'

American pop artist Ron English also took part. He said: 'A problem with painting the Wall is that it does tend to make it into a great work of art instead of an aggressive prison Wall. It was our hope that the art would attract more people to see the effects of the Wall on the people of Palestine. I think Banksy's intention was to bring attention to the Wall by deflecting the spotlight that was following him around – and it most certainly worked – I don't know if any amount of paint could beautify something so oppressive.'

Other Palestinians may not have time for the artwork on the Wall – they're too busy trying to cope with an oppressive daily existence that is made more so by the Wall – but most I spoke to welcomed the show of solidarity from the outside world. Taxi drivers and business owners in Bethlehem were effusive, ready to adopt Banksy as a son of the struggling city, given the number of tourists the project's work has attracted.

Border constrictor

Most Palestinians don't object to Israel giving the world's graffiti and street artists the largest canvas on the planet: what is primarily objected to is its route – it doesn't follow the Green Line, the internationally recognised Palestine-Israel border. If you insist on building a Wall, they say, build it along the internationally recognised border that we share. Fair enough.

But Israel hasn't, and refuses to. The Green Line is 315 km long. The Wall will be 709 km long when it is completed, and about 85 per cent of that will be built on West Bank land. Consequently, its route will annex 10 per cent of the West Bank to the Israeli-controlled side. This insidious path, Palestinians assert, is a *de facto* land grab by Israel.

The reason for this circuitous route? Since 1967, successive Israeli governments have encouraged the establishment of illegally built Jewish-only colonies, euphemistically called 'settlements', on Palestinian land that Israel has illegally occupied for over 40 years. Every one of Israel's 220 colonies and outposts (fledgling colonies) in the West Bank is deemed illegal under international law: they contravene the Hague Convention, the Fourth Geneva Convention and UN Security Council resolution 465. In 2004 the International Court of Justice reiterated that 'Israeli settlements in the Occupied Palestinian Territory, including East Jerusalem, are illegal and an obstacle to peace and to [Palestinian] economic and social development, …[and] have been established in breach of international law'. The colonies themselves occupy just 3 per cent of the West Bank; however, the complex 'security' apparatus and infrastructure that serve these illegal colonies and their 500,000 Jewish settlers, and connect them to Israel, require Israeli control over a staggering 45 per cent of the Palestinian West Bank. The Wall's route is cutting deep into the West Bank to ensure that 80 of the most sizeable and significant colonies (385,000 settlers) will be on the west side of the Wall.

(A Palestinian studying in London once put Israel's colonies into perspective this way. He said: *If a squatter moved into your backyard and brought his family there to live on your land, building a shelter and garden of their own, would you accept this? And what if the police then stepped in and blocked where you could go on your property so that this family had freedom of movement? Imagine then that he starts building a fence deeper into your property and restricts your access to your land, dictating where you can venture and when. Now imagine this happening to your country – would you and others tolerate this?*)

In other words, West Bank Palestinians have been losing land and rights illegally to Israel's colonies for over four decades, and are now losing more land via the Wall – another Israeli project deemed illegal under international law – so that Israel can annex this colonised territory and unilaterally impose a new, larger border.

But it's much more than just a land grab. The impact that the Wall is having on Palestinian lives, livelihoods, businesses and communities is, Palestinians and others insist, designed to isolate the West Bank's communities economically, socially and culturally – and thereby strangle them. The Wall divides major Palestinian population centres into fragmented 'Bantustans' (this was the term used by a recent Israeli Prime Minister, Ariel Sharon). Critically, it isolates the West Bank's major cities from Jerusalem, the economic hub of the West Bank, as well as the Palestinian cultural and spiritual capital. Without Jerusalem, the surrounding cities will wither.

Palestinian land owners are made to apply for a 'visitor' permit to access their farmland, their olive groves, their greenhouses from the Israelis, who then determine who 'qualifies' for a permit. This permit regime has separated 80 per cent of Palestinian farmers from their land and livelihoods in parts of the West Bank, and it regulates the few hours that they can access their land (some permits only allow weekly or seasonal access).

The Wall is about separating families from their communities, their schools, their places of worship, from their clinics, hospitals and specialist facilities. It makes accessing them, via military checkpoints, difficult, time-consuming and

humiliating. It makes Palestinians, as they say, refugees in their own land.

As I toured East Jerusalem and the West Bank, interviewing scores of Palestinians, it was clear, as these pages illustrate, that this is the very real effect that the Wall is having on Palestine. 'Forced transfer' and 'ethnic cleansing' are terms commonly used to describe policies that Israel is pursuing via the Wall. One is left with the impression that it has been meticulously and methodically planned in order to impair the fabric of Palestinian life and society – and it appears ruthlessly effective.

It also seems to have destroyed the prospect of a two-state solution to the conflict. Collectively, the colonies, the infrastructure that serves them and the Wall make a politically and economically viable Palestinian state impossible – they have cut up the occupied Palestinian territory into physically isolated cantons.

Witnessing the reality created by Israel in occupied Palestine – its policies of colonial expansion, control and repression, and its Wall, which is a manifestation of all three – is shocking the more one sees what Palestinians are made to endure, and what the rest of the world allows to happen. 'Security' – the reason Israel gave for its need to construct the Wall – seems disingenuous and riddled with inconsistencies, many legal experts and humanitarian organisations argue. The Israeli human rights group B'tselem and Bimkon co-published a comprehensive study, aptly called *Under the Guise of Security: Routing the Separation Barrier to Enable Israeli Settlement Expansion in the West Bank*, which shows the 'security' element to be a political ruse.

This book coincides with the anniversary of the ICJ's Advisory Opinion, which unequivocally stated that the route of the Wall in the occupied Palestinian territory is illegal under international law; that Israel must stop building it and demolish what has already been constructed; and that Israel is under an obligation to make reparation for all the damage caused by the construction of the Wall in Palestine. This advisory opinion was overwhelmingly backed by a UN General Assembly Resolution – backed by words and six years of underwhelming inaction: Israel immediately rubbished the ICJ's ruling and continues to build the Wall with impunity; our governments, which the ICJ said are obliged to help enforce its decision, remain complicit through their silence and inaction.

The book thus closes with an epilogue that highlights one Palestinian community – the village of Ni'lin – currently on the frontline of opposing, through peaceful protest, the construction of the Wall on their land. The Israeli response to this popular resistance is what many call a 'grossly disproportionate response': Israel routinely uses 40mm tear gas canisters, rubber coated steel bullets and live ammunition against largely defenceless civilians. They have killed 19 demonstrators and injured thousands over the past five years. Israel also uses brutal, collective punishment to try to break the unity and spirit of collective resistance within these communities. Ni'lin, like many other Palestinian communities, continues with its struggle for justice, undeterred and resolute, against overwhelming odds.

The idea for this book started as a facetious text. I was walking around Bethlehem as I did my research for a magazine article on the Santa's Ghetto project. While taking in the volume of witty and moving artwork – nowhere is this richer, more varied, concentrated, pressing and on such a vast scale than on the Wall in Palestine – I realised how kaleidoscopic it is too; so much had changed since a visit just half a year earlier, and was bound to change before my next visit. I texted my partner: *Someone should document the artwork on the Wall for posterity. One day the Wall won't be here so we need a record of it lol!* Several decades after the Berlin Wall fell, this book is being published.

I have tried to provide a glimpse into the richness and spirit of the artwork and graffiti out there, and the complex reality that generates it. However, there can be no substitute to witnessing it – and sensing the nature of the Wall – for yourself. And, as Banksy said in a text to *The Times* newspaper in 2007 from Bethlehem: 'It would do good if more people came to see the situation here for themselves. If it is safe enough for a bunch of sissy artists, then it is safe enough for anyone.'

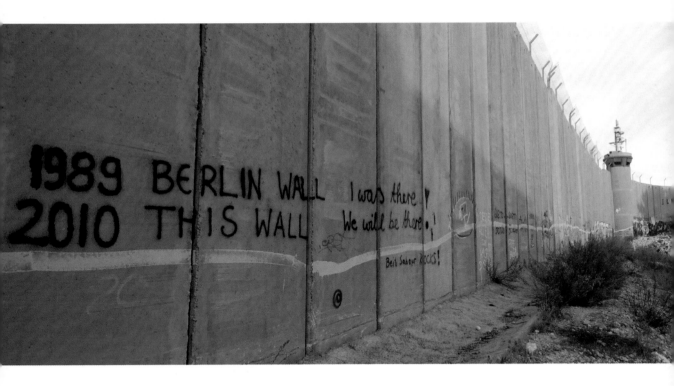

Acknowledgements

I am indebted to many people, without whose support and assistance this book would not have been possible. Sawsan Asfari's generosity made this project possible. Anne Beech and her team at Pluto Press supported the idea of this book from my first email, and then the project as it materialised; and Tom Lynton helped fulfil my vision of the book with his design talents. Tristan Manco and Simon Durban at Pictures on Walls generously allowed me to reproduce images from the 2007 Santa's Ghetto project. I am also indebted to Ron English for his support, foreword and artwork. Thanks also to Antony Micallef, Swoon and Blu for their contributions of text and/or artwork. Thanks in addition to Ahdaf Soueif, AL Kennedy, Joe Sacco, Damon Albarn, Ghada Karmi and Ken Loach for their support. I am also grateful to Sony UK for the loan of photographic equipment.

On the ground in Palestine and Israel, I am grateful to many, whose assistance, generosity and support were instrumental in making this book a reality. Organisations including UNRWA, UN OCHA, EAPPI, Stop the Wall, Machsomwatch, B'Tselem, ICAHD, the International Committee of the Red Cross, the Palestinian Red Crescent Society, Abu Dis University and St John's Eye Hospital, provided assistance and contact details. I am particularly grateful to Ray Dolphin for his generosity and on-going assistance. Thanks also to Amal, Mona and Usama for their ample support throughout the project, and to Manal Hazzan for her legal input.

I am especially grateful to all of the Palestinians interviewed in this book for allowing me into their homes and lives, and who always welcomed me with warmth and generosity. Their strength and steadfastness were an inspiration throughout, and remain so.

Last but not least, this book would be nothing without the ineffable love, support and input of Awatef Sheikh, who has helped me throughout in a myriad ways – from the most mundane to the most profound – to make it what it is.

William Parry

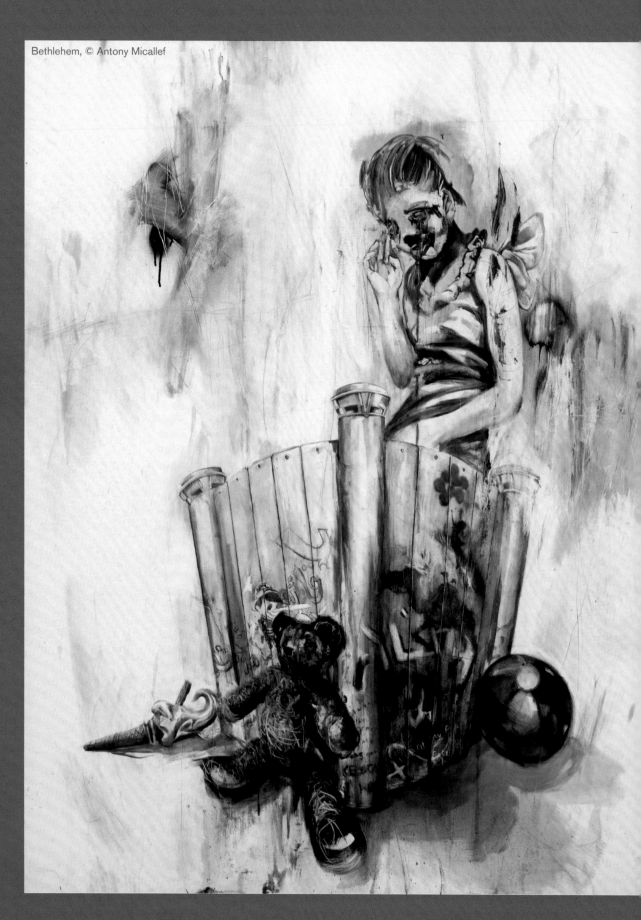

Bethlehem, © Antony Micallef

O LITTLE TOWN OF BETHLEHEM

The road to Bethlehem was painted with best intentions in December 2007. While US President George Bush Jr, Palestinian President Mahmoud Abbas and Israeli Prime Minister Ehud Olmert were busy in Annapolis looking at the 'Road Map to Peace' the wrong way round, Banksy, a London-based organisation called Pictures on Walls, and 14 artists from the UK, US and Europe, pulled off a phenomenal publicity stunt that put Bethlehem and Palestine back on the world map. Carried by media organisations all over the world, their Santa's Ghetto shop, transported from London to Manger Square, drew international attention to the impact of Israel's illegal Wall on Palestinians and forced interested art buyers and collectors to see in person how miserably Bethlehem was faring under Israeli occupation. The art collective's provocative, challenging and witty images on the Wall and throughout the city reminded Christmas shoppers worldwide that this is where it all started and that Christ's hometown, imprisoned by the Wall, was suffering immeasurably under Israel's illegal and oppressive occupation.

Some of the images were lost on the local population, and a few unintentionally 'culturally insensitive' images lost the support of many locals; but today, as visitors to Bethlehem of a certain age walk through the Wall, a dozen taxi drivers will vie for their dollars, offering a 'Banksy Tour'. John Lennon controversially said in the 60s that the Beatles were more popular than Jesus; in Bethlehem, what remains of Santa's Ghetto competes with what remains of Mary and Joseph's grotto for the top tourist attraction.

Most of the artwork and graffiti – and there is scarcely a blank bit of concrete now – is by internationals wishing to voice their solidarity with Palestinians, and to make others visiting Bethlehem think about what is being done to this culturally important little city. It's a simple act of defiance, a gesture of solidarity, and one way to channel their frustration and sense of relative powerlessness. Most locals don't mind, especially if it brings money and attention to the city. Many appreciate the intention. For others, the medium is the message: a plain, oppressive concrete Wall eight metres high that imprisons a city while stealing their land mutely communicates all that needs to be said.

Apart from Armaggedon-leaning born-again Christians, it's difficult to understand how hundreds of millions of Christians around the world tolerate what is happening to Bethlehem under Israeli occupation. Muslim and Christian heritage sites here and elsewhere are under threat as Israel rewrites the region's history in an attempt to emphasise Jewish heritage to 'legitimise' its colonisation. The Palestinian Christian community that remains in Bethlehem (and which is shrinking rapidly) is bewildered by the international Christian community's silence and inaction.

It's not an issue of faith, however, but one of grave breaches of humanitarian and international law. Bethlehem is already home to three refugee camps, overcrowded with several generations of Palestinians who were originally forced to flee from their homes in mandatory Palestine in 1948 by Jewish militias, and whose right to return to their homes has been disregarded by Israel for over six decades. These Palestinian refugees, with their rights in limbo, are now having their displaced communities threatened again by Israel's illegal occupation, colonisation and the Wall.

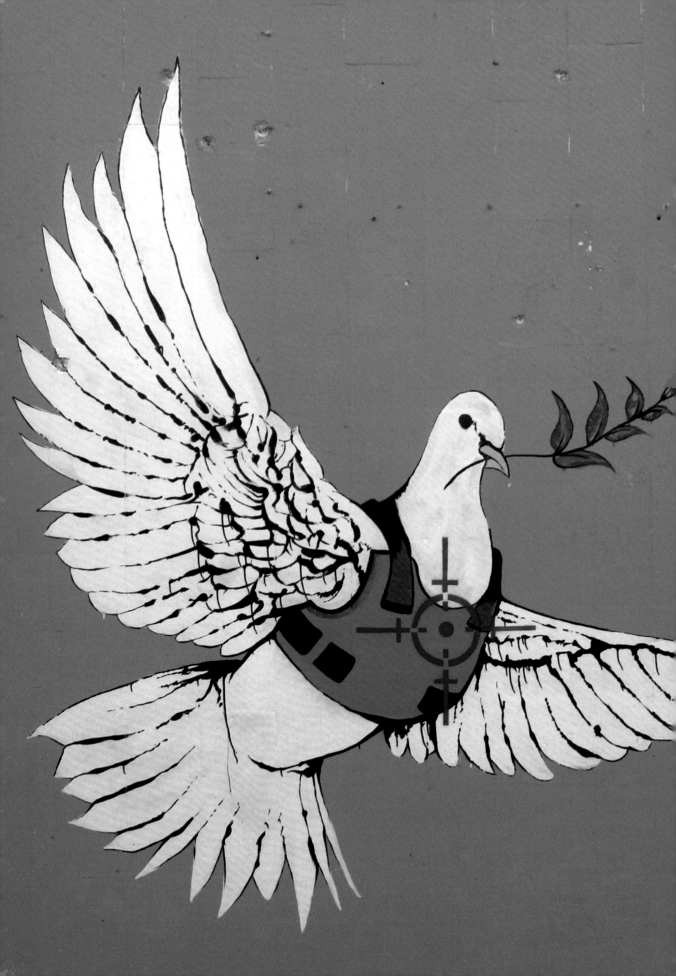

Israel is pursuing its colonisation of Palestinian land in the Bethlehem governorate with vigour. There are 35 illegal Israeli colonies and outposts, home to 86,000 Israelis, with plans for considerable growth. The Palestinian Authority (ie government) controls just 13 per cent of the entire governorate, and much of that is fragmented – the rest is under Israeli control. The Wall cuts 10 km into Bethlehem and will annex 12 per cent of Bethlehem's land when it is completed – much of that is important agricultural land, vital for livelihoods, and areas required for residential growth. The Wall is also separating communities from one another and cutting villages off from key services such as schools, clinics, as well as families and cultural/religious centres. The city's access to East Jerusalem has been drastically restricted, causing major economic hardship and severely restricting access to families and places of cultural and religious importance – and East Jerusalem's specialist hospitals. A recent UN report, entitled *Five Years after the International Court of Justice Advisory Opinion: A Summary of the Humanitarian Impact of the Barrier*, concludes that 'Bethlehem's potential for residential and industrial expansion and development has been reduced [by the Wall, settlements and closures], as well as its access to natural resources. The traditional mainstays of the Bethlehem governorate economy, such as work in Israel, tourism, agriculture, herding and the private sector have been undermined. Continuation of these Israeli measures compromises the future economic and social development of the Bethlehem governorate.'

Without consolidated international pressure on Israel to force it to comply with international law, Bethlehem will have to produce another messiah soon if it is to retain any of the historical character that has come to shape it over the past two millennia. The phenomenal street art gallery that it is home to is not enough to save it.

LEFT
Banksy's dove with flak jacket and cross-hairs, Bethlehem.

RIGHT (MAIN)
Donkey by Erica il Cane, Camel by Sam3 and, by Palestinian artist, Wissam Salsaa, a leg breaking through the Wall (see detail).

Sadly, someone's since walked off with the leg, though the cracks remain.

(Detail photo © Pictures on Walls.)

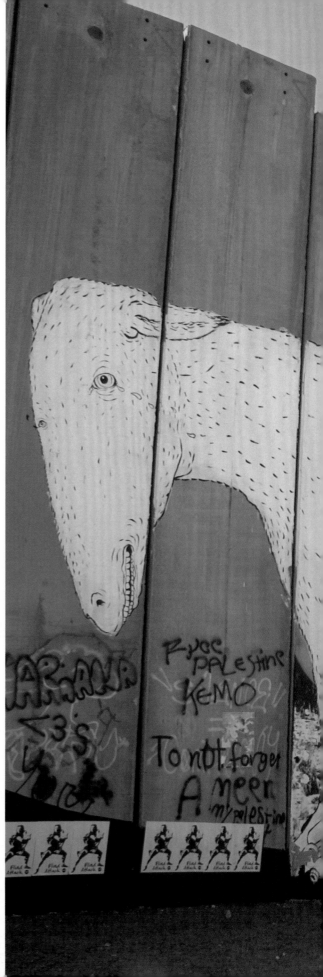

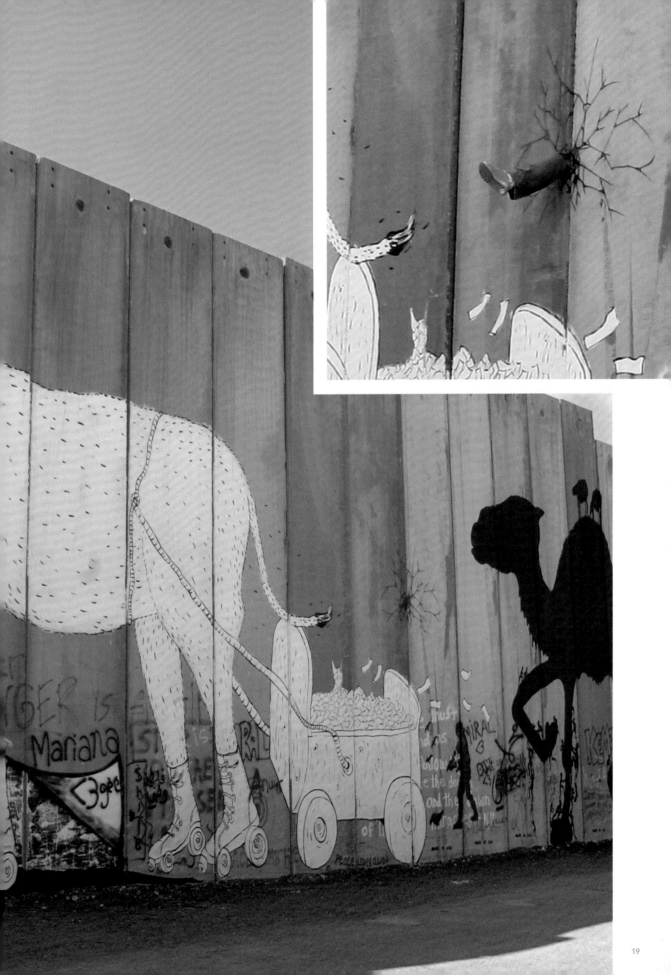

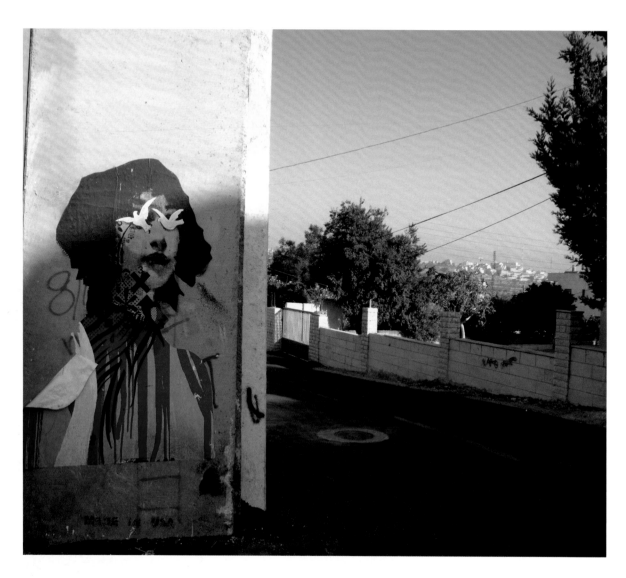

ABOVE Liberty by Paul Insect

RIGHT If you can't beat it, advertise on it
Joseph Hasboun had the menu for his
Bahamas Seafood restaurant painted
on the Wall in July 2008, between Erica
il Cane's Donkey and Sam3's Camel.
Hasboun's Wall Lounge, next door,
also advertises on the Wall. Locals and
tourists can choose between seafood
that includes Canadian lobster and sea
bream, a 'Wall Chicken Sandwich', local
cuisine, or sip a cocktail or espresso and
savour the ambience. Originally opened
in 1997, Bahamas Seafood closed in
2000, when tourists avoided Bethlehem
due to clashes between the Israeli military
and Palestinians, during the second
Intifada. Hasboun and family are creatively
capitalising on, rather than capitulating to,
Israel's oppressive Wall.

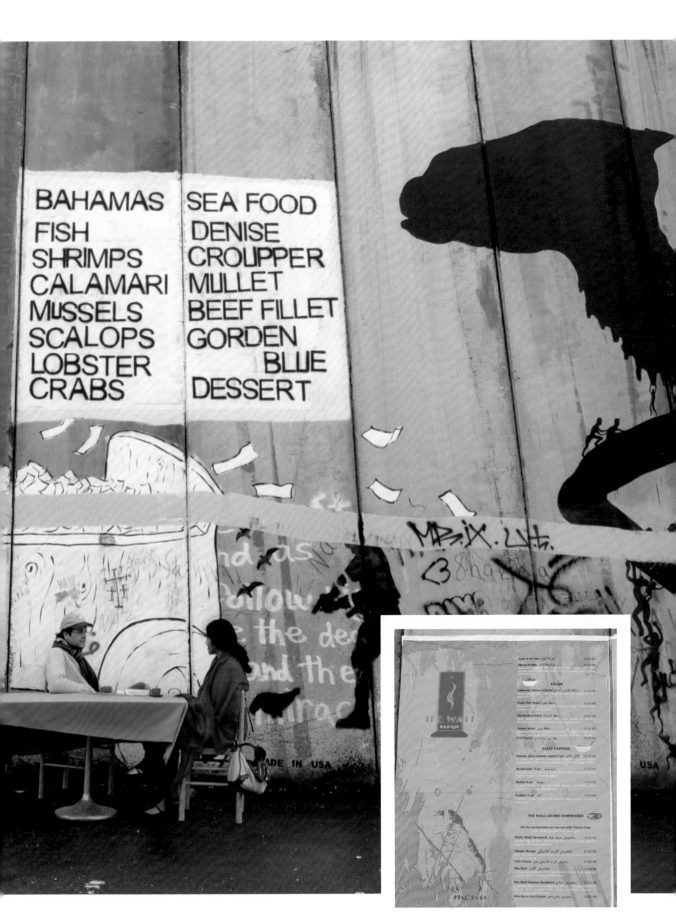

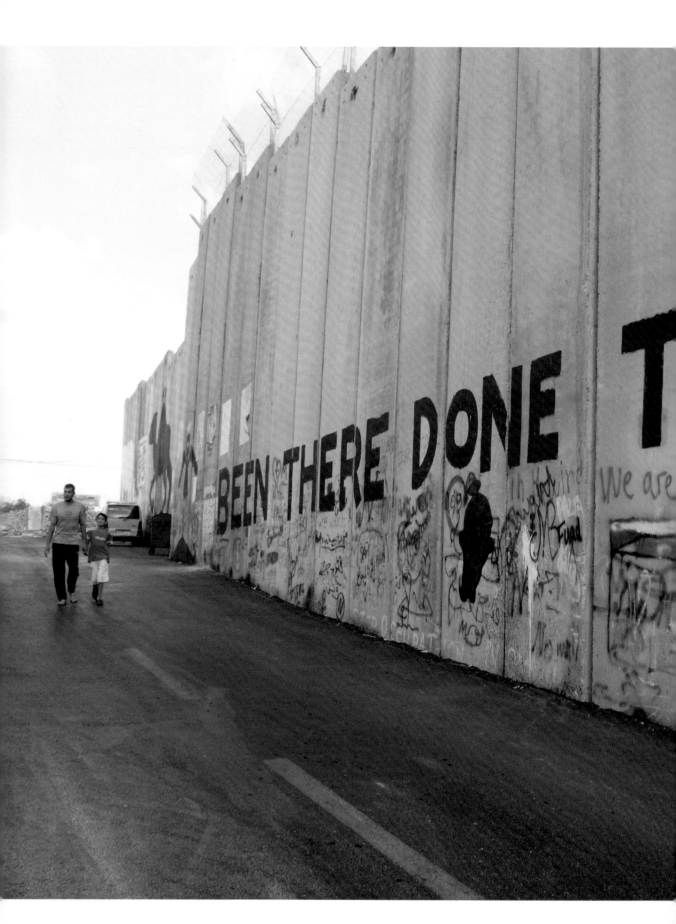

MIDDLE IMAGE, ABOVE
reads 'Freedom attack'.

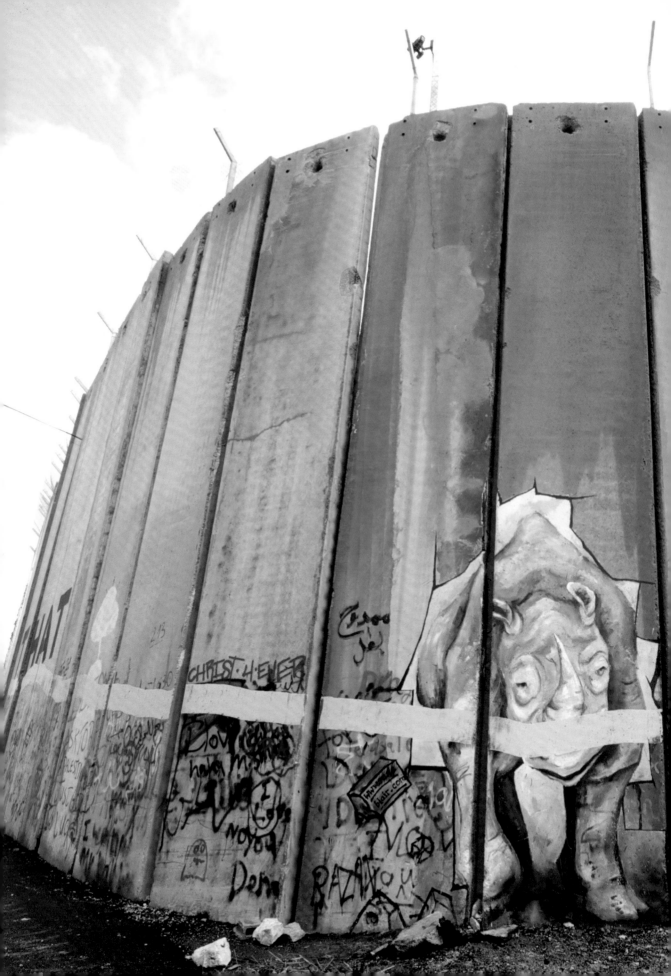

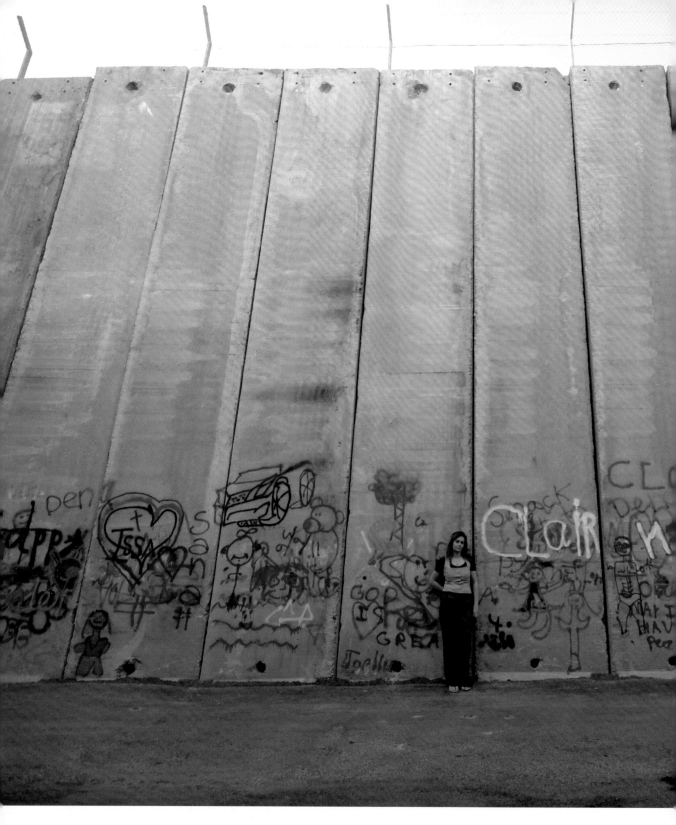

Clair and Johnny Anastas built their home a decade ago opposite Rachel's Tomb, on the Hebron-Jerusalem Road, in one of Bethlehem's most affluent neighbourhoods. Today, the road that for generations was travelled by pilgrims and patriarchs comes to a dead end outside their front door, and the neighbourhood is a ghost town. (The economic, cultural, social and historical significance and importance of this road cannot be underestimated: it linked Hebron and the south West Bank with Bethlehem and Jerusalem and the north West Bank. Israel's severing of this artery had deliberate, strategic purposes.) The Anastas house, which is home to nine children and five adults, is surrounded on three sides by walls eight metres high. Peer from any window and you see nothing but concrete.

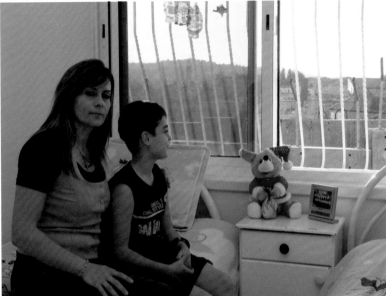

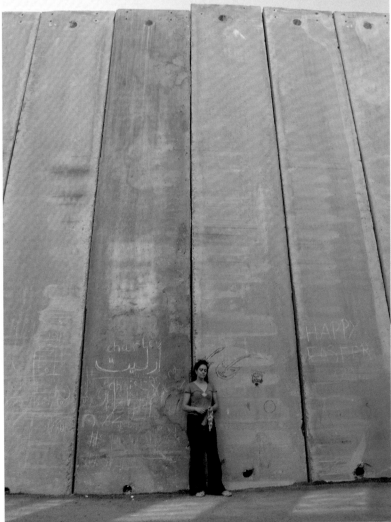

The claustrophobia is overbearing. The Wall has cost them their life savings, their family businesses, their lifestyle, and their will to stay. The last time I spoke to Clair, months after taking these photos, she said the family was trying to emigrate to Canada.

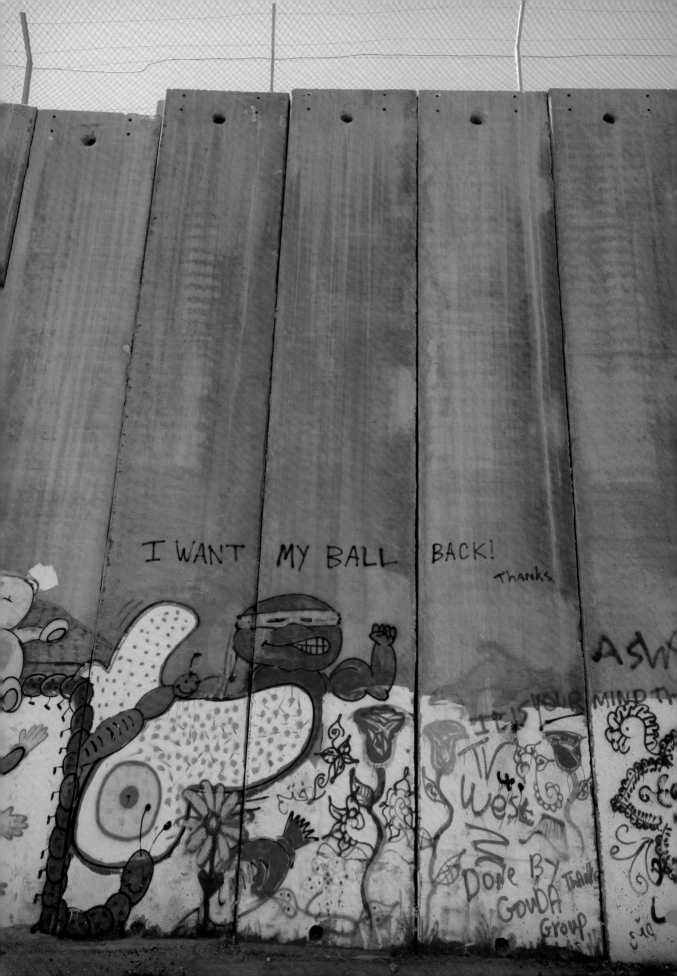

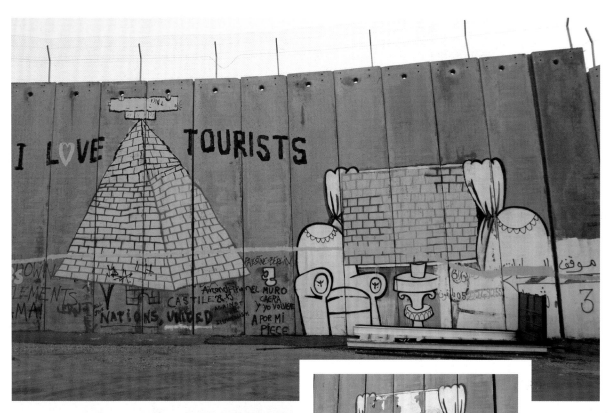

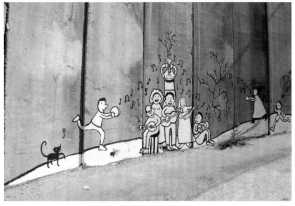

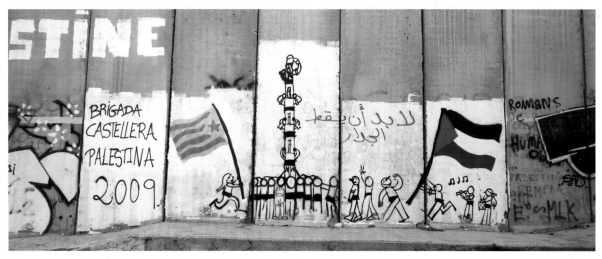

An assortment of graffiti and street art near the Anastas home. Banksy's 'living room' scene with its view of a lake and mountains, put up in 2005, has undergone some 'debeautifying'. The Arabic writing scribbled over it reads: 'Park your car here for 3 NIS' (50 pence).

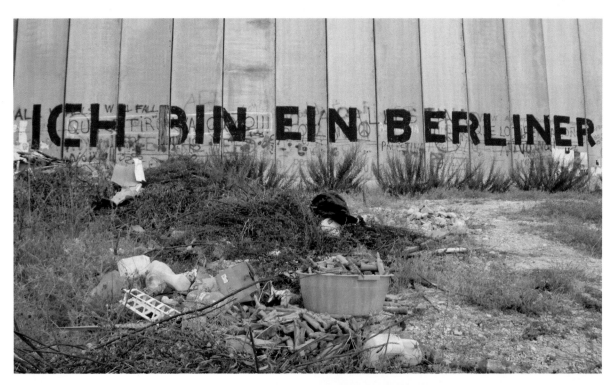

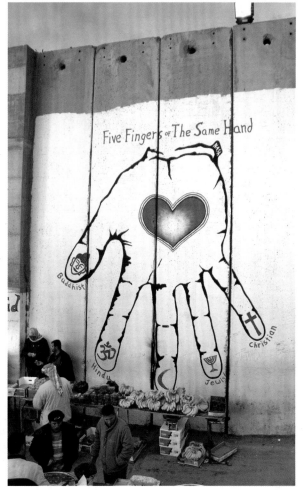

OPPOSITE

'November 9, 1989, will always be remembered and cherished in the United States. Like so many Americans, I'll never forget the images of people tearing down the [Berlin] wall. There could be no clearer rebuke of tyranny, there could be no stronger affirmation of freedom' – US President Barack Obama in a message to the German people, November 9, 2009.

OPPOSITE, BOTTOM RIGHT

Five Fingers of the Same Hand by Nash.

RIGHT, TOP

Ali, from the Aida refugee camp, next to Banky's image of a girl frisking an Israeli soldier.

RIGHT, MIDDLE

'Hanthala', the famous creation of the late, great Palestinian political cartoonist, Naji al Ali, looks out towards a free Palestine, beyond the Wall. Aida refugee camp.

RIGHT, BOTTOM

ICAHD is the Israeli Coalition Against House Demolitions. It is a non-violent, direct-action group originally established to oppose and resist Israeli demolition of Palestinian houses in the Occupied Territories. All of its work in the Occupied Territories is closely coordinated with local Palestinian organisations. Since its founding, ICAHD's activities have extended to three interrelated spheres: resistance and protest actions in the Occupied Territories; efforts to bring the reality of the Occupation to the attention of Israeli society; and mobilising the international community for a just peace.

Israel executes two types of house demolition orders: those pertaining to planning laws and those pertaining to military penal codes. ICAHD estimates that over 24,000 Palestinian homes have been demolished by Israel since 1967. Under the 4th Geneva Convention, Occupying Powers such as Israel are prohibited from destroying property or inflicting collective punishment (unless for 'imperative military purposes'). Israel will argue that homes are demolished because they were built without a permit. What they won't add is that permits are virtually impossible to obtain by Palestinians living under Occupation.

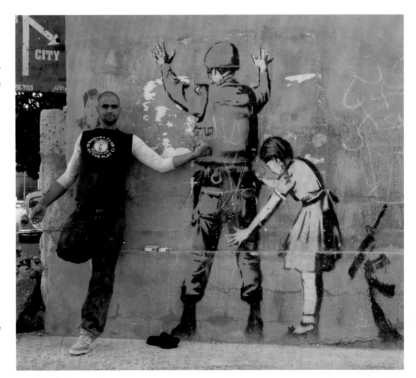

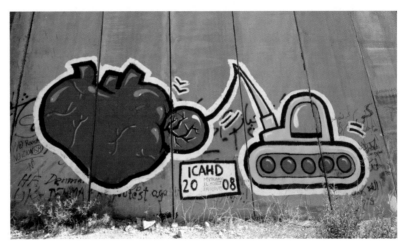

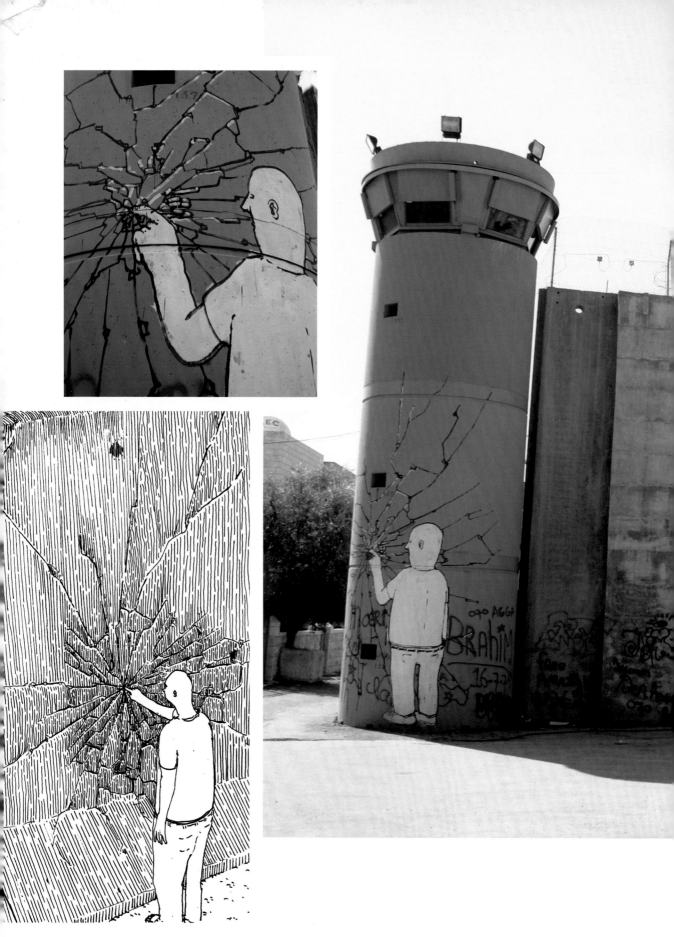

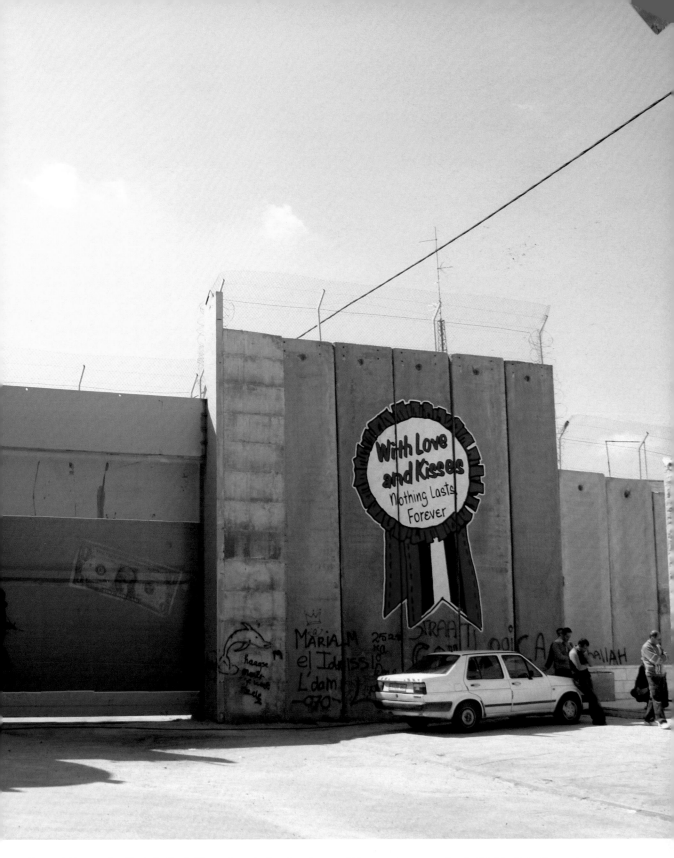

Beyond this gate lies Rachel's Tomb. The area, with shops and several beautiful traditional homes with gardens of fragrant jasmine and olive trees, is now a wasteland, the buildings and businesses largely abandoned – over 90 per cent of the shops and commercial establishments in this area have closed or relocated, UN OCHA reports. Artwork by Blu (detail and drawing), Who's paying for this? by Peter Kennard and Cat Picton Phillips, and With love and kisses by the New York collective, Faile. (Drawing reproduced with the permission of Blu.)

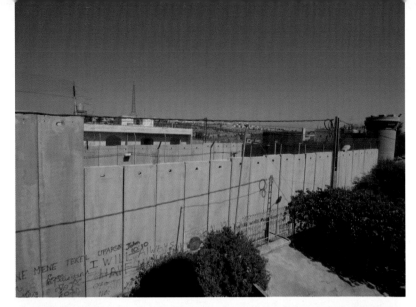

Walking around the Khoury home is like strolling through a faded photo album. The furniture is covered with sheets, curtains are drawn, there are plates of rat poison on the floor. It's eerie. Neighbours who were once a minute's walk away are now several kilometres away, given the Wall's disruptively circuitous route. It's a snapshot of the past, of former, happier, securer lives. Since the Wall was erected, the family have rented a home just outside of Bethlehem for the sake of their sanity.

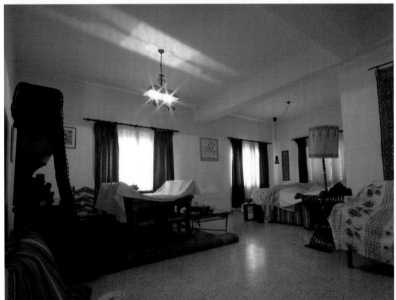

The ground floor of this beautiful home is used as the office of the family business, Bassem Khoury Architectural Bureau. Bassem and his daughter, Dima (pictured), are both architects. Business has been reduced to a trickle – once employing 50 staff, they are down to five, given the Wall's economic impact on Bethlehem and the surrounding area.

This house is also on the Hebron-Jerusalem Road. Bassem says that their home is worth a quarter of what it was before the Wall was erected. As he leaves the office, I am photographing in the front garden, which they keep bright and cheerful with flowers. 'You see what we plant?' he asks. 'And what they plant?' he adds, nodding towards the Wall.

This walled in, barren space has been placed in the heart of Bethlehem's former artery with Jerusalem. It has stood barren like this since 2006. Like a toxin, it is blighting the life around it. Jewish-imposed access to Rachel's Tomb comes at a high cost to the Jewish and Muslim communities and their heritages here in the occupied West Bank.

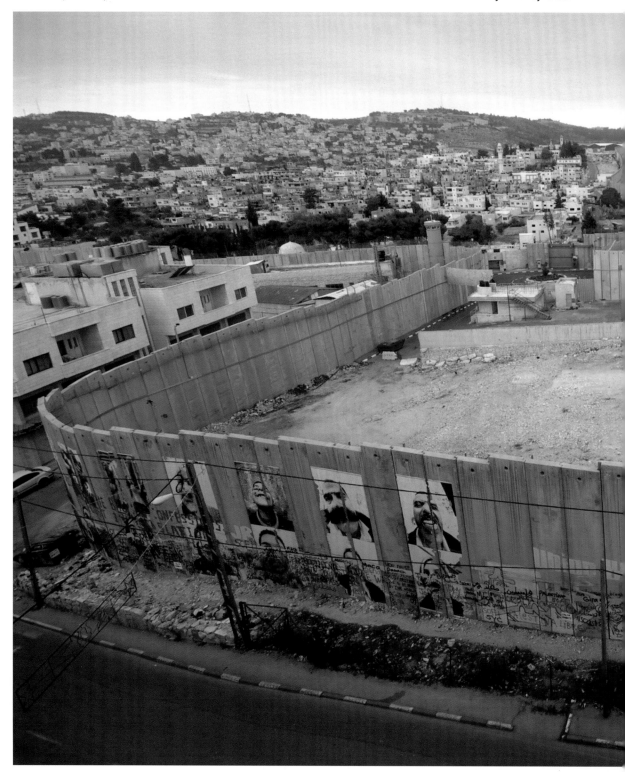

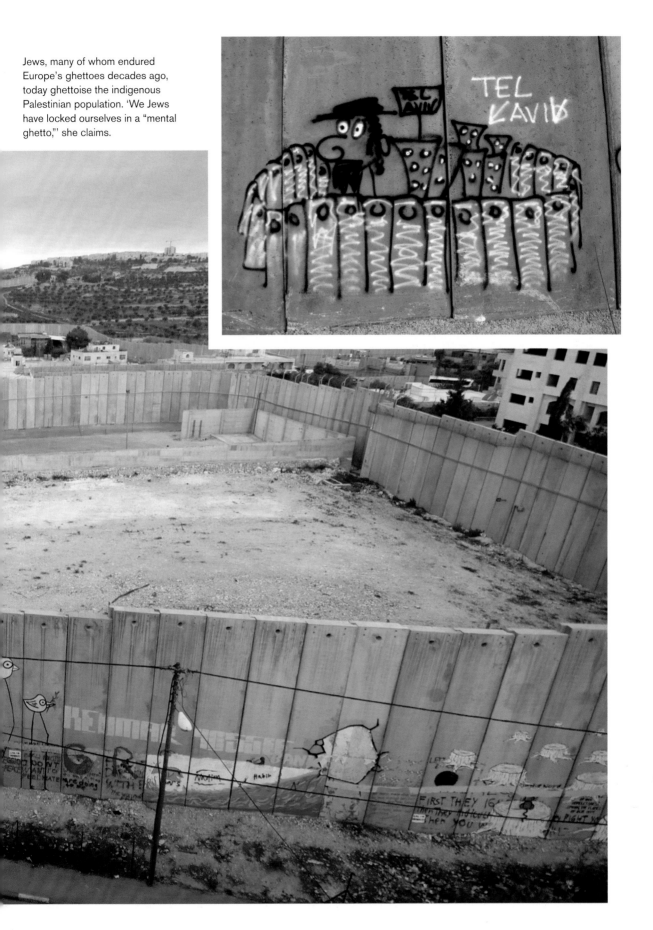

Jews, many of whom endured Europe's ghettoes decades ago, today ghettoise the indigenous Palestinian population. 'We Jews have locked ourselves in a "mental ghetto,"' she claims.

View from the rooftop of the Nasser Towel Factory (NTF), run by Alberto and his brother, Hanna (a previous mayor of Bethlehem). The company opened in the 1920s, and operated from this location from 1962. The Nasser family lost five elegant buildings in Jerusalem in 1948 as Israel waged its war against the indigenous population to create the State of Israel. Although the family was sheltering in Bethlehem just a few kilometres away, they were declared absentees by the new State and their properties were confiscated, says Hanna, who is 62. 'Of course I'll stay here,' he says. 'In my life I've not seen one happy day. We're not going to stay here because peace is coming – peace is doomed. Israel doesn't want it. We're here to stay because we've no other choice. It's our home.' Adjacent to the factory, the family owns a large, elegant home, though in need of maintenance, with dozens of olive trees and fragrant bushes in that were in bloom. It and a nearby beautiful Ottoman building were the only buildings that existed on this road in the 30s, Alberto says, established well before the State of Israel came into existence.

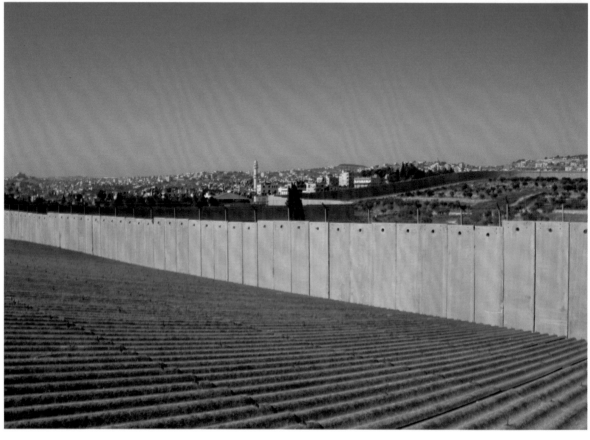

At its peak the Nasser Towel Factory employed 170 staff – as I took photographs, it was preparing to close its doors for good, laying off the remaining 45 staff. Pictured: Sabir, father of 6, employed by the factory for 30 years; Yousef, father of 5, who has worked with NTF for 21 years; and Abu George, who has 4 children and has been with the company for 50 years. Thick layers of oily dust coated much of the machinery and indicated the passing years of declining business.

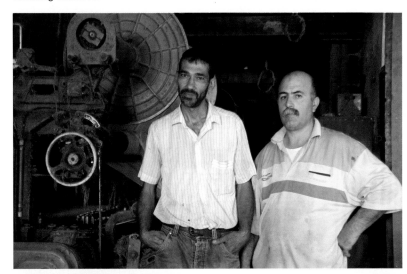

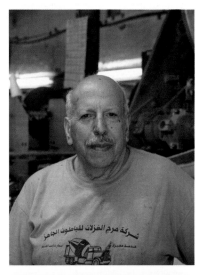

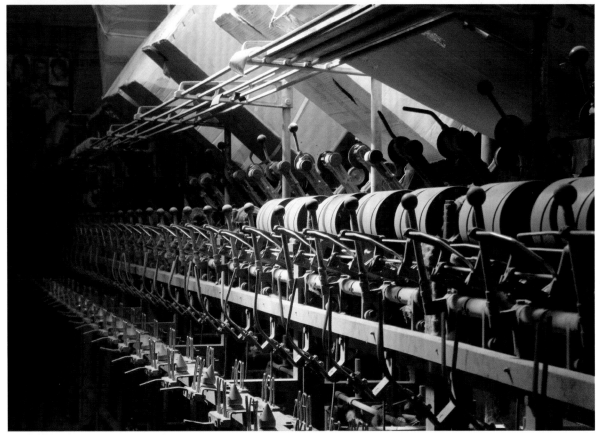

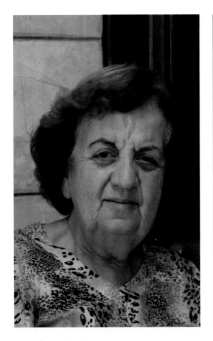

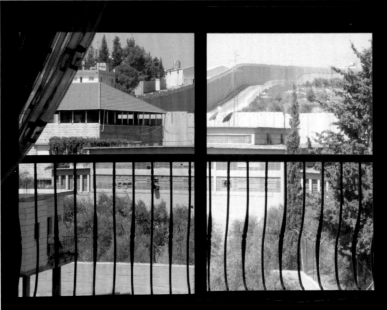

Graffiti in a Jerusalem suburb reads: Mirror, mirror on the wall, when will this senseless object fall?

Antoinette Knesevich, a former music teacher at the neighbouring Aida refugee camp, shows me through her brother's home, which is shared by three generations of the family. Opposite this mirror is a baby's crib.

The family had 80 dunams confiscated by the Israelis when the Wall was built. Antoinette is patient and philosophical about their predicament. 'They can build Walls and surround us like animals or prisoners, but the Wall will not bring them security – only justice will bring them that. They have taken our land. They have taken our water. They have taken our rights. But written on every forehead of our people is "I am Palestine". In our veins runs Palestinian blood. The Israelis cannot take this from us.'

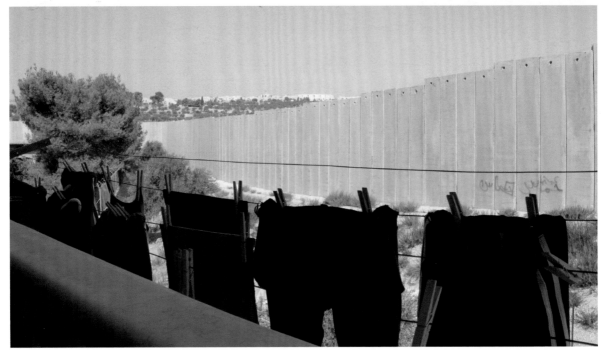

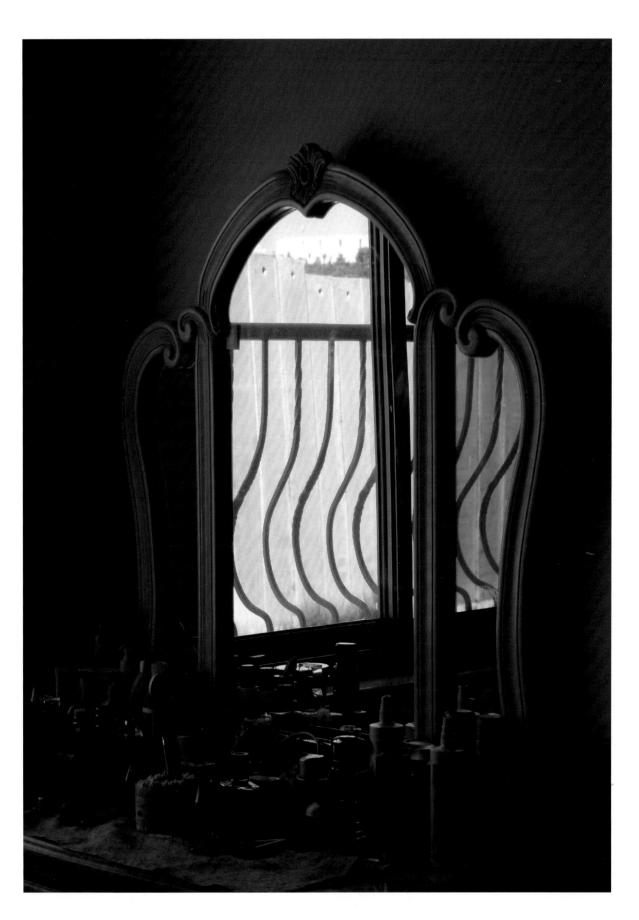

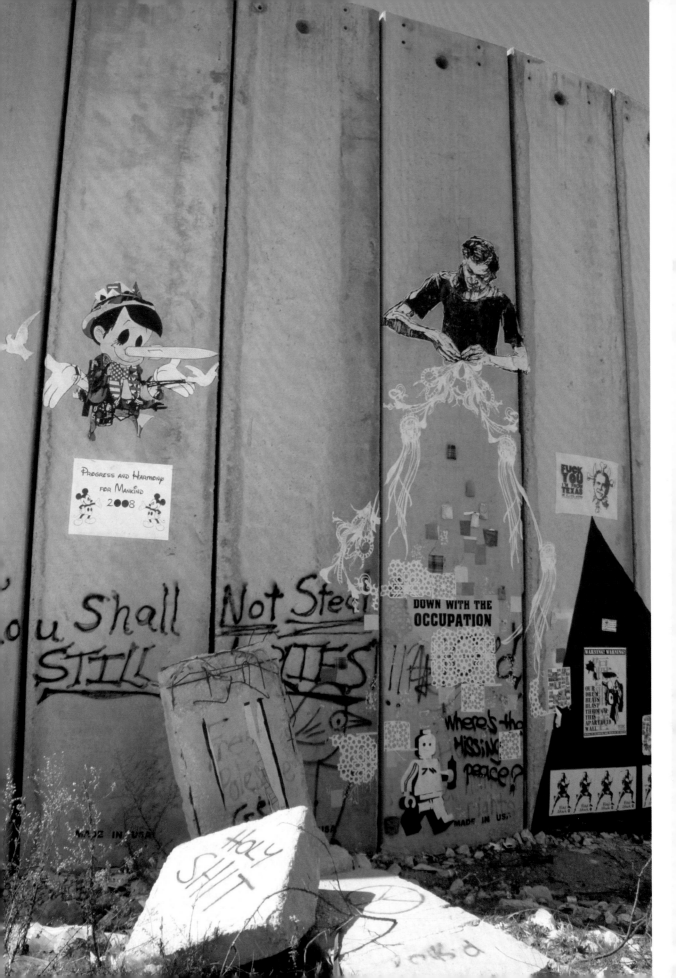

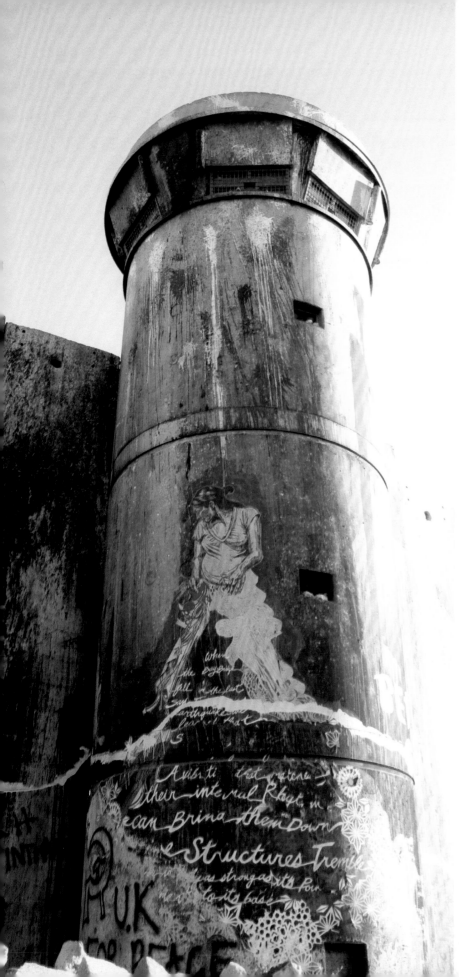

Swoon, a street artist from New York, joined Banksy and co. in Bethlehem in 2007 as part of Santa's Ghetto. Two of her pieces in Bethlehem – elaborate, painted cut-outs – were pasted onto sentry towers. The first (pictured opposite) is near the Bahamas Seafood restaurant. '[This] was inspired by a woman Eduardo Galeano described in *The Book of Embraces*,' says Swoon. 'She wore a huge patchwork skirt filled with a million and one pockets, which were in turn filled with a million and one scraps of paper, each of which contained a few words that would remind her of a story. Wanting to embody that in some way, I glued all kinds of pockets all over the Wall, into the figure of this woman, and in the pockets I placed little strips of paper containing quotes by Arundhati Roy, Asatta Shakur, Martin Luther King, and anyone else I could find saying inspiring things on the subject of the struggle for basic human rights and freedom.'

The second large image [pictured here and located opposite the Aida refugee camp] was pasted onto a spot that had been stained by fire. The fire was started in protest because it was there that a 17 year old boy had climbed a ladder to place a Palestinian flag at the top of the Wall: he was imprisoned for 8 years for this simple act. The image of a woman contains a quote about how, by matching the resonant frequency of any structure, it is possible to bring that structure down without using so much force. That quote struck me because it seems that when a people are under constant pressure from a power with much greater force than they have, it becomes necessary to find paths through that force which can destabilize it using only the modest means available to them.'

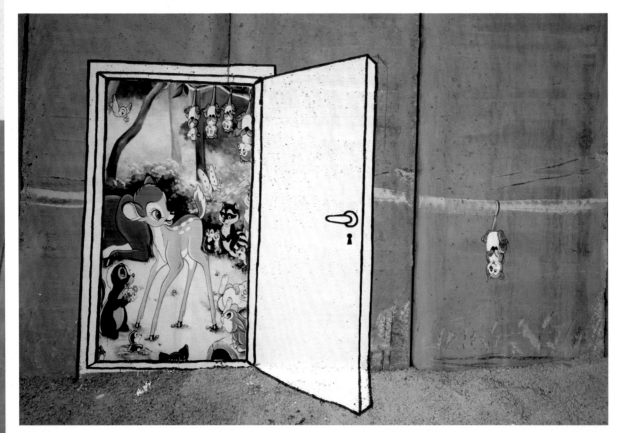

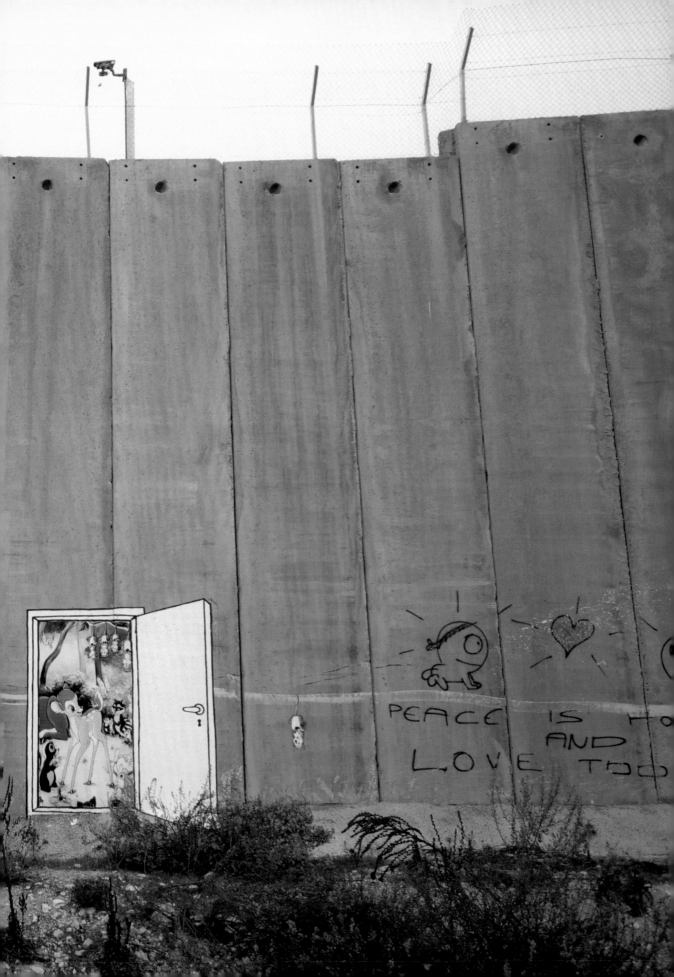

PEACE IS HO
AND
LOVE TOO

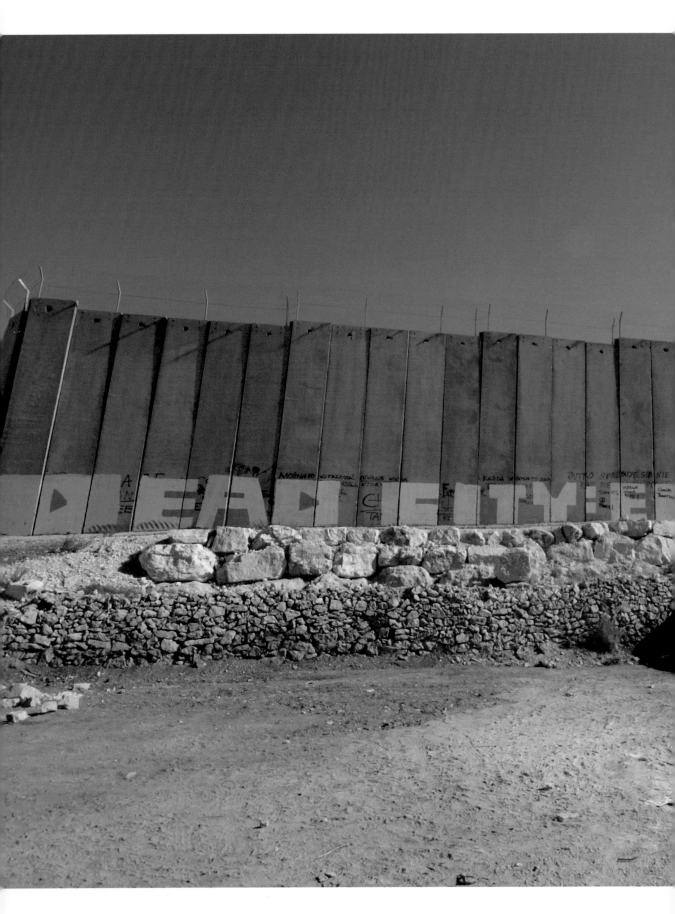

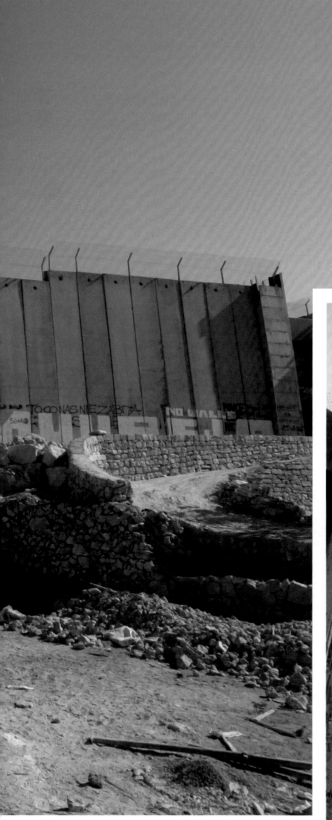

'Dead city' reads the graffiti in English and Spanish along a span of the Wall that separates Rachel's Tomb from Bethlehem. Bethlehem feels like a dying city – and is definitely dead in parts. Despite the occasional bumper year of tourists, such as 2008, the economic strangulation is apparent the moment one walks from the checkpoint to the swarming pool of taxi drivers, kids selling gum or post cards, or men selling necklaces – all of them eager to greet each visitor, all desperate for some income, all offering a special price, then an even more special price. Behind this section of Wall was a café run for 40 years by Abu Khalid. Its fate was sealed by the completion of the Wall here in 2006. A simple, hospitable man who enjoyed the company of locals and tourists, his life has been destroyed by the loss of his livelihood and sense of purpose.

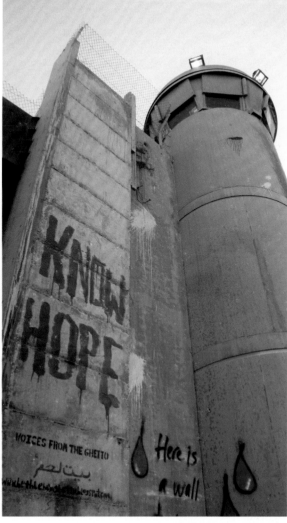

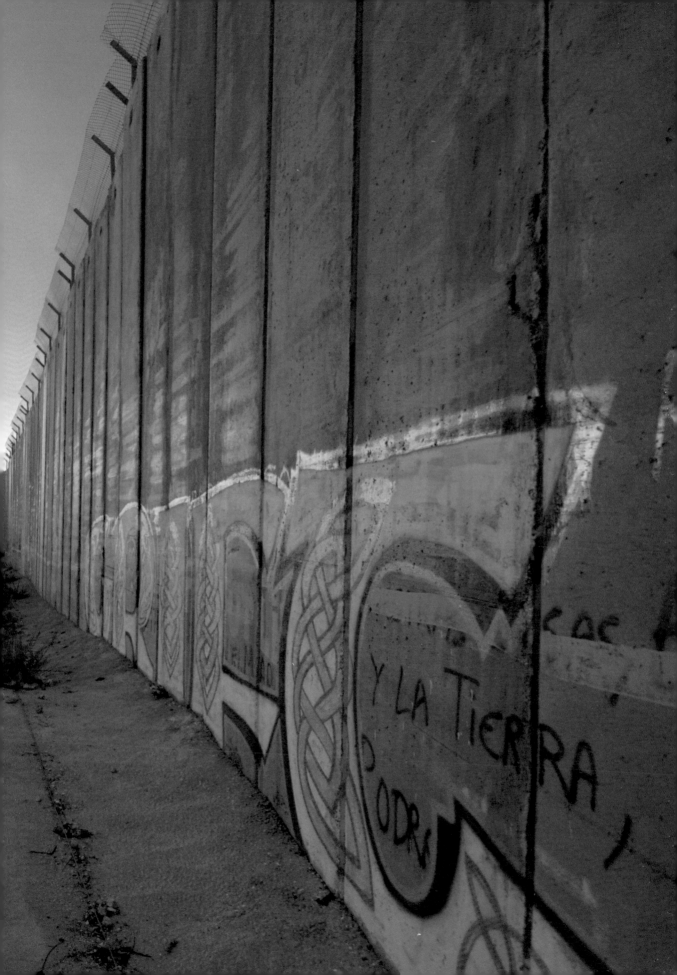

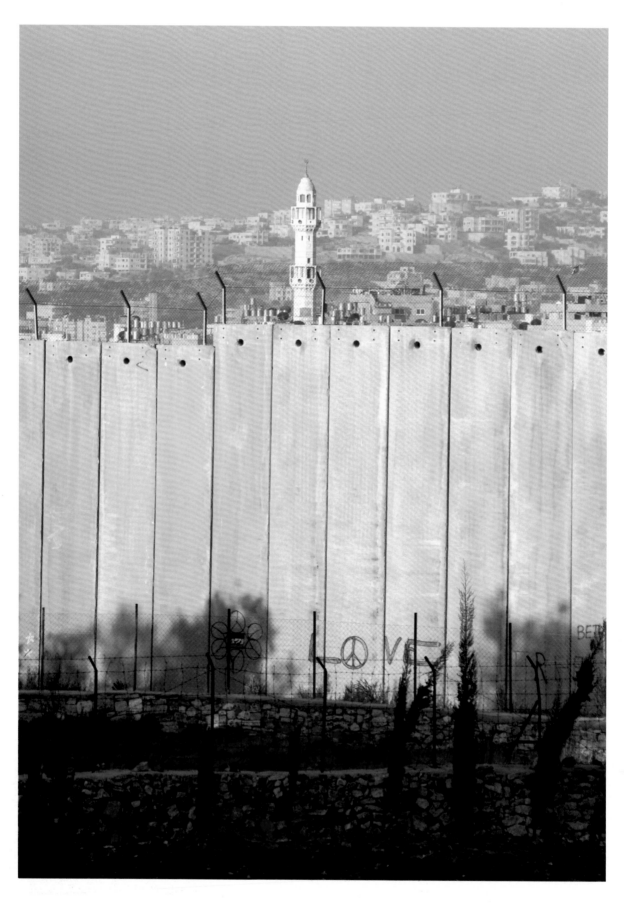

Two pieces by Banksy backfired as far as local sensitivities were concerned in 2007. Many Palestinians took offence at being compared to rats armed with catapults (below). What might have fetched a small fortune in the West was duly destroyed by locals (inset).

Main image below © Pictures on Walls.

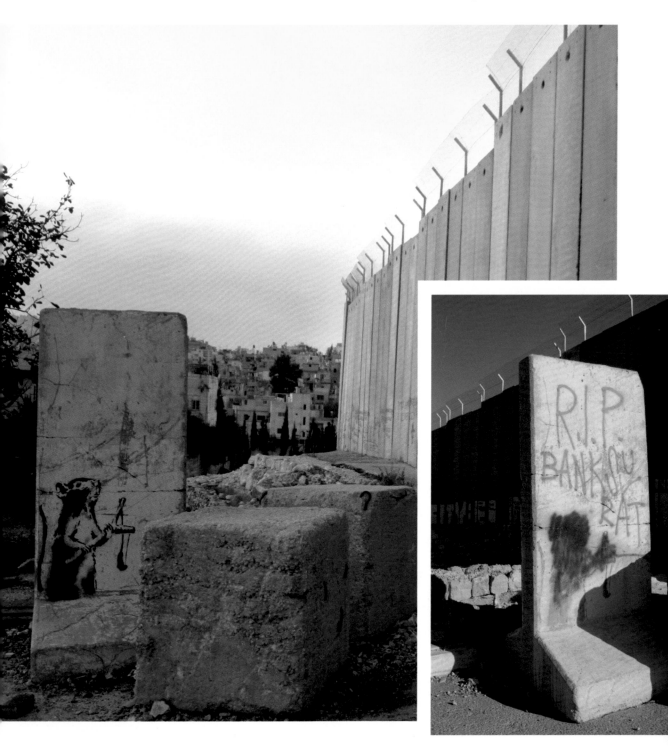

Graffiti and artwork are some of the few things showing any sign of life in neighbourhoods that are being systematically depopulated by the Wall. The view from the Khoury family home on p 33 shows the house above. To get from one home to the other prior to the Wall would have meant a 30 second walk; now, it's easily a 20 minute walk away. On this street, shops have closed up, and handsome homes are abandoned. Barbed wire, smashed windows and padlocks tell wordless stories. In the homes that are still occupied, the owners I spoke to shake their heads at the unimaginable transformation of their neighbourhood and livelihoods. Anger, resignation, hopelessness, desperation – the artwork on the Wall is an antidote to these emotions. On the other side of the Wall, bullet-proof buses bring tourists and pilgrims from Jerusalem and beyond through military gates, with military escorts, to pray at Rachel's Tomb, oblivious to the reality beyond the concrete Walls. Palestinian labourers building a surveillance platform at one end of the street refuse to be photographed: work of any sort is difficult to find, and they must take whatever is on offer.

even if everybody
can't forget his hat
for this fucking wall
we have to not
love break it forget

SAPERE AUDE!

KANT.

الدُ الى ياف
ى مكان
الخروج
جناح الطير
عاى
صاروخ

In Emmanuel Kant's essay, 'What is Enlightenment?', *Sapere aude* translates as 'Have the courage to use your own reason' or 'Dare to discern.' It was a call for Kant's readers to exercise intellectual self-liberation, to question what authority tells you. The Wall is necessary for Israel's 'security', Israeli officials tell the world.

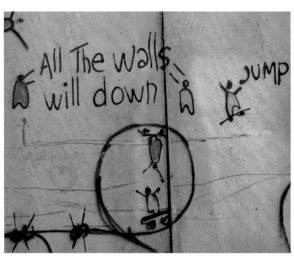

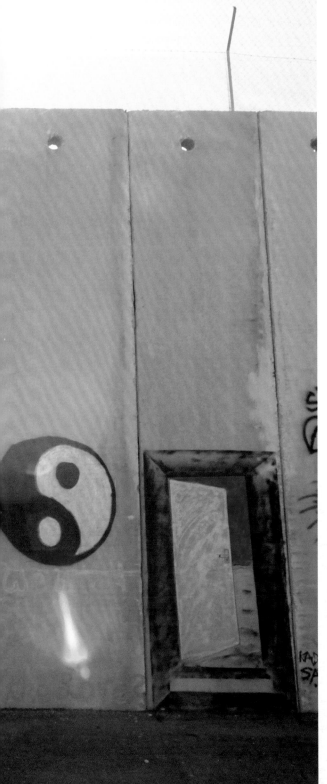

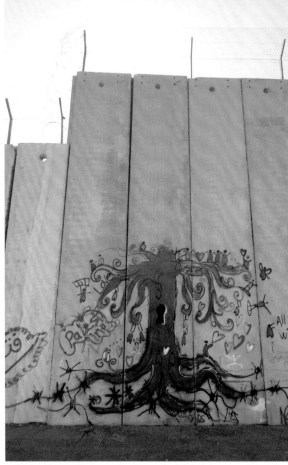

Faccouseh Handicrafts, which opened in 1970, is struggling to survive. Run by Jimmy and Randa Faccouseh (opposite page, bottom), the company specialises in high quality, hand-carved figures and nativity sets made from local olive wood.

They cannot get their products to the lucrative markets in Jerusalem, they say, and tourism in Bethlehem is precarious at the best of times. Before the Wall, the company trained and employed 15 staff, mainly from the Aida refugee camp. There are now six, including Jimmy and Randa, working reduced hours, four days a week to stay afloat.

'Holy' graffiti is common on the Wall. This (below, right) is from Psalms 72:12: *For He shall deliver the needy when he cries; the poor also, and him that has no helper.*

They're waiting.

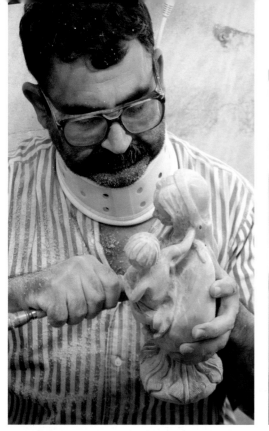

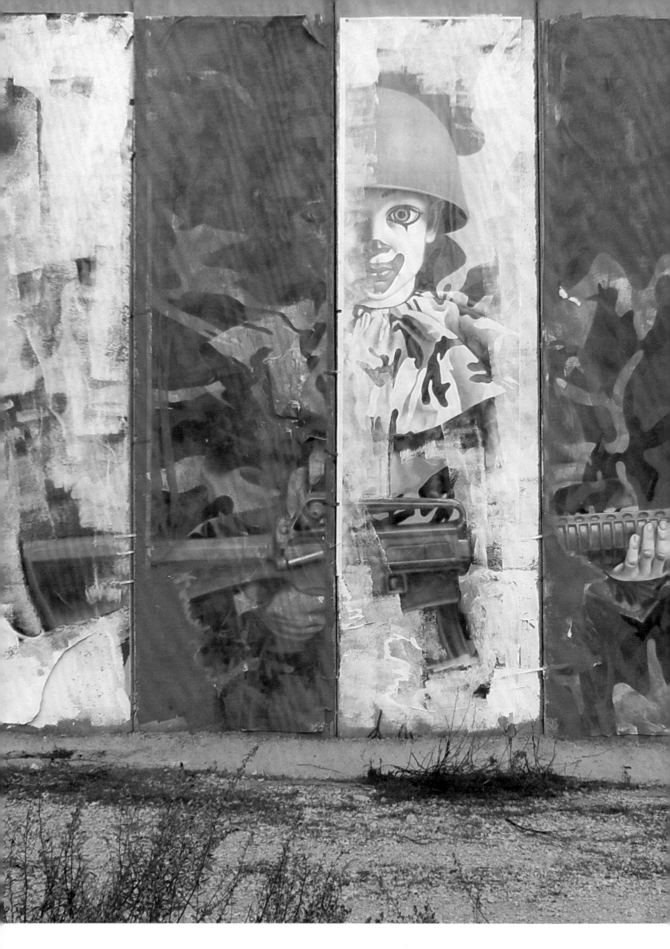

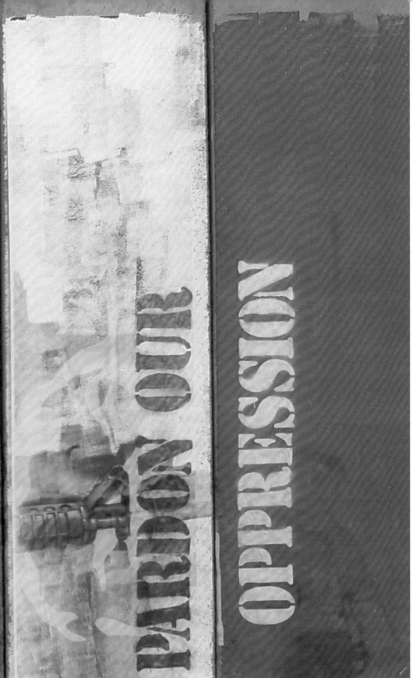

American artist Ron English is a veteran
when it comes to putting murals onto
walls while having guns trained on him.
Contributing to Santa's Ghetto project
was his third such experience in 20 years
(Checkpoint Charlie, Berlin Wall, and a
building occupied by squatters in New
York City's East Village).

English produced three pieces for the
Wall, all near the Aida refugee camp. He
describes the idea behind each:

'The concept behind Pardon our
Oppression was to link American support
to the oppression of the Palestinian
people. Since Israel is our welfare state,
we have a certain responsibility for the
Palestinian people that we don't seem to
want to acknowledge.

'The second piece I did was a
Guernica with kids being bombed by
a little American pilot – again, with the
same underlying thematic.

'The third piece was Mickey Mouse
wearing an Arab headdress that said
'You're not in Disneyland anymore', which
was an offhand comment on the actual
project, of trying to morph the Wall into a
tourist attraction.'

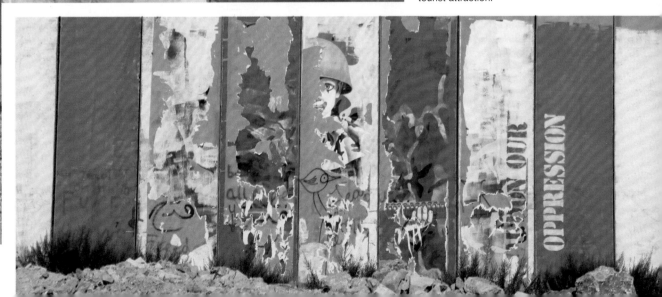

English adds: 'I probably never would have had the nerve to go to Palestine on my own – but this experience made me realise how important it is to actually go to places to experience things firsthand – the American media is very biased and we rarely get the truth about much of anything abroad. I wish there was a way we could get more Americans to see what their tax dollars are doing to other people around the world.'

Several things about his experience in Palestine impressed English. 'I was taken by the warmth of the Palestinian people and their support for our artistic efforts. I was amazed by Banksy's organisation, Pictures on Walls, and their ability to seize the moment and actually do something important using art and artists. Lastly, I really fell in love with the kids from the refugee camp, who became our little helpers in the project.'

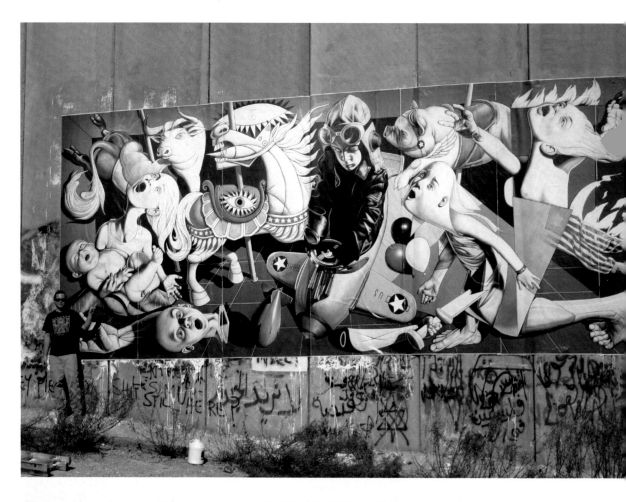

In an interview in 2008, English told me: 'American support of Israel remains unquestioned in the United States. As an American taxpayer, I help fund what has become, in many instances, oppression for the Palestinians and their children. The uncertainty of their lives concerns me as an American and as a world citizen.'

ABOVE
Grade School Guernica
(photo courtesy of Ron English).

RIGHT
Ahmad, outside Bethlehem checkpoint, 2006. He sells gum after school but says he wants to be a doctor when he is older.

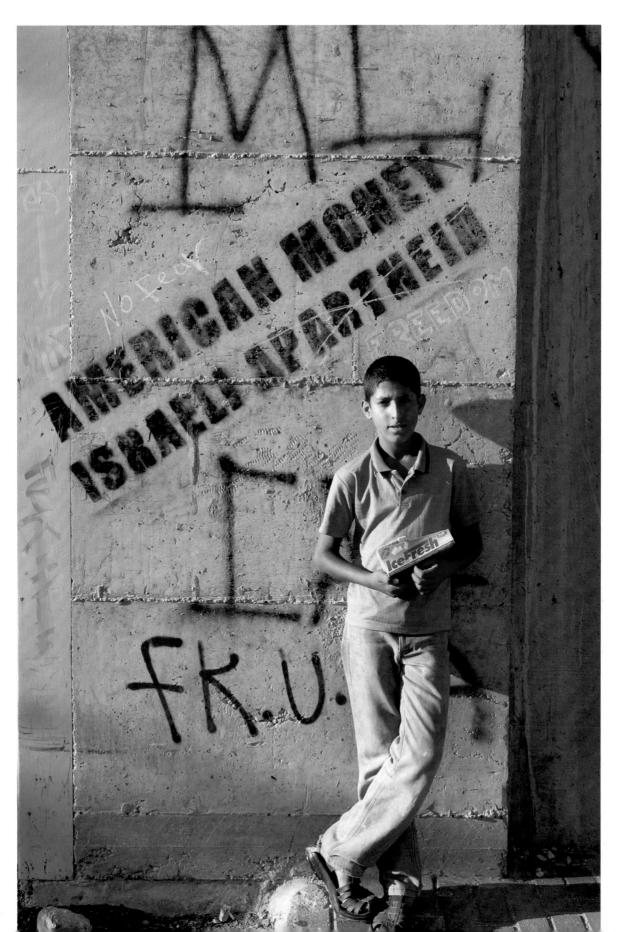

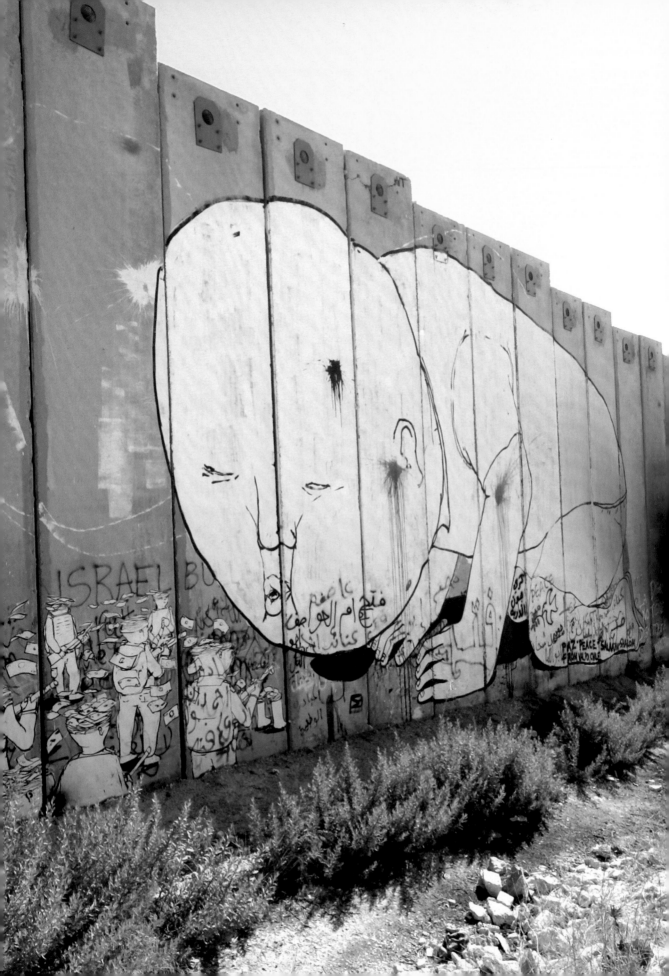

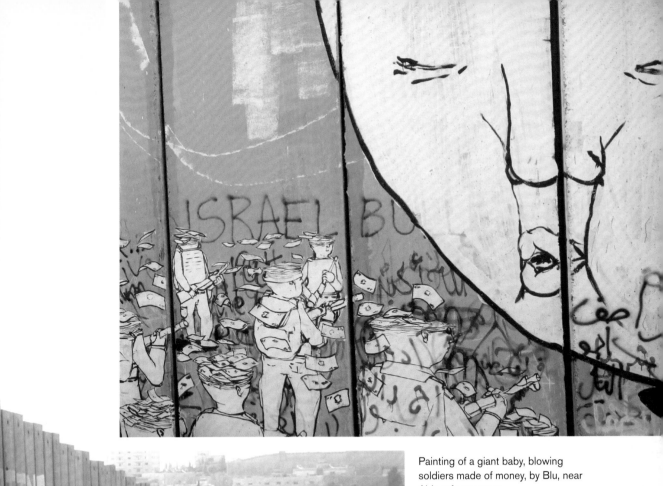

Painting of a giant baby, blowing soldiers made of money, by Blu, near Aida refugee camp.

Peter Kennard and Cat Picton Phillips entitled one of their pieces, *Who's paying for this?* Israel currently receives $3 billion annually from the United States in military aid.

OVERLEAF
Painting by Sam3. Artwork near the Aida refugee camp.

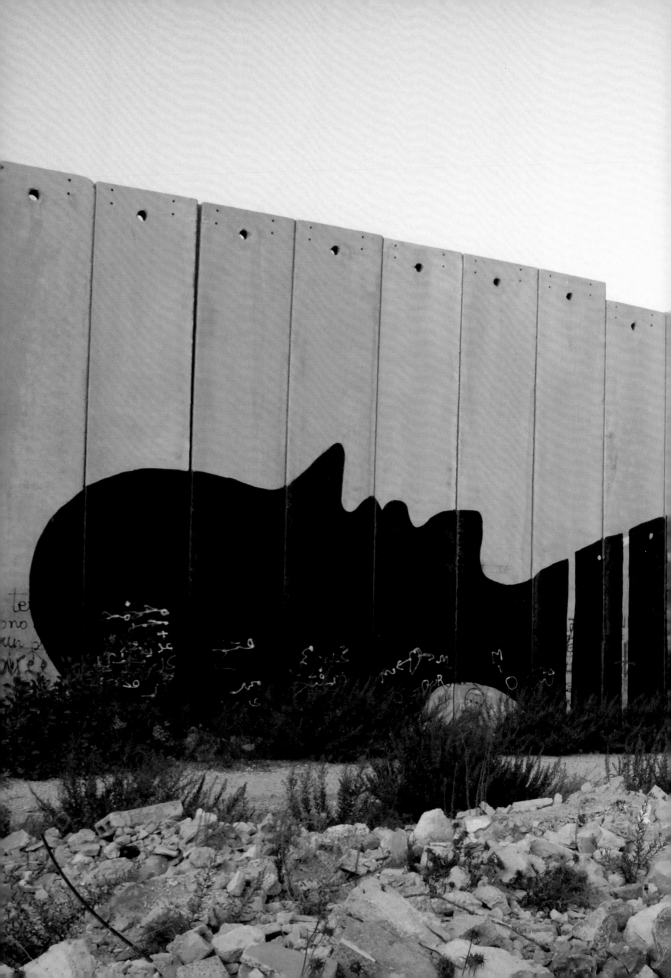

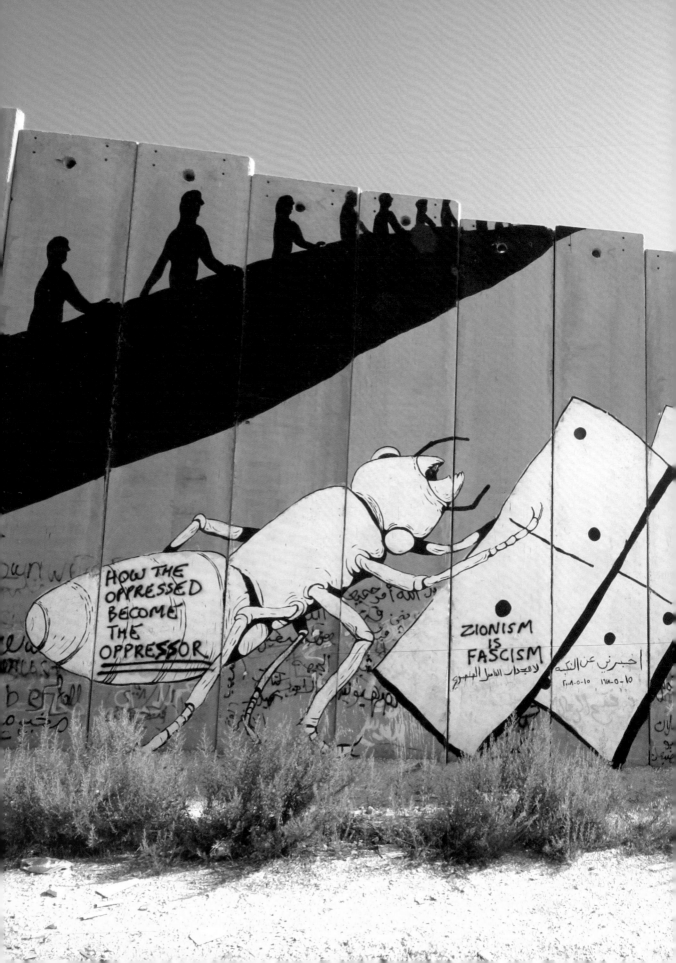

A vast escalator transporting people over the wall, by Sam3, next to a piece by Erica il Cane, with some common sentiments graffitied on top by others.

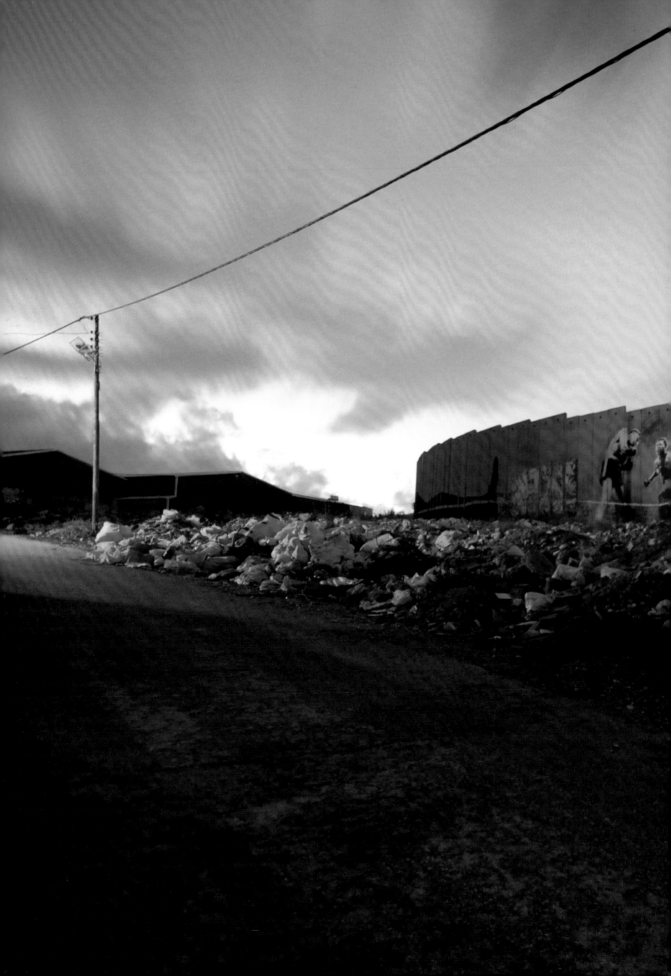

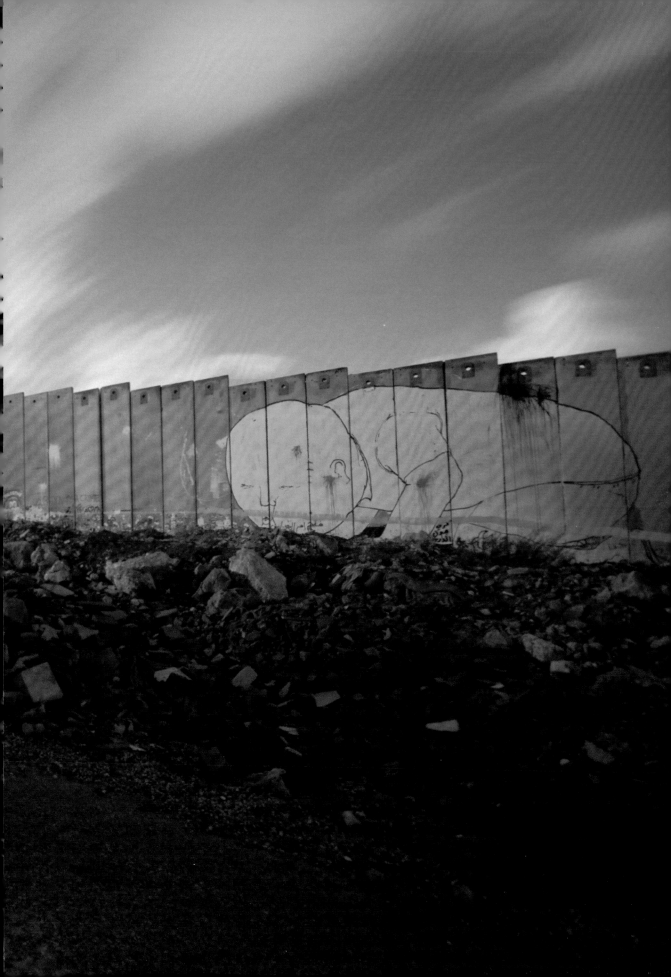

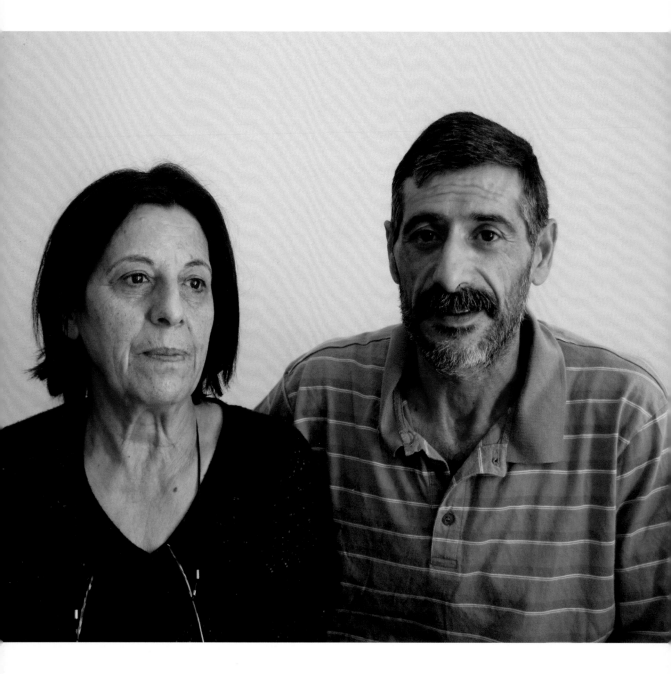

What happens to Palestinians with emergency medical cases that require access to specialist facilities at hospitals in major cities on the other side of the Wall? 'It depends on the mood of the Israeli soldiers,' says Dr Muhammad Awadeh, director of emergency medical services at the Palestine Red Crescent Society (PRCS). 'That will determine how long an ambulance is held up – if 30 minutes, consider yourself lucky, but it can easily be hours,' says Dr Awadeh.

The fate of Anton Ballout, pictured right (his widow and son, above),

was determined by a soldier at the Bethlehem checkpoint. Suffering from suspected mesenteric venous thrombosis – a blood clot in the major veins that drain blood from the intestine – Mr Ballout had security clearance to be transported by ambulance to a specialist hospital in Jerusalem, but his doctor didn't. The doctor argued that Mr Ballout's life depended on him treating and monitoring Mr Ballout en route. The soldier on duty, questioning the expert medical advice of the doctor, delayed Mr Ballout's transfer to the hospital

by 40 minutes.

Mrs Ballout witnessed the entire exchange and offered to leave the ambulance so long as the doctor could accompany her husband. Eventually, the soldier allowed the ambulance to pass with the doctor. Moments after the ambulance was beyond the Wall, Mr Ballout died.

Dr Awadeh gives another recent case of a one day old baby in critical condition, whose ambulance was delayed because the soldier insisted on seeing the newborn's ID. While the ambulance was held up, the baby

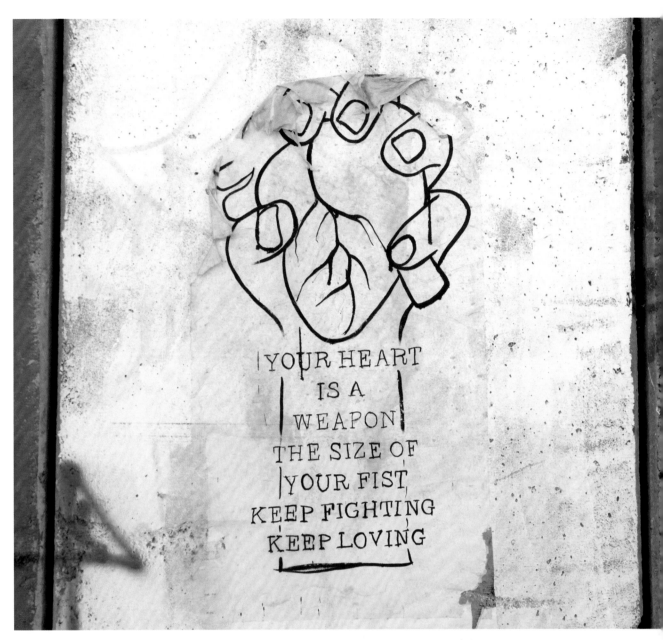

YOUR HEART
IS A
WEAPON
THE SIZE OF
YOUR FIST
KEEP FIGHTING
KEEP LOVING

stopped breathing and died.

The right to health is enshrined in international humanitarian law. The PRCS has tried to coordinate security clearance of staff and vehicles with Israeli officials to facilitate movement, Dr Awadeh says, but without success. Why? 'This is the land of "just because,"' he says, exasperated. 'They don't need a reason because they can get away with it. At checkpoints, the soldiers have to see blood and tubes, and have sirens and lights before they are convinced it's a real emergency,' he adds.

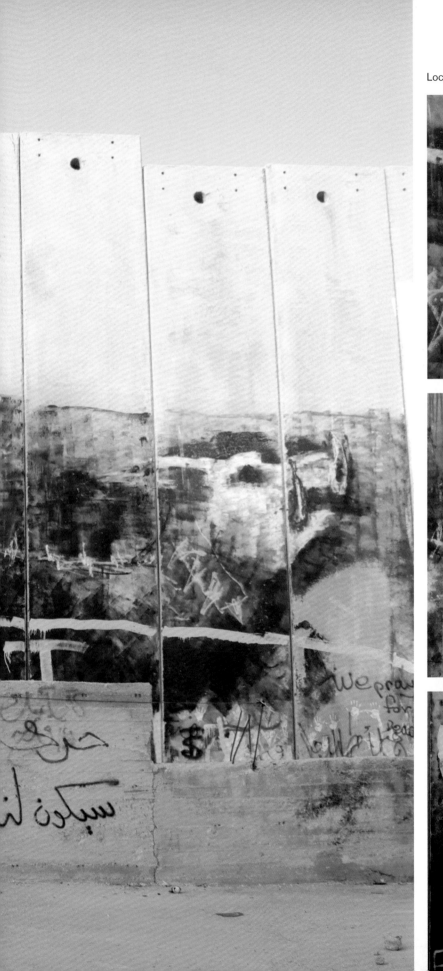

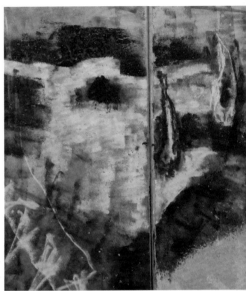

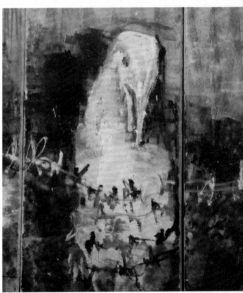

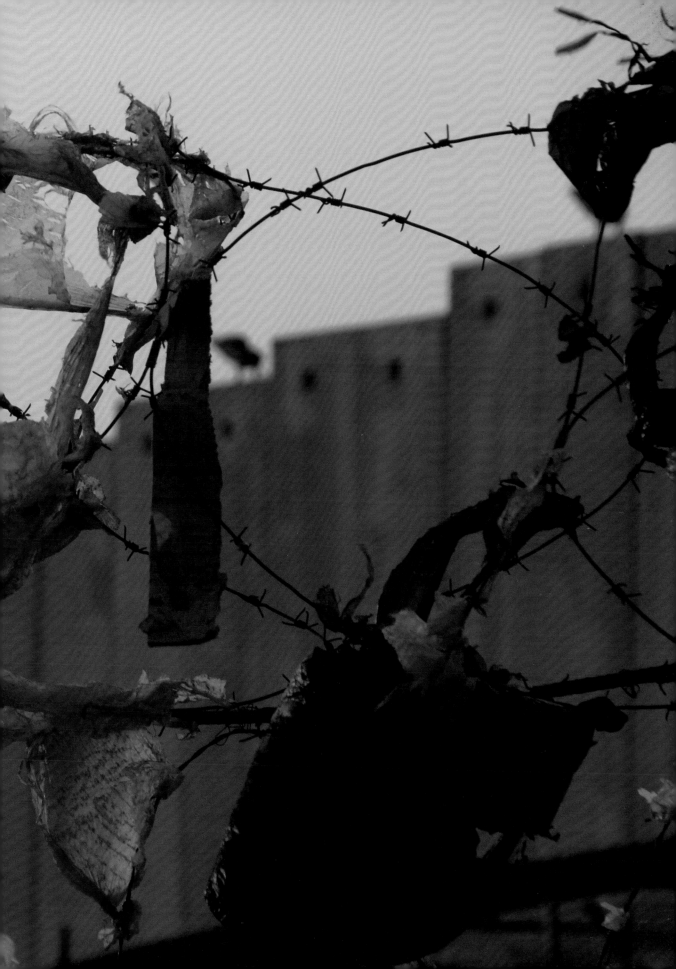

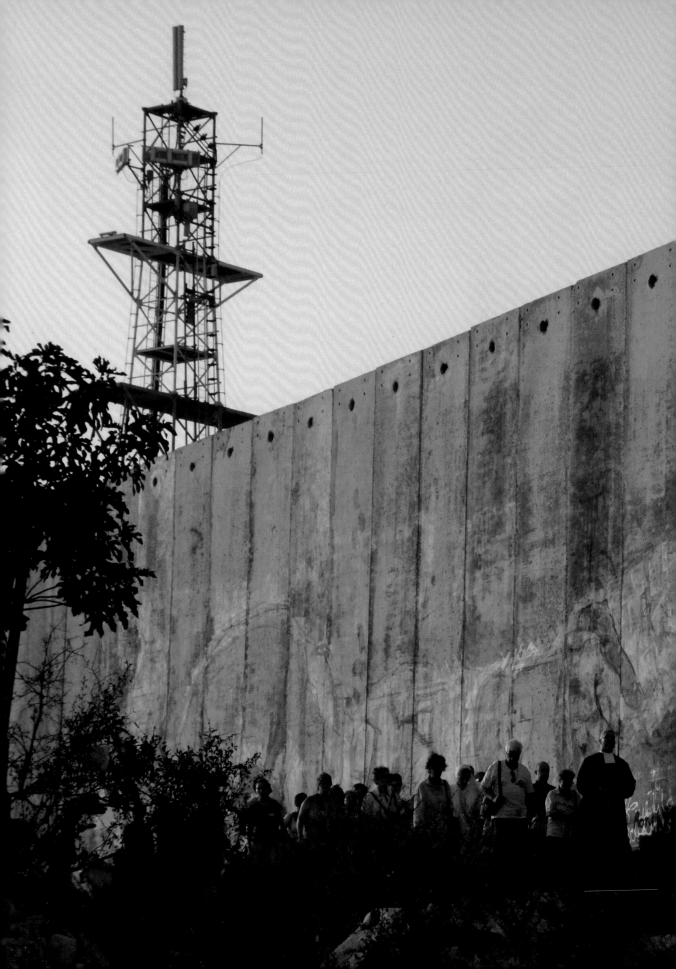

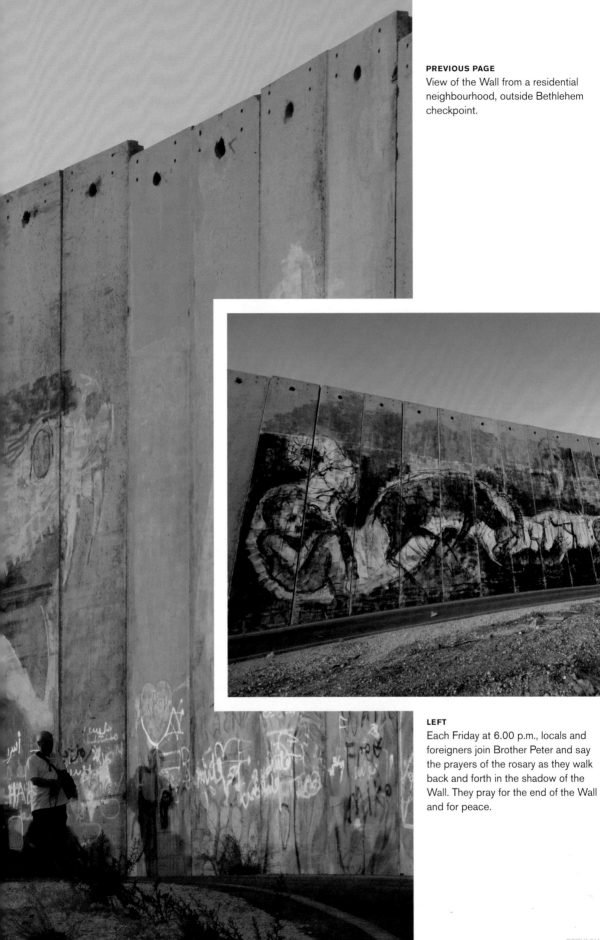

PREVIOUS PAGE
View of the Wall from a residential neighbourhood, outside Bethlehem checkpoint.

LEFT
Each Friday at 6.00 p.m., locals and foreigners join Brother Peter and say the prayers of the rosary as they walk back and forth in the shadow of the Wall. They pray for the end of the Wall and for peace.

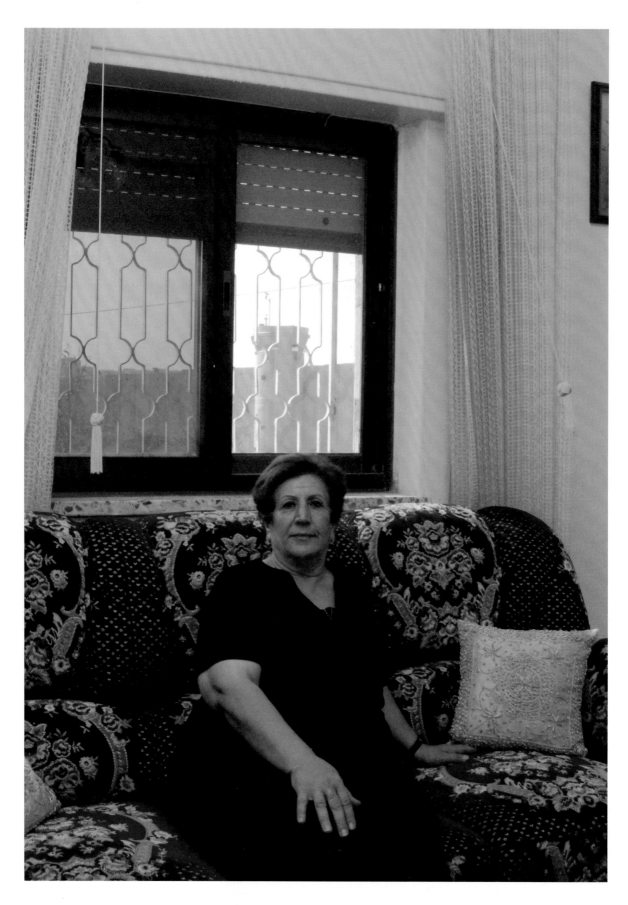

Clemence was born in Yaffa. She was two years old when her family were forcibly expelled from their home by Jewish militias in 1948. They sought safety in Jordan. In 1966 she got married and she and her late husband settled in Bethlehem and began building the house she lives in, 20 metres from the checkpoint. 'We have family roots in Bethlehem going back 400 years,' she says.

Her brother and sister-in-law share the home – all are in their sixties. Since the Wall was built, they have been harassed and frightened by Israeli soldiers. Clemence had shutters installed to stop soldiers in the sentry tower (visible, opposite) shining their gun lasers through the windows and into the home. Even though the building is overlooked by a sentry tower, heavily armed soldiers occasionally enter it and search it. They've lost the 44 olive trees that they harvested for oil, and the additional income from the sale of the oil. Technically, Clemence could access the family's olive grove, but she refuses to for two reasons: 'First, it's our land, so why should we pay $100 for permits to get to our olive trees? Second, why go when we can be attacked by [Israeli] settlers? People have been killed by them.'

Throughout the West Bank, attacks by Jewish settlers on Palestinians and Palestinian property are showing an alarming increase, according to a 2008 UN OCHA Special Focus report, *Unprotected: Israeli settler violence against Palestinian civilians and their property*. Attacks are increasingly common during the olive harvest. OCHA reports an increase of more than 75 per cent in attacks in 2008 compared with 2007, and notes that half of those attacked were vulnerable groups: Palestinian children, women and those over the age of 70. Israeli authorities do not prosecute in the vast majority of cases.

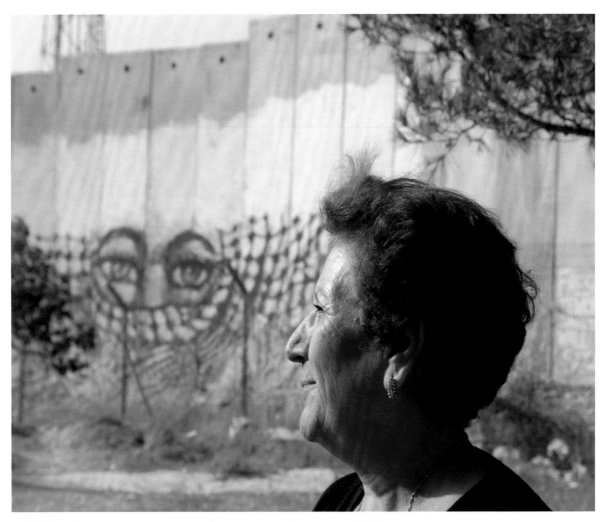

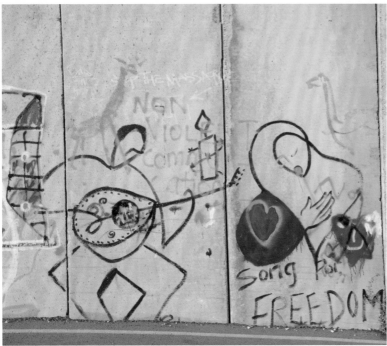

Song for Freedom by UK artist, Paula Cox, with the Amnesty International symbol. Cox produced a range of artwork from Palestine, called *Art for Palestine*; prints are available to buy (www.paulacoxart.com) with 10 per cent going to women's projects in Palestine.

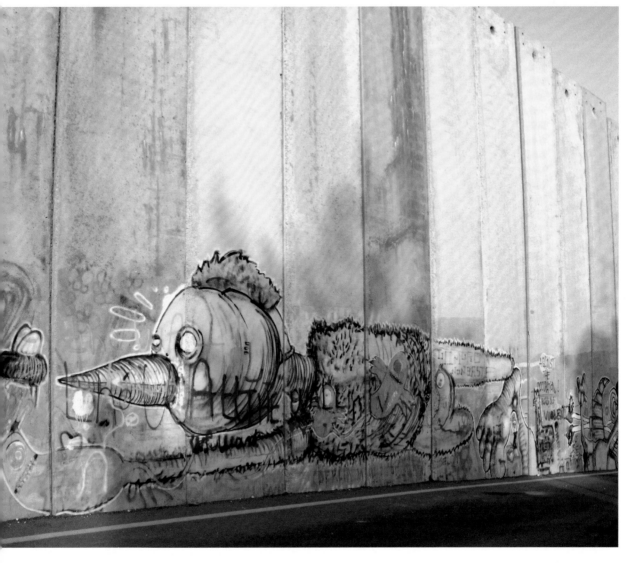

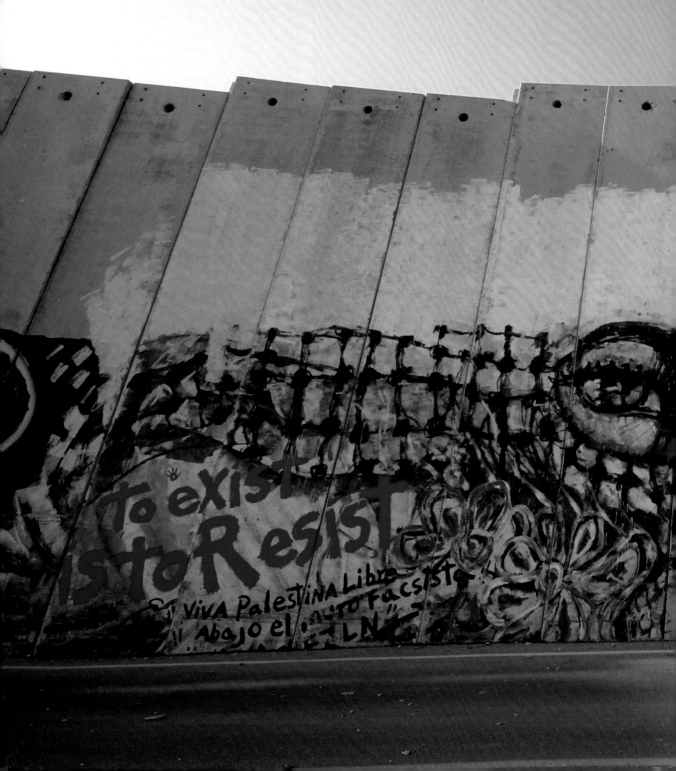

'To exist is to resist' – a slogan repeated in graffiti and artwork all over Palestine. This solidarity mural is by Mexico's Ejército Zapatista de Liberación Nacional (Zapatista Army of National Liberation).

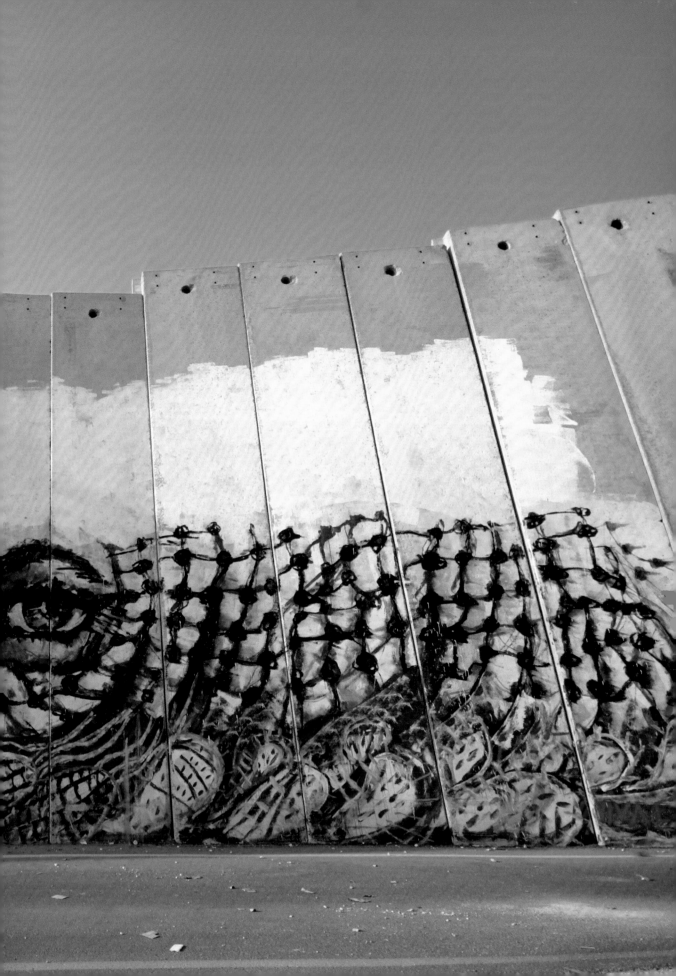

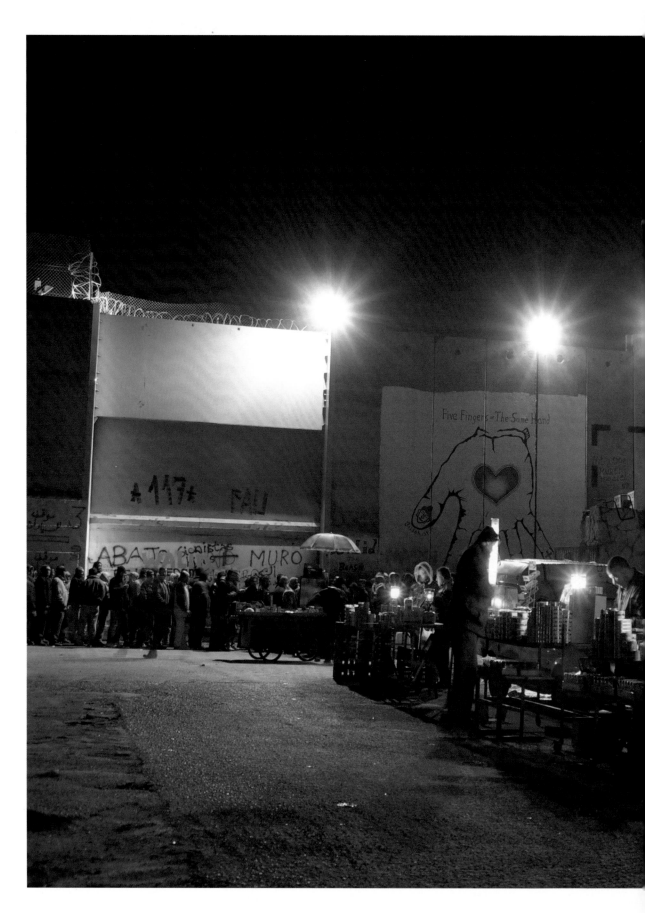

It's 5.30 a.m. outside the Wall at Bethlehem's checkpoint. Some 2,000-2,500 workers with permits to work inside Israel queue here each morning, the earliest arriving at 2.00 a.m. – including these vendors selling tinned and processed food and drinks, which are much cheaper than on the Israeli side. Work is scarce in the West Bank thanks to Israel's illegal occupation, and the Wall is making circumstances much worse. It is a tragic irony that many of these men will work in Jerusalem building Israel's illegal settlements – one worker tells me he earns 150 NIS (£23) a day. The occupation that is strangling Palestine utilises cheap Palestinian labour to build and tighten that stranglehold. It's a cynical, parasitic relationship that serves Israel's colonizing interests.

The men – who must be over 30, married and have at least one child – sit and rest in a narrow metal corridor that resembles a cage, all with insufficient sleep. Some talk, smoke cigarettes, all waiting for the processing booths to open at 5.00 a.m. – sometimes 5.15, sometimes 5.30, workers say – so they can then get lifts to work to scrape together a meagre living. In winter months, workers burn cardboard boxes on the edges of the corridor – dangerously close to clothing – to keep warm through the cold morning hours. Those not in the corridor start forming a queue, which morphs into a cacophonous scrum of shouting bodies pressed tightly against each other as more workers arrive.

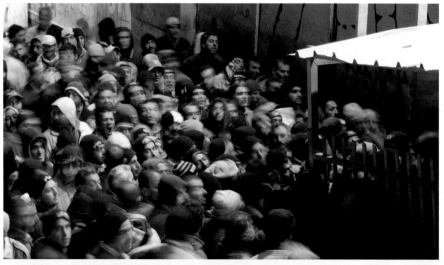

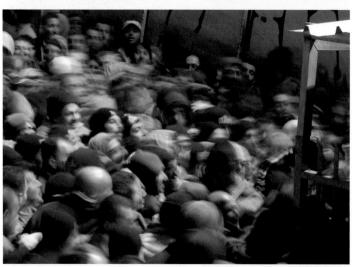

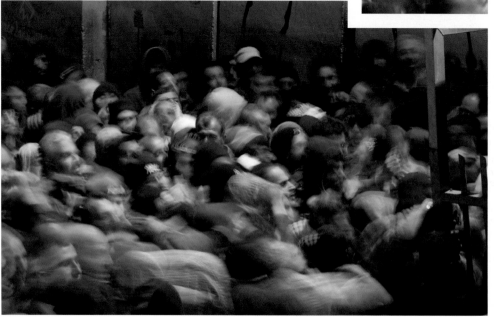

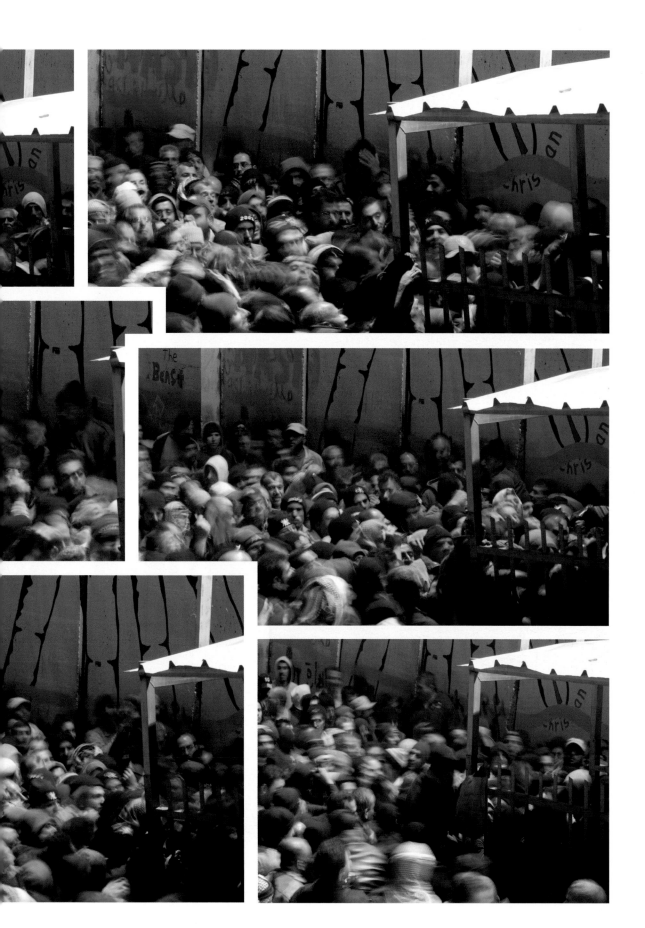

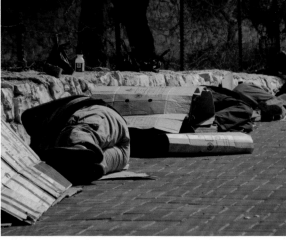

These men are not homeless. They are the first through the checkpoint at 5.00 a.m., now trying to get a bit of sleep before their transportation arrives to take them to work. A dozen or two line the pavement at 5.30 a.m.

Inside the checkpoint, these workers face more stringent and humiliating security checks than most Westerners do when boarding a flight. The whole process can take up to three hours – the checkpoint has the capacity to process more people, more quickly, but is under-staffed. Only then does the journey to work properly begin, followed by a physically intense working day and a return home via the checkpoint.

A few hours later, these men are in bed to get some sleep before it all starts again long before the crack of dawn.

As I photograph these workers jammed into this cage, a man calls out in perfect English: 'What do you make of this?' he asks. 'It's fucked up, isn't it?' His name is Mohamad Issa. 'If Jesus came back and had to do this every day, he'd become an atheist,' Issa half jokes. How does everyone endure this, I ask. 'It's the Palestinian spirit. They can build walls around us, they can subject us to this every day, but they can't break our spirit.'

Unfortunately, religious leaders and heads of state on official visits always skip this demeaning scene, and most tourists and pilgrims get the 'checkpoint lite' experience – they bypass the terminal building and travel in air-conditioned comfort through the sanitised vehicle checkpoint. Instead of witnessing the appalling treatment of these workers, they are treated to giant posters that cover the Wall, greeting them with 'Peace be with you'.

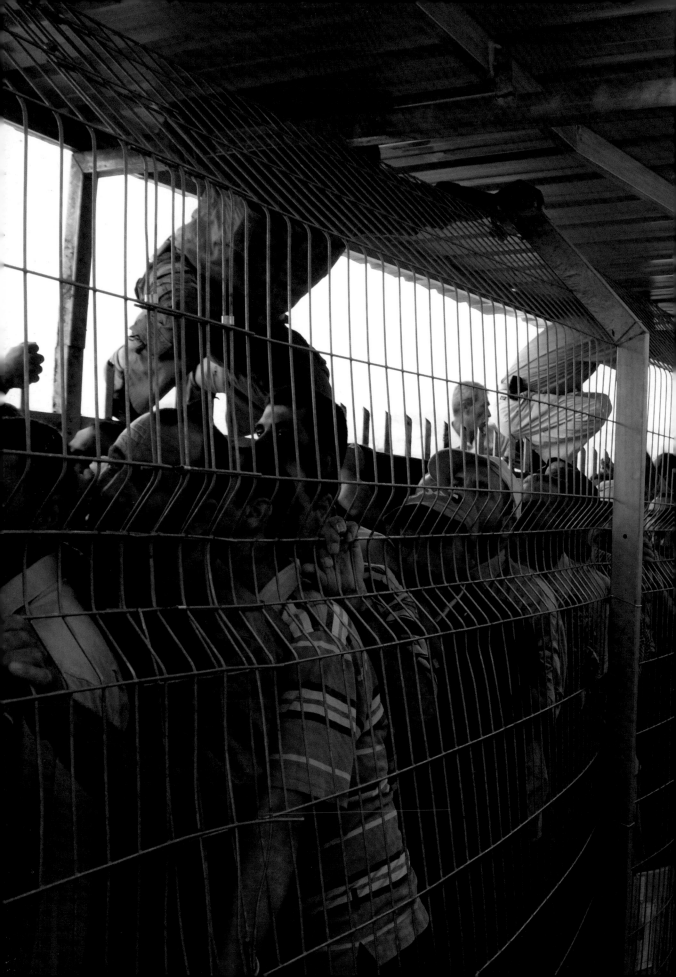

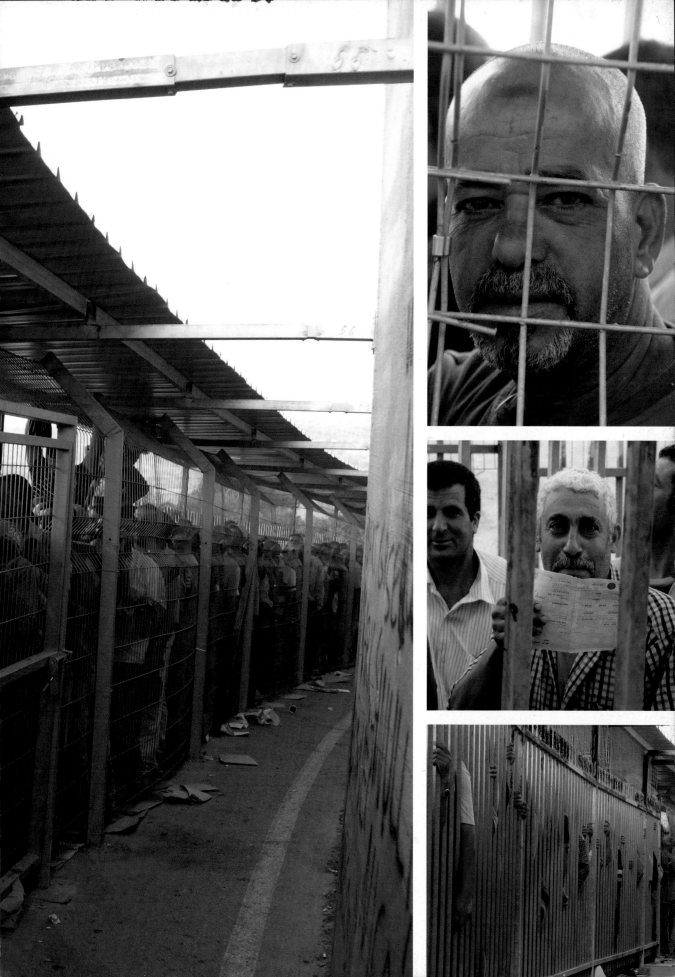

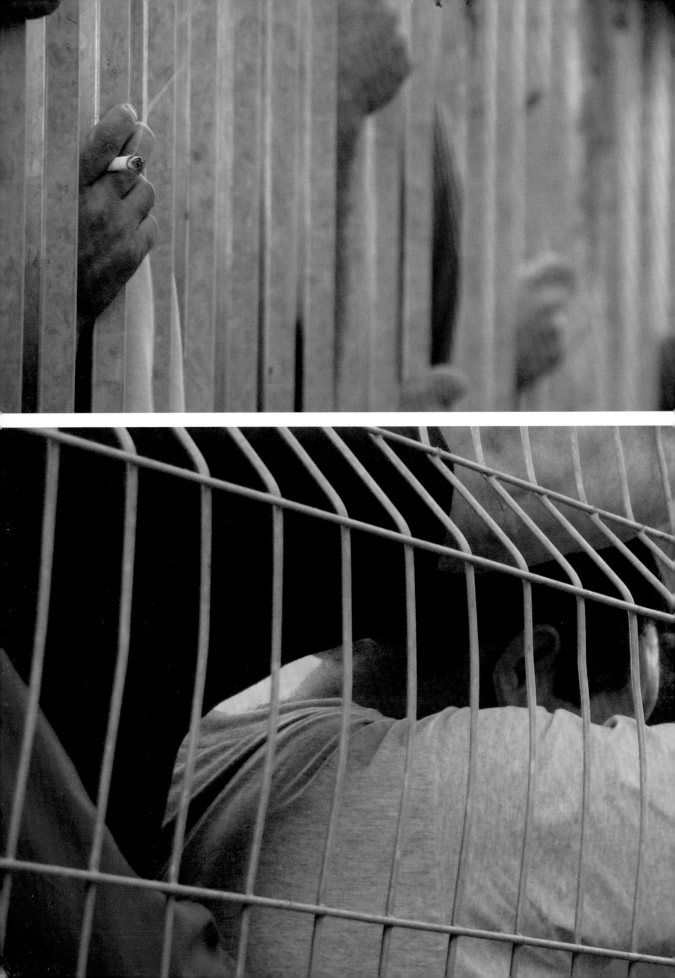

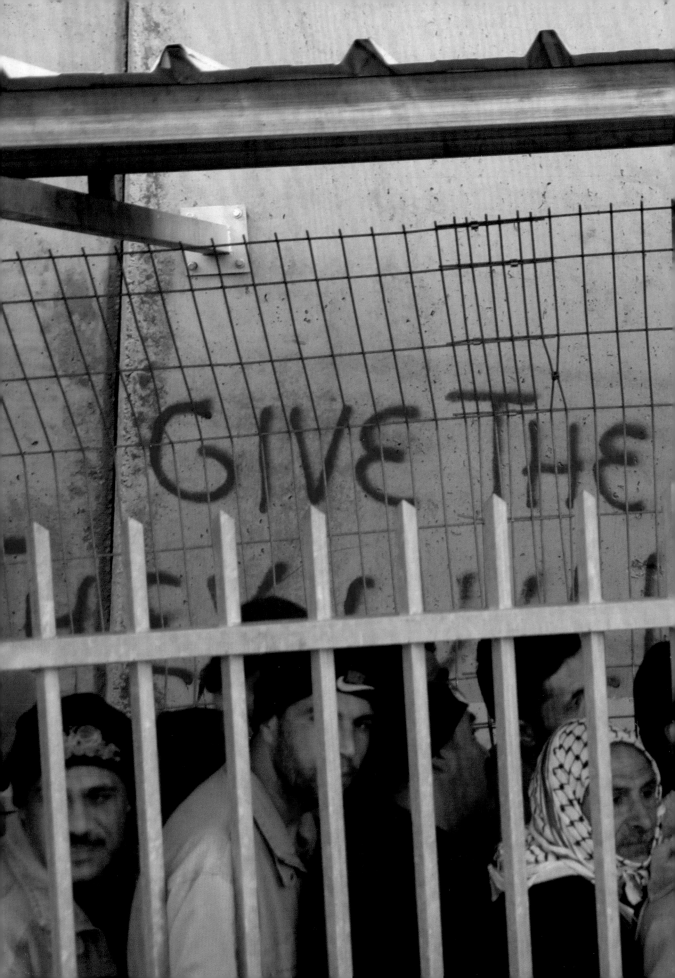

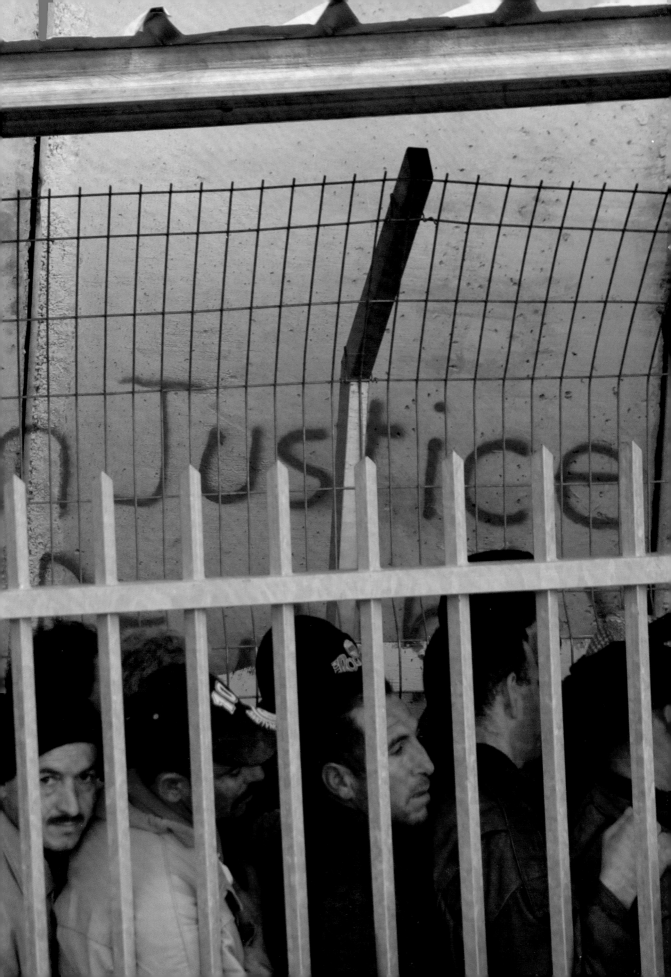

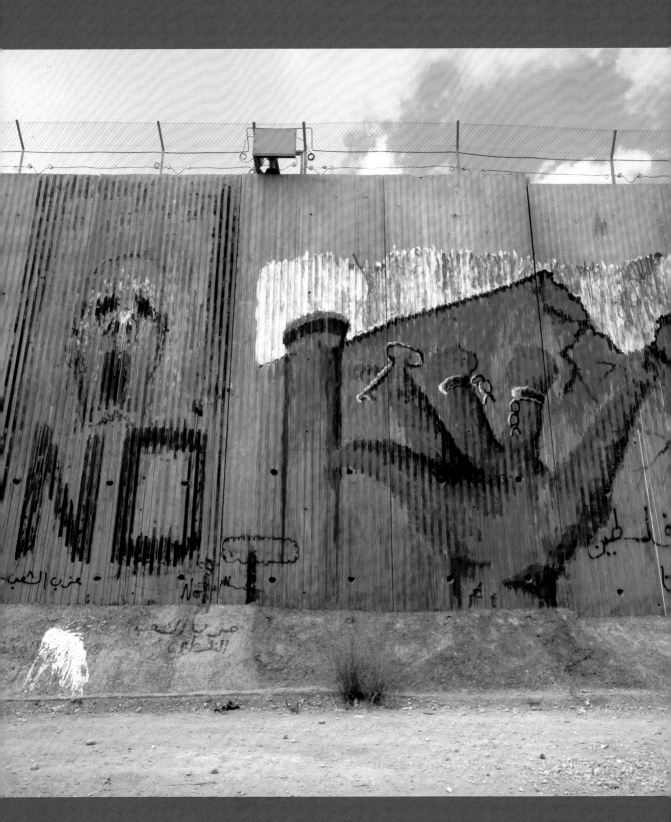

NORTHERN WEST BANK

‘ The impact of the [Wall] has been particularly severe on Palestinian rural communities. The impact is due, in part, to the destruction caused to trees, crops and irrigation systems by the [Wall's] system of electronic fence, patrol roads, ditches and buffer zones ploughing through Palestinian farmland. More significantly, the route of the [Wall] through eight of the West Bank's eleven governorates isolates the farms, greenhouses, grazing lands and water resources of tens of thousands of Palestinians. An OCHA/ UNRWA survey in 2007 identified 67 communities with an estimated population of 220,000 in the northern West Bank alone, which had land isolated in the closed area between the [Wall] and the Green Line. ’
Five Years After the International Court of Justice Advisory Opinion: a Summary of the Humanitarian Impact of the Barrier, UN OCHA, 2009

The Wall's impact throughout the northern West Bank is clear: by annexing and controlling access to land and water resources, Israel has turned this area, the former bread basket of the West Bank, into a basket case. Villages that once supplied large parts of the West Bank with fruit and vegetables are now largely dependent on food aid – and as farming becomes increasingly difficult, there is a forced migration of residents to other towns and cities in the West Bank or even abroad. Idle land is usurped by the Israeli state. 'This Wall has nothing to do with security,' says Abu Omar, a prominent Palestinian farmer from Jayyous, struggling to maintain his livelihood – 'Israel simply wants our land without us.'

The land the Wall expropriates throughout the northern West Bank is prime agricultural land and covers vital underground aquifers. Is this route necessary for 'security' or is it a land grab? If for 'security', why in a village like Jayyous, for example, is there a 6 km 'security' zone, with building plans for the existing colony of Zufin, illegally built on Jayyous land, that will paradoxically consume most of that buffer zone?

The Wall cuts 22 km deep into the northern West Bank. It carves out two huge gashes, known as the Ariel and Qedumim 'fingers', deep into the Salfit governorate, to incorporate these and several other Israeli colonies, built on Palestinian land in breach of international law, onto the west side of the Wall. The northern West Bank has lost vast amounts of land because of the Wall: as of June 2008, 22,141 dunams of the northern West Bank had been 'confiscated' out of a total of 49,291 dunams; another 89,498 dunams here have been 'isolated' by the Wall.

Israel exercises virtual control over West Bank water supplies. Three main underground aquifers comprise the major sources of water for Israel and the West Bank – and these are largely under West Bank land. A 2009 World Bank report states that Israel and its colonies receive four times as much water as the Palestinian communities that are situated atop much of this water. The World Health Organization recommends 100 litres of water per person, per day, as a minimum

quantity for basic consumption. In Israel and its colonies, the mean per capita water consumption for domestic and municipal usage is 235 litres a day; for West Bankers that figure is just 66 litres a day. The evidence is starkly visible travelling throughout this area. The colonies, with their lush vegetation and swimming pools, must look like mirages to neighbouring Palestinian villages that have to ration existing water and pay for extra water for agricultural and domestic use. Periodic cuts are common during summer months – among Palestinian communities only.

Farming isn't the only livelihood being devastated by the Wall in this area. The town of Qalqilia, once a thriving commercial centre with 85,000 shoppers passing through it weekly, now has an unemployment rate of 67 per cent and rows of abandoned shops. The Wall has cut the town off from Palestinian Israeli citizens – mainly shoppers – and dozens of villages and towns to its north and south.

There's the northern village of Nazlit Issa, a relatively uncommon instance of where the Wall runs along the Green Line rather than deep into West Bank territory. Nazlit Issa was formerly a bustling community that allegedly saw 30,000 people cross the Green Line every day. Today, the main street, which once connected the West Bank and Israel, is desolate, abandoned, with the number of permanently shuttered shop fronts a testament to the once good times.

Graffiti and artwork on the Wall throughout the northern West Bank are concentrated in just a few locations. Graffiti on the Wall in Qalqilia sums up the feelings of most Palestinians I spoke to here: 'The only peace Israel wants is a piece of my land.'

RIGHT
Two elderly women wait to cross a checkpoint – along with several dozen workers – to reach their fields in the humid morning sun in Qalqilia.

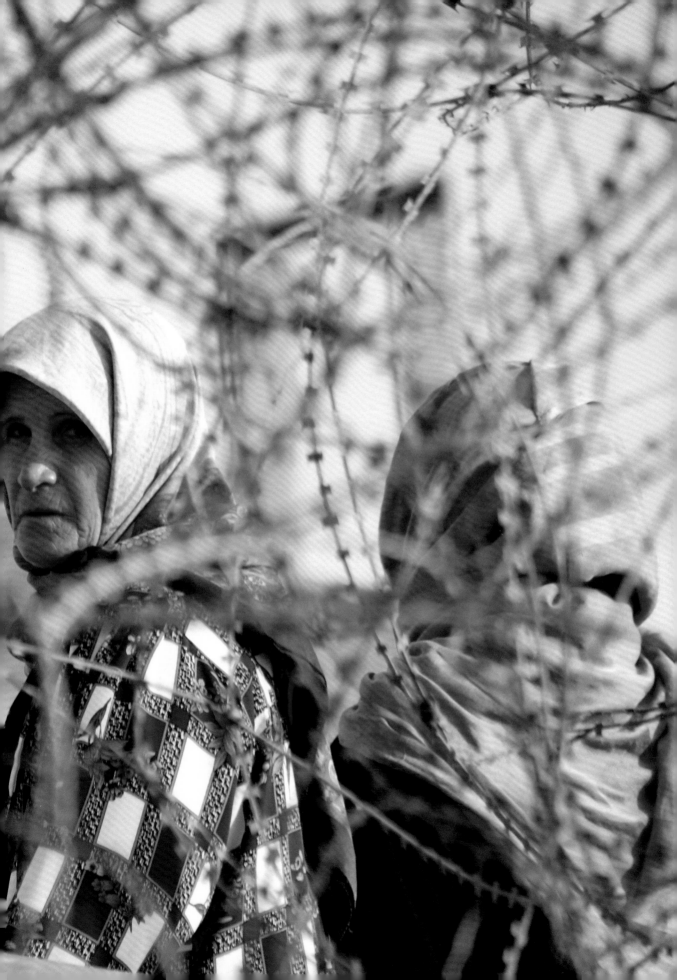

Muneera Amr arrives at her home in Mas'ha, about an hour's drive north of Jerusalem. This is the absurd procedure her family of six have to go through every time they return home – ever since the Wall was erected several years ago. This is an improvement, however: at first, Israeli soldiers kept the key to this lock, and the family's movements in or out relied on the army turning up to open the 'security' gate. The army regularly threatens to resort to this to punish the family for speaking about their plight.

Muneera, her husband, Hani, and their four children have lived in their modest home since 1973. The attractive homes visible beyond belong to Israeli settlers, living illegally on West Bank land. Settlers started building here in 1983, says Hani. The Amr family are regularly harassed and threatened by the settlers, who shoot into the air, throw stones at them and, occasionally, break into the property. When the Amr family last complained to the Israeli army about trouble from the settlers, they were told they could be offered no protection, Muneera says.

Not only is the Amr family trapped between a Wall and electric fence on three sides and hostile settlers on the other, but an army patrol road runs through their property too. Gates at either end warn of mortal danger to anyone who tampers with them. Army patrol vehicles rumble through, day and night, disturbing the family.

They always knew that by staying, by fighting for their rights, they would face retaliation from the Israelis – they were warned that their lives would be made miserable if they refused to move. Hani said that the army has searched the house in the middle of the night many times, forcing every one out into the cold night air. Heavily armed soldiers pointing guns at the family traumatised the children. On the last occasion, says Hani, the commander asked him: 'Why do you do this to your family? Why make us come and search your home?' Hani replied: 'You do it – stop coming. It doesn't matter how much you terrorise our family, we're not leaving this house.'

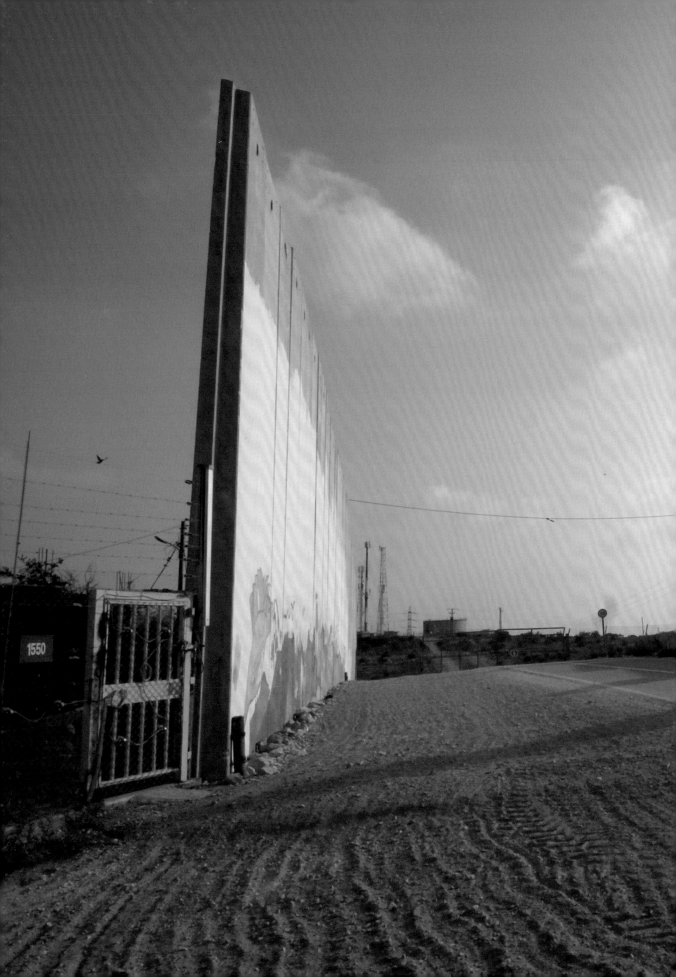

Jayyous, a village in the agricultural heartland of Palestine. Here, productivity has declined from approximately 9 million kg of fruit and vegetables in 2002 to some 4 million kg in 2008 because of the Wall. Four thousand olive trees were uprooted to make way – this sort of 'collateral damage' is common throughout the West Bank.

Abu Azzam is one of the most charismatic activists in Jayyous. However, given his outspokenness, his permit to access his own land was not being renewed for 'security' reasons when these photos were taken. None of his sons has been given a permit to work the family land – though one has a permit that allows him to conduct business in Israel.

Role reversal: Abu Azzam cannot farm his land, so Seham (above), who has a bad back, goes instead with their grandson and son-in-law; Abu Azzam stays and makes me breakfast and tea. 'Each day that I can't go to my land, I feel very angry,' he says.

Jayyous is traditionally dependent on agriculture. In September 2008, only 216 of its 700 farmers had permits and of those with permits, many were awaiting renewals, like Abu Azzam. Crops perish quickly if not regularly maintained and harvested, and Israel knows this. Much of a year's income will literally rot in the face of such specious, bureaucratic obstacles. Two-thirds of Jayyous is now dependent on food aid, says Abu Azzam, a preposterous and inexcusable situation given the town's agricultural potential. Unemployment

stands at 70 per cent. The Wall and the system of checkpoints have also virtually destroyed the main regional market for their produce by making access near impossible, which has significantly reduced demand and revenue for the crops produced – Abu Azzam has managed to maintain production output, but his income has fallen by 50 per cent since the Wall was erected.

It's not just about land and agricultural markets: the Wall currently cuts 6 km deep into the West Bank from the Green Line here, swallowing six water wells as well. Meanwhile, the illegal Israeli settlement of Zufin, built on Jayyous's land, is doing well, with additional homes and an industrial zone currently under construction.

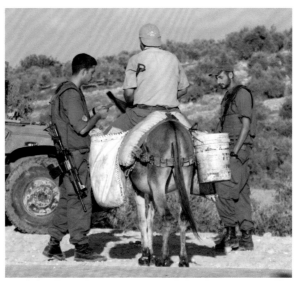

ABOVE
Abu Azzam points to his farm land from his rooftop.

LEFT
A farmer arrives with his donkey. It has been reported that Israeli soldiers have not allowed donkeys through agricultural gates without security permits...

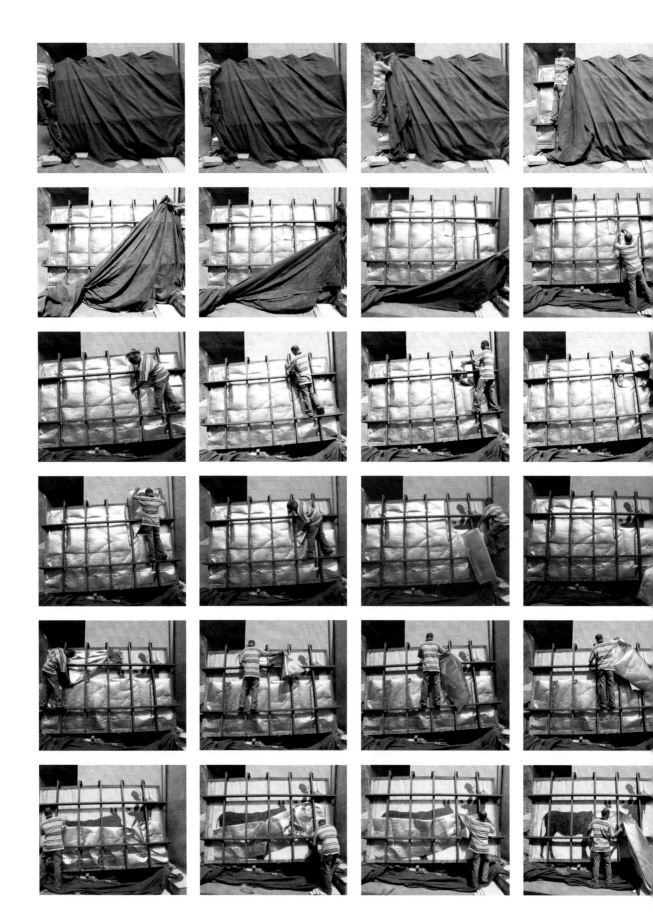

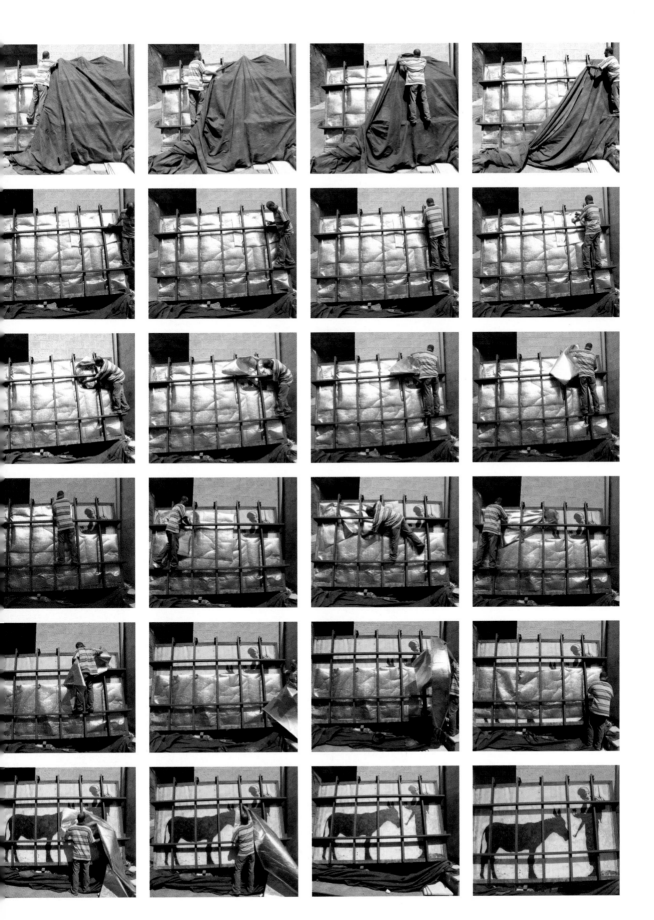

This is the other Banksy piece from the Santa's Ghetto project by Banksy that upset locals. In this region, to call someone a donkey is an insult. Banksy, however, seemed to be making a point about the absurdity of Israel's 'security' checks – and donkeys have faced security checks at Israeli checkpoints, as it happens. Suleiman Mansour, a prominent Palestinian artist who participated in Santa's Ghetto, sees the reaction as a cultural misunderstanding, exacerbated by Banksy's elusive nature: 'He wasn't there to explain his work, so it was misinterpreted!' Mansour told me.

Contrary to some reports, this Banksy piece wasn't defaced or destroyed. Rather, the owners of the building where it was painted, a canny family with a prominent local business selling a range of items to tourists, realised that they had landed a valuable and original art work. They removed the section of the Wall, replaced the missing bit, and have put the carefully preserved original up for auction to the highest bidder. In December 2009, that was $200,000 to someone from the West.

Going, going…

MAIN PHOTO
© Pictures on Walls

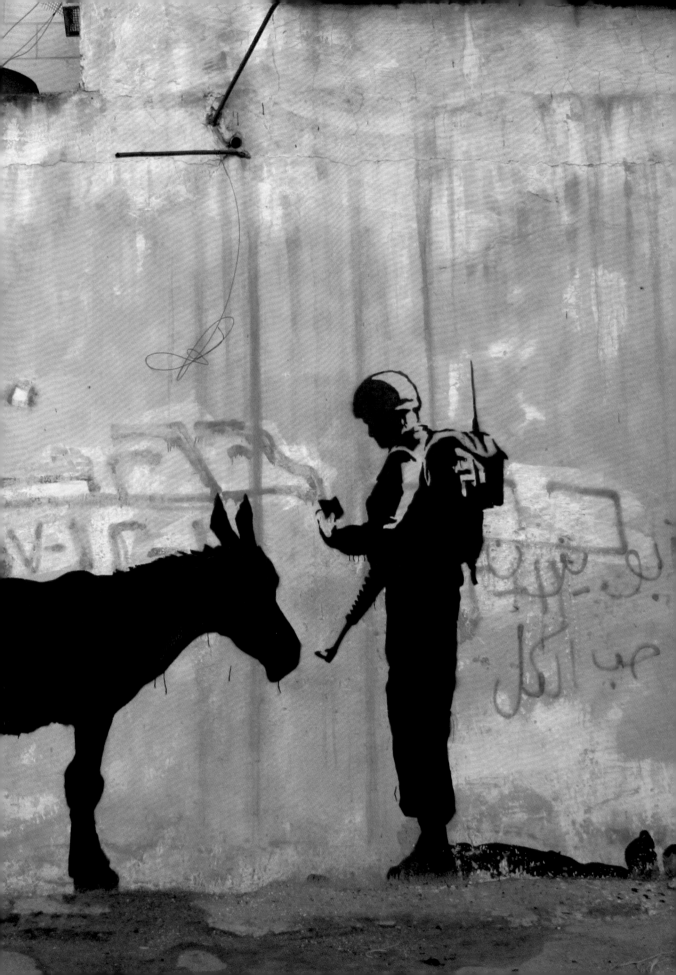

Although short on graffiti, the village of Azun Atme is typical of a Palestinian village that, like many, has inadvertently found itself 'seamed in' on the west side of the Wall – in other words, it is neither in the West Bank nor in Israel, but in a Kafkaesque bubble between the two. The reason? The proximity of illegal Jewish colonies. The Wall needs to go around these to keep them on the so-called 'Israeli' side of the Wall, but given their physical proximity, the two can't be easily separated. Thus, residents of Azun Atme need permits to go in and out of their town. (Although it is the Jewish colonies that are relatively new, and illegal under international law, it is the indigenous Palestinian population that is punished twice over – first by having their land illegally confiscated for colony development, and then by having their rights and their freedom of movement curtailed to protect the Jews colonizing Palestinian land.) The gate access to the town has restricted hours, so if you are late returning, too bad, you don't get home.

And if you have a stroke or a heart attack, or are pregnant and go into labour, or suffer any other medical emergency, your access to medical facilities is dependent on liaising with the local Israeli coordinating office, which will then order an ambulance and arrange to have the gate opened – i.e., to go from one West Bank location to another West Bank location. Ask the relatives of the many people who have died waiting at the gate how efficient or just that system is.

It's 2.00 p.m., a taxi driver is first in a queue of cars entering Azun Atme. He has a passenger. The Israeli soldiers, aware of the vehicular traffic on one side and pedestrian traffic on the other, make each side wait – and wait. Ten minutes go by. It's fiercely hot. It's Ramadan. The soldiers, sheltered from the sun, joke among themselves. The taxi driver taps his horn once. With his back to the car, a soldier gestures for the car to come forward. The soldier tells the passenger to get out and walk the rest of her way uphill.

The driver is then hassled for 10 minutes to punish him for having the impudence to honk. He argues. The soldier takes his ID. Another soldier joins. A third closes the gates. All of the Palestinians waiting to cross the checkpoint will suffer consequently. It's collective punishment. They make the driver remove every item from his car, they shout at him. The exercise in humiliation over, they open the gates and order him to drive back out: he's not getting through.

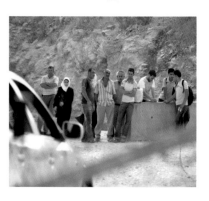

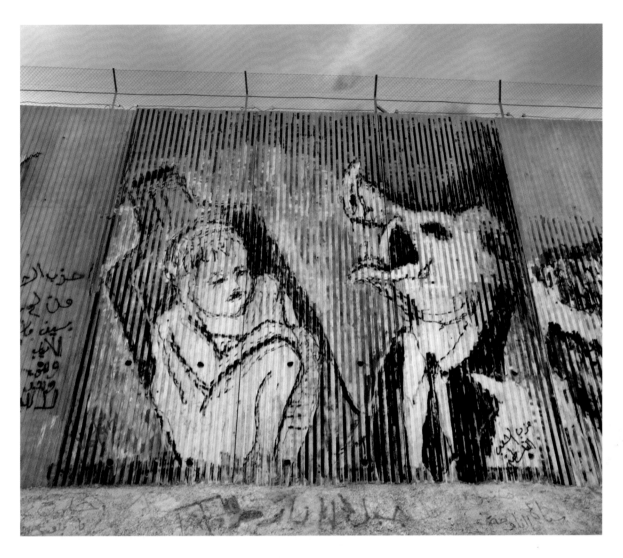

It's the holy month of Ramadan for Muslims, when most of them will be fasting during daylight hours. The Israeli Civil Administration proudly issues a press release, which is carried in the Israeli national press, declaring that Israel's 'security' operations in the Occupied Palestinian Territory will be conducted in a sensitive manner by the Israeli military and border police during this Muslim feast: 'The soldiers have been instructed to show extreme sensitivity with regards to the operating times and procedures at checkpoints,' the official press release reads. 'In addition, they have been instructed to refrain from openly eating, drinking and smoking in front of the Palestinian public.'

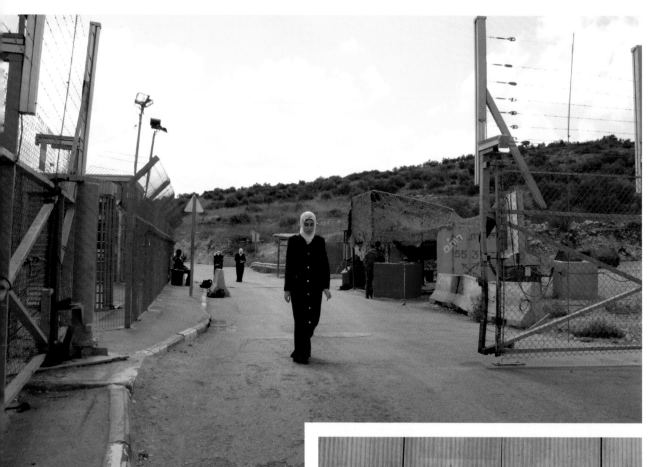

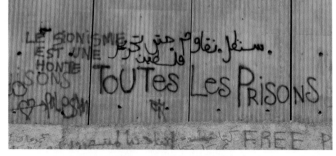

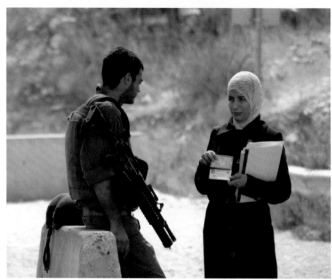

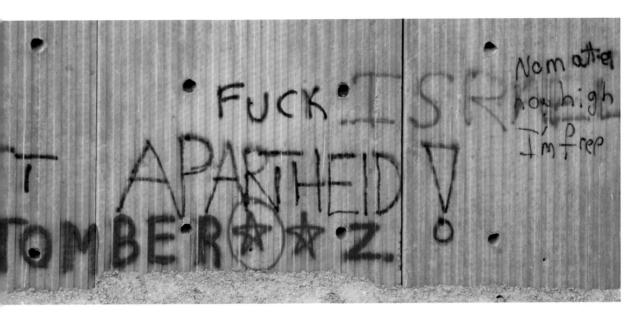

Students of all ages, labourers and locals coming and going must all enter and exit Azun Atme through this checkpoint, and each must present ID or a permit. These soldiers proudly showed me a Palestinian thief who had been caught trying to steal a car's cd-player. He was forced to squat for several hours, with his wrists bound behind his back, and was verbally abused by the soldiers. Makes you wonder how they would treat someone caught stealing large amounts of land.

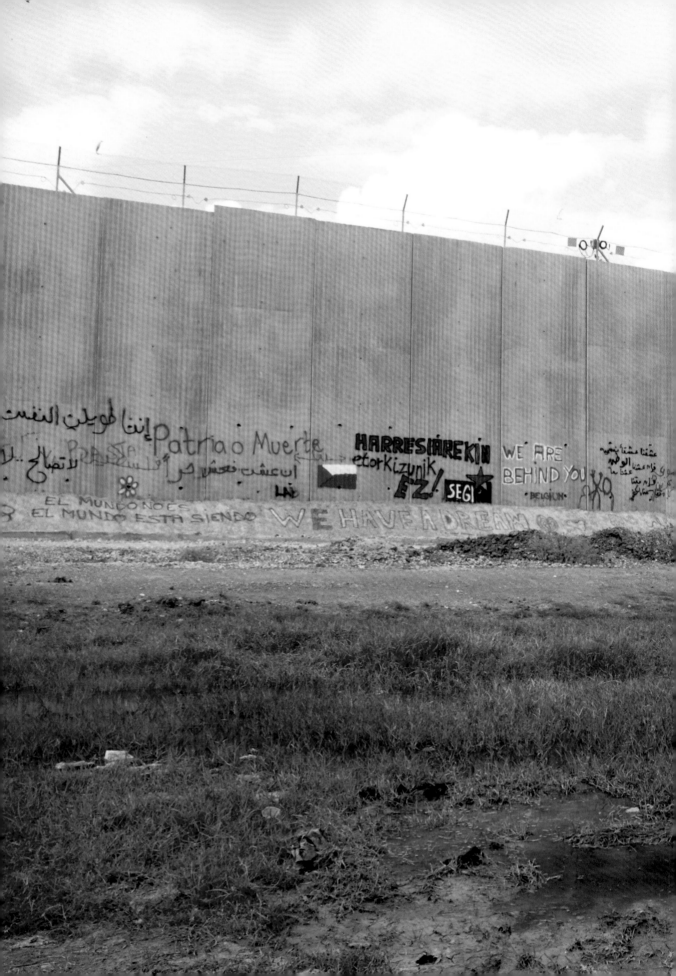

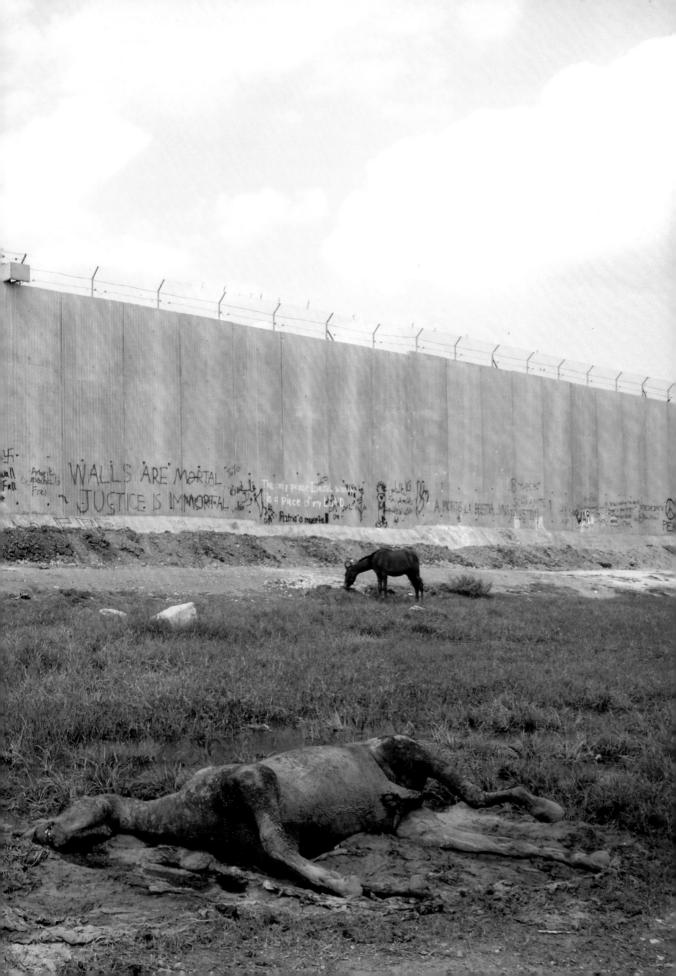

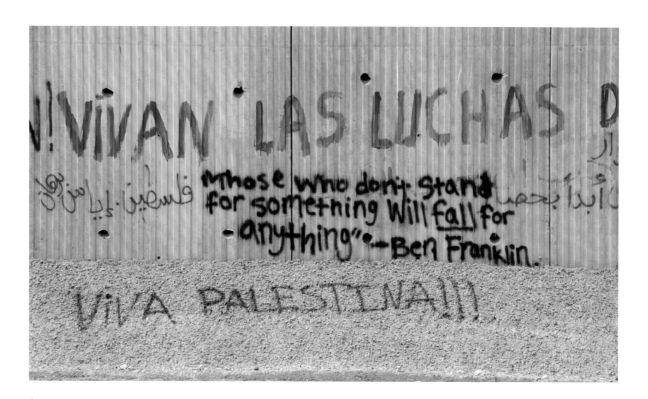

¡!¡VIVAN LAS LUCHAS D
"Those who don't stand for something will fall for anything" —Ben Franklin.
¡VIVA PALESTINA!!!

This is Abdullah Mahmoud, from the village of Jubarah, which is also isolated on the west side of the Wall – one of 35 Palestinian towns that will be isolated on all four sides by the so-called 'seam zone'. Abdullah is completing his degree in international law, which he plans to use to defend his people's rights.

On the page opposite is the Wall cutting through the West Bank – nearly 5 km in from the Green Line – and isolating Jubarah from the neighbouring towns and villages. (Note one of two homes completely isolated on the 'wrong' side of the barrier – access to and from it is via the military patrol road seen here, and only the family and military can use this stretch of road.) The Wall swallowed 300 dunams from Jubarah, and has made 9,000 dunams inaccessible to residents from neighbouring villages, Abdullah says, pointing out the villages.

Israeli measures and restrictions – all in the name of 'security' – will ensure that this village dies, freeing the land for Israel. It is already dying. Names and details of the villagers were taken by the Israelis in 2003. Those from Jubarah who have married and moved to neighbouring locations are unable to move back. Homes cannot be extended to make room for the younger generation as they

marry and start new families, as is the local custom – those who build additions risk their homes being demolished. Abdullah and his siblings, for example, will have to move out of Jubarah when they marry if they want a home. Their children will not be entitled to stay in their ancestral village. If Abdullah married a woman from a neighbouring village, his wife would not be allowed to move to Jubarah with him, so he would have

to move out to her village. If he moves away, he'll have to perform bureaucratic somersaults to obtain the necessary permits should he ever wish to visit his family

Agricultural businesses and chicken farms are closing as access to markets diminishes. Access to land, as is the case elsewhere in this region, is also severely restricted by the Israelis. The construction of a new school, which

began in 2005, was halted and it remains an unfinished cement shell (opposite) – the 100 school children of Jubarah have to travel to a neighbouring school 7 km away via the checkpoint, and are often harassed by soldiers as they leave and enter the village, Abdullah says.

As there is no shop in Jubarah, residents travel to larger neighbouring towns such as Kafr Sur and Kafr Zibad to get food and supplies. In Abdullah's house there are three generations of one family – 20 people – living in the home. They say that what they are able to bring through the checkpoint is monitored and strictly limited by the Israeli soldiers – a claim I have heard from people in other 'seamed in' communities in the West Bank: quantities of tomatoes, chickens, eggs and bottles of cola were among items confiscated because the soldiers deemed the quantities to be beyond the immediate needs of the family, or because the family hadn't had the list approved by the soldiers.

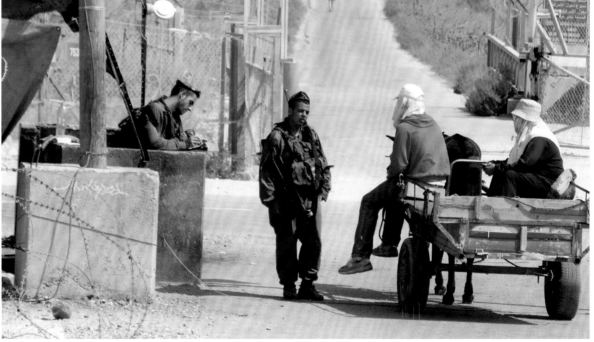

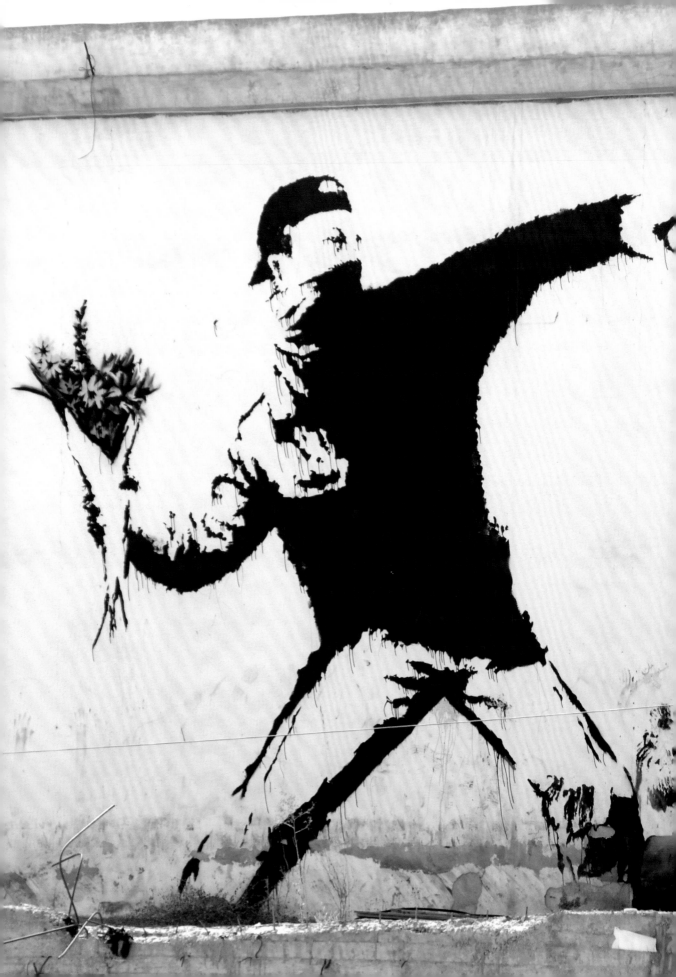

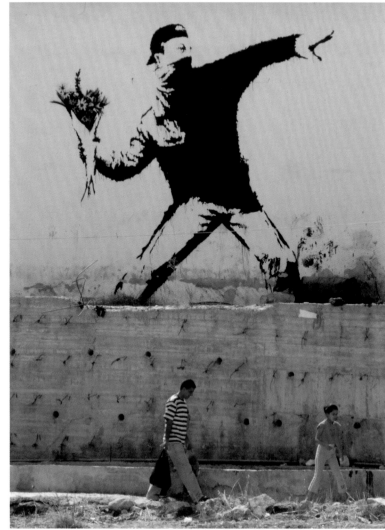

Qalqilia is one of the West Bank's main commercial centres – or at least it was. The Wall encircles the city, cutting in several kilometres from the Green Line; to the east, it narrows to create a bottleneck that is choking Qalqilia, as business after business closes down. Local towns and villages have been cut off from it to the south, and travel restrictions to the east and north severely limit access. All around it, some of Israel's larger settlements flourish, with an infrastructure that ensures the free flow of people and goods.

Hassan Shqairo (pictured on p.126) didn't envisage himself continuing his father's and grandfather's line of work – farming – until he saw Israeli soldiers on the farm land that his father used to work. 'None of my brothers wanted to continue it after our father died. But seeing those soldiers on our land – rather than let the Israelis take and misuse our land, I decided then to become a farmer, to keep the land and heritage in our family.'

With entrepreneurial flair, Hassan established a flourishing nursery business in the 1990s. At its peak he employed between 50 to 60 staff. The business included nurseries and a market where they sold trees and flowers to Palestinian and Israeli customers. Just as the business began to earn a profit, the Wall's path through Qalqilia cut right through the centre of his nurseries and market, crippling his business. He still has a nursery business but it is a tenth of its former size. His market was levelled to make way for the Wall: the area was blocked off by the military and days later it was concreted over.

Hassan is understandably nervous about Israel's intentions. His work supports his wife and their seven children. He received no compensation for the damage to his property or business, he says. 'I'm always afraid they'll do it again,' he says. 'Just give me one year – just one year – of profit!' he says, part joking. As a precaution, he started an English language school in Qalqilia, which employs a dozen teachers. 'It's an insurance measure in case the Israelis decide to close my nursery business,' he says.

To access his nursery, which is on occupied Palestinian land, he requires a permit from the Israelis and has to pass through a checkpoint several times a day – as do his staff. 'Some mornings

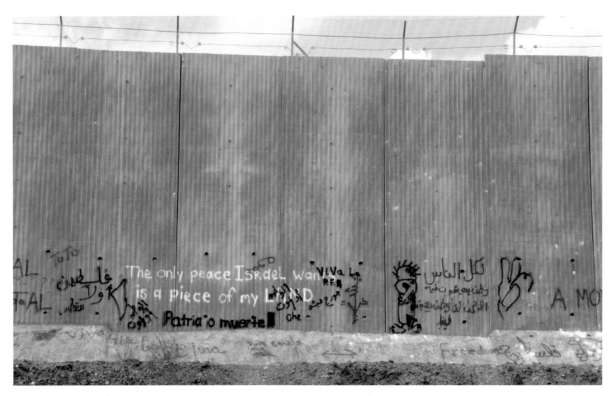

we can be delayed hours,' Hassan (pictured, left) says. 'You never know, you can never predict what their mood will be. They may not like the colour of your shirt.' It sounds like a joke but it can be as absurd and as random as that.

The nursery is now on the 'Israeli' side of the Wall and his customers are virtually all Israelis, who are free to travel without permits, and who are oblivious to what their government's policies have personally cost Hassan. Given the damage inflicted by the Wall, and the constant potential threat he senses, I ask how he feels about the Israelis. 'I don't want revenge. Whatever they do, I'll start my business again. What am I going to do – blow myself up? No, I have my family to look after.'

ABOVE

This was a bustling road before the Wall destroyed it. To the right was Hassan's market – now levelled and covered with cement. (Further down is the spot where most of the graffiti in this chapter is located.) To the left are abandoned nurseries.

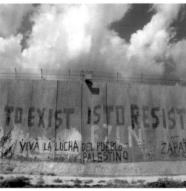

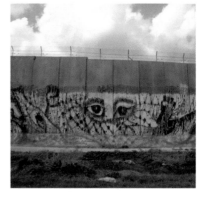

I sat with some 40 workers who were waiting for the agricultural gate to be opened. It was 6.30 a.m. when I arrived, humid and uncomfortable even though the sun was scarcely up. They had been waiting since 6.00 a.m. In winter they huddle around fires to keep warm. One worker collects the others' permits as they arrive so that there is a queue.

Given the whims of the soldiers, the workers queue early to increase their chances of getting to work on time, in case there are hold ups. The queue of 40 workers took 90 minutes to clear. The gate only remains open for two hours in the morning – if there are delays and not everyone is processed, the gates close anyway.

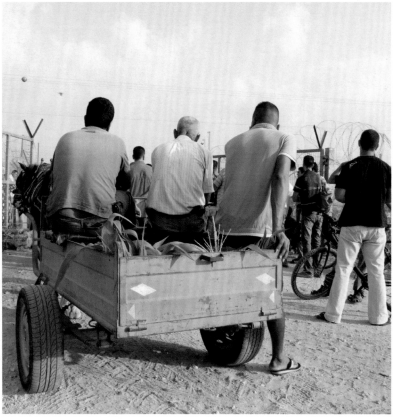

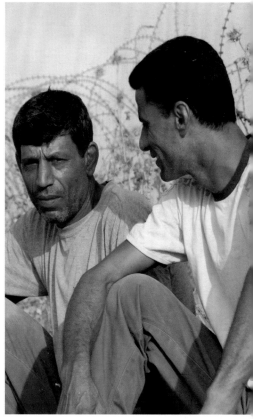

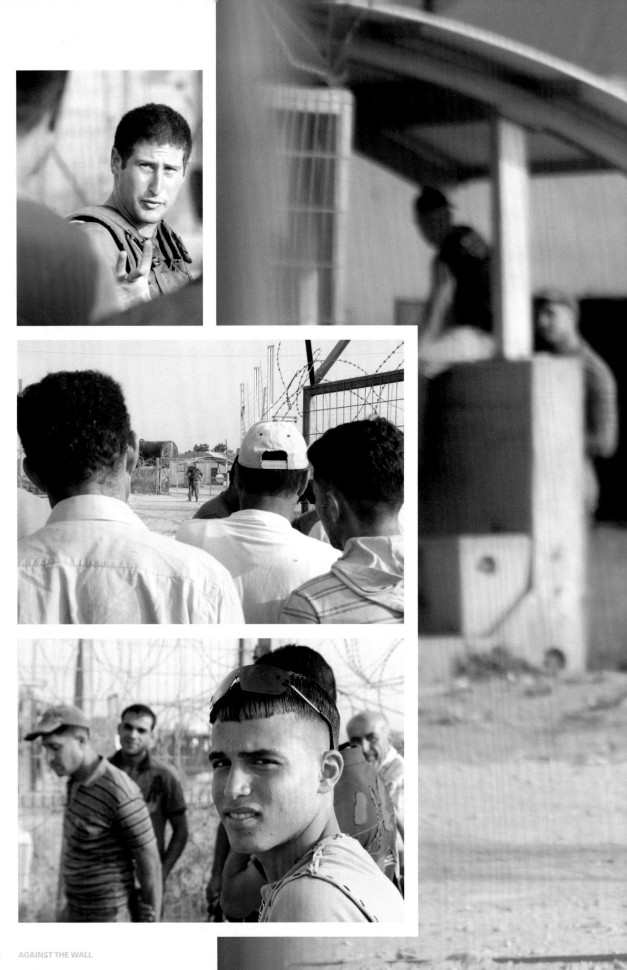

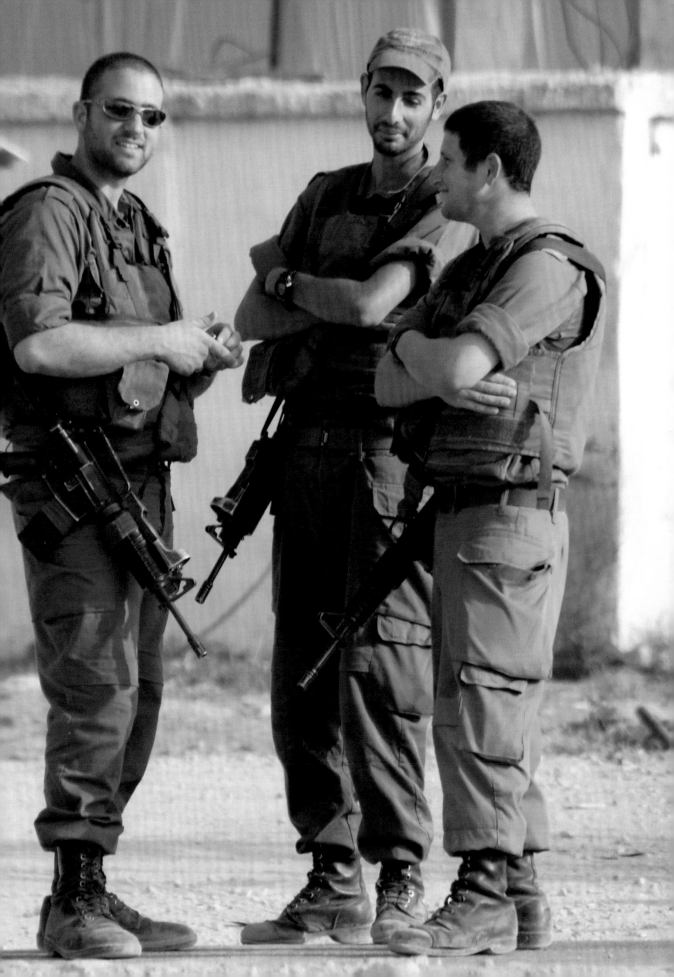

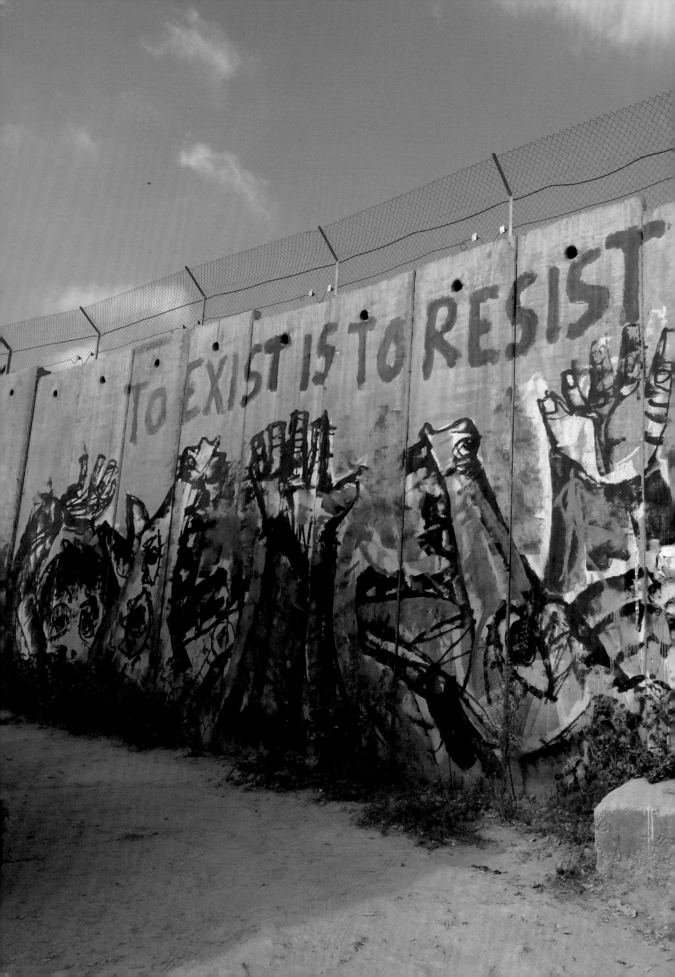

Nazlit Issa, north-western West Bank

If you were Abdul Halim, with a wife and children dependent on you, what would you do? You're building a large, new home for the family – your sons are nearing that age when they will marry and they will share the house and start their own families. As the house nears completion, Israeli soldiers recognise its strategic position and decide they'll position themselves on the rooftop – and there they set up base. The commander, his soldiers and their guns say: 'We're going to use your rooftop whether you like it or not.' They station themselves there for 18 months and completion of the house is postponed as it's now effectively a military structure, replete with bullet-proof glass. Things then get even worse: the house abuts the Green Line and you receive notice that the building you have nearly completed is going to be demolished to make way for the Wall. However, the Israeli military intervenes, telling the Israeli Civil Administration folk: 'Don't demolish it, we're using it.' Civil Administration agrees to freeze the demolition order – and it remains frozen to this day.

Visiting Adbul Halim and witnessing the nightmare that he and his family are subjected to is truly Kafkaesque. How can this happen? As your eyes move up along the outside of the building, they pass an ornate plaque on the wall asking God to bless the home. Camouflage hangs over the rooftop. Surveillance cameras observe everything in the vicinity. The family can hear the soldiers laughing, talking, changing shifts, coming and going down a stairwell that the military has built at the back of his house. In the main stairwell, Abdul Halim poses next to barbed wire that blocks him from the rest of his home. The Wall, meanwhile, ploughs through his front yard and literally becomes part of the side of his house – the house and Wall are one before the Wall continues down through the village. 'I'm happy as long as they don't destroy the house – they can stay on the roof,' says Adbul Halim with as much composure and sincerity as one can expect.

The Wall blocked a small but important and bustling artery between the West Bank and Israel here. Five shops that Abdul Halim owned along the Green Line were closed, and the Wall

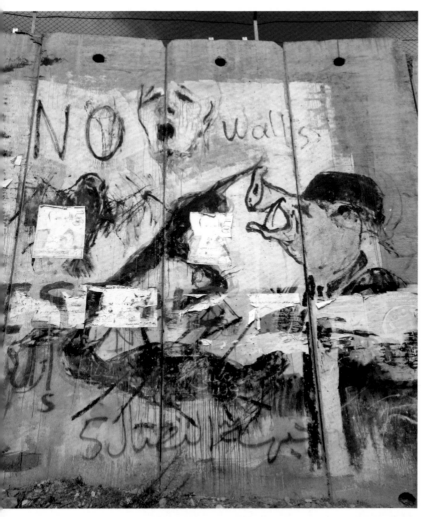

stole 42 of his 84 dunams of land, and the olive trees on them that he cultivated. Denied a permit for the first two years, he now has to produce, and regularly renew, his permit from the Israelis to tend to his olive trees on his land. When he does, he is harassed by the army and by Jewish settlers. The Wall also puts 80 km between him and his sister and daughter, who live on the Israeli side. Previously they were a 15 minute walk away.

Nazlit Issa is now a ghost town. The town's busy past is evident by the number of shop fronts that line the main thoroughfare – all boarded up except for a shop here, a mechanic's shop there. It's eerily quiet and deserted. Another strangled village.

Abdul Halim has a small but colourful garden between his home and the Wall – natural camouflage. 'It is a small way of beautifying the space,' he says. Looking at the military camp on his roof, then to the Wall, he turns and says: 'I don't have any other option. I have to cope and deal with it. I put all of my effort into this. I wouldn't replace it for a castle. I want to keep my family around me.'

'When it comes to Israelis' security, they're deadly serious,' Abdul Halim says. 'But for us, look at how they treat us. If we go to our land, they harass us. The people here are defeated, there's no resistance. They just want permits to get to work to live. That's their priority.'

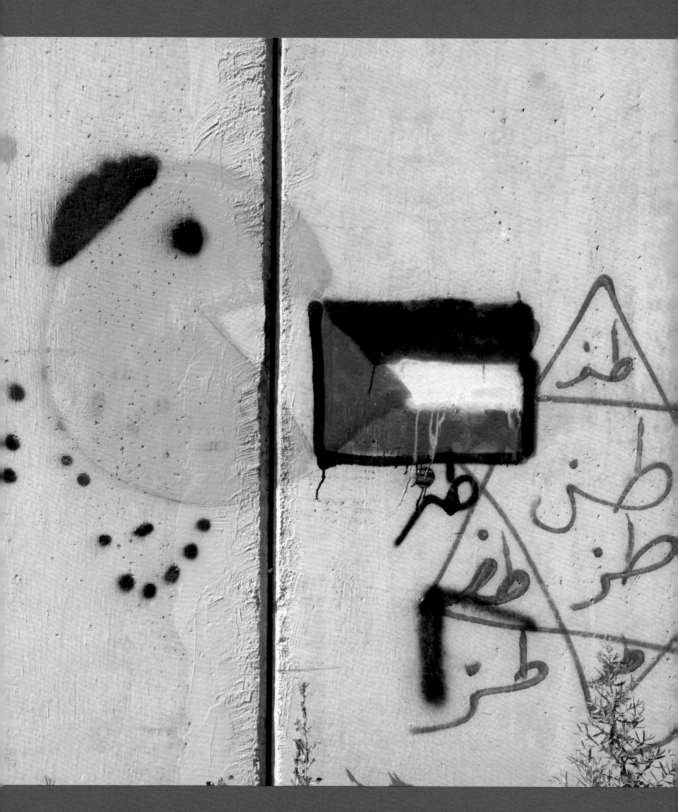

JERUSALEM AND ITS ENVIRONS

6 The 75 km Wall being built in East Jerusalem is an instrument of social engineering designed to achieve the Judaization of Jerusalem by reducing the number of Palestinians in the city. The Wall is being built through Palestinian neighbourhoods, separating Palestinians from Palestinians, in a manner that cannot conceivably be justified on security grounds. 7

Professor John Dugard, former UN Special Rapporteur for
Human Rights in the Occupied Palestine Territory

For more than four decades, Israel has been building a 'New Jerusalem' at the expense of the city's Palestinian residents. Israel's publicly stated policies of social engineering are intended to manipulate the demographic balance in order to consolidate the claim that Jerusalem is the 'eternal and undivided capital of the Jewish people'.

In 1967, Israel illegally annexed 70 square kilometres of Palestinian land and incorporated the expropriated land, now commonly called East Jerusalem, into the newly enlarged boundaries of the Municipality of Jerusalem. Ever since, Israel has used an arsenal of discriminatory policies to maintain a 72/28 per cent ethnic balance in Jerusalem between Jews and Palestinians. The Wall is the latest addition to this on-going policy.

Jerusalem's social engineering practices involve severely restricting the space in which Palestinians can construct residential buildings (just 7 per cent of the confiscated Palestinian land) and then making it virtually impossible to obtain a permit, resulting in a massive housing shortage, estimated to be a shortfall of some 125,000 homes in 2009. While the Palestinian population has had little choice but to build illegally, the Municipality has enforced a rigorous and punitive campaign of fines and house demolitions, and has recently started confiscating construction equipment used to build homes that lack a permit. Over 42 years, the Municipality has built 55,000 Jewish-only homes on the expropriated Palestinian land and none for the Palestinian population that comprises a third of the city's population. It has offered tax breaks and low interest mortgages to encourage Jews to populate Palestinian land. East Jerusalem is now home to 200,000 Jewish Israelis. This violates Article 49 of the Fourth Geneva Convention – 'The occupying power [Israel] shall not deport or transfer parts of its own population into the territories it occupies' – and the international community continues to regard East Jerusalem as illegally occupied West Bank land.

Jews from anywhere in the world can move to Jerusalem. They can come and go as they please without jeopardising their right to live in the city. Not so for the 268,400 Palestinian Jerusalem ID holders, however, who have to prove annually that Jerusalem is their 'centre of life' or risk losing their ID and their right to live there, despite having been born in East Jerusalem. Working abroad or living just outside the Municipal boundaries, despite the housing shortage in East Jerusalem

– these are not options for the Palestinian population here. Israel also prevents family unification for East Jerusalemites who marry someone from the West Bank or Gaza. If a woman with Jerusalem ID marries another West Banker or a Gazan man, she cannot bring him to live in Jerusalem, and, in some cases, their children will not be allowed to hold Jerusalem IDs either – and if Jerusalem isn't her 'centre of life', she will have her ID and all of its rights revoked.

Additionally, although Palestinian Jerusalemites comprise a third of the population and contribute the same to municipal taxes, they receive a fraction back in services: in 2007 only 8.5 per cent of the Municipal budget was spent on Palestinian neighbourhoods and social services. Jewish neighbourhoods received 91.3 per cent of Municipal spending, according to Israeli Coalition Against House Demolitions (ICAHD). They also note that 70 per cent of fines collected by the Municipality between 2001-2006 were from Palestinians.

Like the graffiti in and around Jerusalem, the city's ethnic discrimination is hidden from the tourist's view – you've got to seek it out. It is by venturing into these neighbourhoods in search of some stunning artwork that exists on the Wall in and around Jerusalem that Israel's demographic control policies manifest themselves. Two distinct cities have evolved – one thriving and growing, one being stifled and in decay. Jewish neighbourhoods are tidy, have plenty of green spaces and children play in parks and playgrounds. Roads, sidewalks, sanitation, street lights – all are well maintained. In Palestinian neighbourhoods, children play in pot-holed streets or in rubbish-strewn patches of land. Rubbish tips overflow, streets are dilapidated, many are unpaved. There are few street lights.

In East Jerusalem, 74 per cent of Palestinian children live below the poverty line. Classrooms are seriously overcrowded and the school drop-out rate is 50 per cent. Children live in communities without sewage systems and more than half of their homes do not have adequate or even legal connections to the water supply. The innocence that we equate with childhood eludes Palestinian kids – the landscape and the daily routine have stolen that from them – yet they are charming, warm and sweet, and precociously politically astute.

At the start of this chapter they are juxtaposed with images of the Wall and artwork to put into perspective the Israeli government's policies on tomorrow's generation of Palestinian men and women living in and around Jerusalem – and to question the wisdom of blighting the futures of hundreds of thousands of innocent lives within and on the margins of Israel's unilaterally and illegally imposed border.

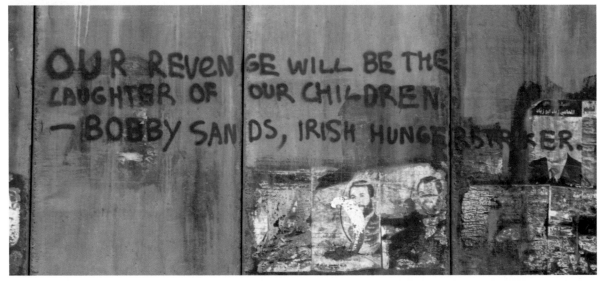

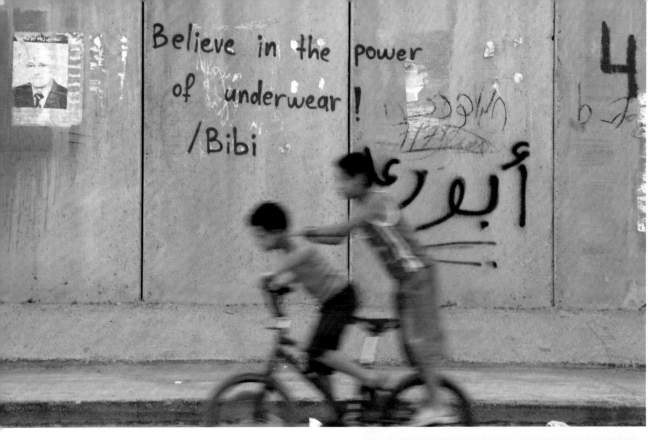

Believe in the power
of underwear!
/Bibi

Seif's family home is opposite the Wall on the Jerusalem side. His uncle's family live 20 metres away, directly on the other side of the Wall in this neighbourhood of Dahyet al-Bareed in East Jerusalem. The two families sometimes talk to each other over the Wall from their rooftops, but effectively they are a costly and hassle-ridden 14 km journey apart now.

Seif's father, Sameer, has six brothers who own property on the other side of the Wall, but five of them have Jerusalem IDs. To retain these, they have had to rent apartments on the Jerusalem side of the Wall – as have thousands of other Jerusalem ID holders – to prove Jerusalem is their 'centre of life'.

Consequently, Sameer's brothers cannot rent out their homes as the Wall has created a surge in demand for accommodation on the west side of the Wall and a surplus on the east side of the Wall:

rental costs have dived by more than 50 per cent in this area while rent costs on the other side have doubled.

A dozen metres from Seif's house a pipe spills sewage onto the street and flows downhill, passing the houses. The road is unfinished – and will probably remain so. Rubbish skips overflow. Everything about Seif's neighbourhood shows blatant municipal neglect, the most visible manifestation – apart from the rubble of demolished Palestinian homes – of the discrimination that East Jerusalemites face.

TOP

Shaima, above, is five years old. She reads a book and does some school work while waiting for her school bus at the Adu Dis junction in the Jerusalem suburb of Ras el-Amoud. This neighbourhood formerly connected Jerusalem with the suburbs of Al 'Ezariya (Bethany) and Abu Dis. As it is now a dead end, the neighbourhood has withered. Al 'Ezariya, on the other side of the Wall here, is where Christ is said to have raised Lazarus from the dead. 'The area needs a similar miracle,' comments a local who runs a once busy petrol station, which has been in the family for three generations.

BELOW

A girl with balloons, by Banksy, in Ar-Ram, another Palestinian suburb of East Jerusalem disconnected by the Wall.

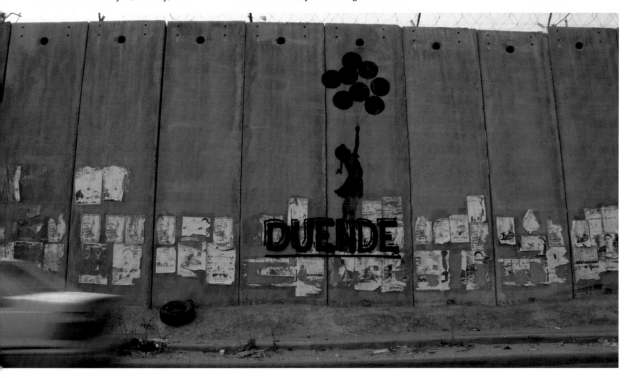

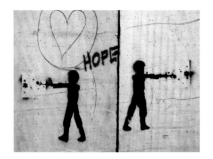

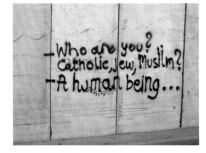

BELOW
Girls in Abu Dis up close and against
a backdrop of the Wall that cuts them
off from relatives in Jerusalem. The area
either side of the Wall seen here is
occupied Palestinian land.

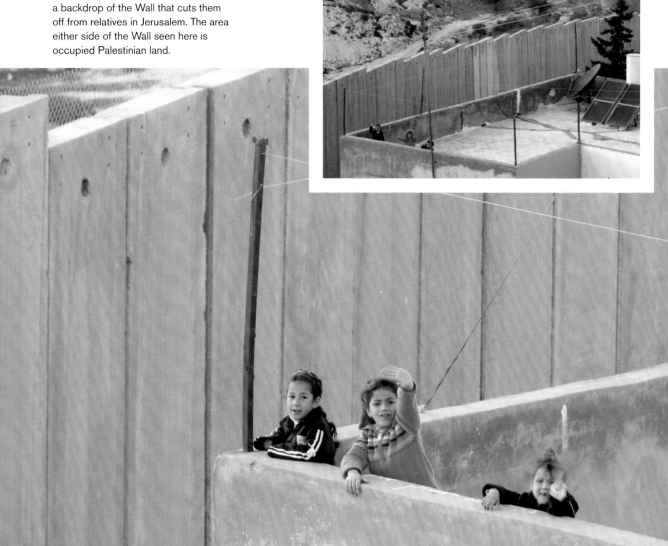

LEFT

This girl, whose family live on the edges of Abu Dis, poses against her living room wall as daylight fades. Her father and uncle both worked in construction and have been unemployed for four years. They are desperate for income. 'This fucking Wall is killing us,' her uncle, Ibraheem, says. His voice resonates with anger and desperation. 'There is no work now, no business. How do we feed our children? How do we explain to them? We can't even leave. The Israelis have made this into a prison and they leave us to starve in it.'

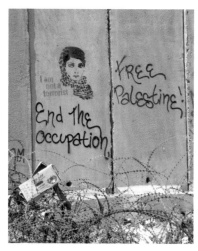

ABOVE

Graffiti from Qalandia. The image above is of Leila Khaled. She was made a refugee in 1948 as a young Palestinian girl and, in 1967, became the first female member of the Popular Front for the Liberation of Palestine (PFLP). Khaled made headlines for herself and Palestine by hijacking two passenger airplanes in 1969 and 1970, under the PFLP motto 'Going after the enemy everywhere.'

LEFT – MIDDLE AND BOTTOM

Children and their mothers wait for hours at noon in September at Qalandia checkpoint to enter Jerusalem to pray during Ramadan.

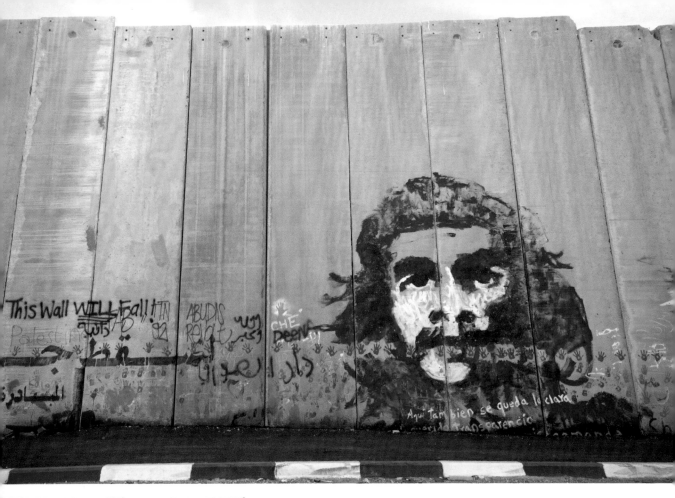

This Wall WILL Fall!!

Aqui también se queda la clara

Artwork of Che Guevera (**TOP**), friends (**LEFT**) and brothers (**RIGHT**) in Abu Dis.

OPPOSITE, TOP
Boys in Abu Dis, Hizmah and Qalandia.

OPPOSITE, BOTTOM
Artwork in Abu Dis. The graffiti reads: 'The right to return [of Palestinian refugees] is a right that doesn't die.'

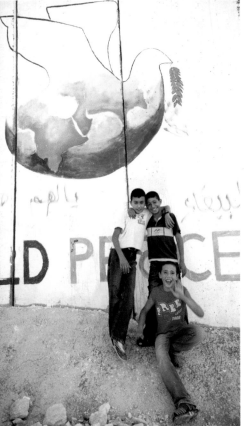

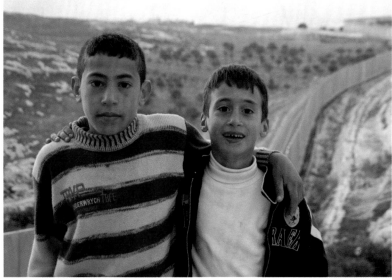

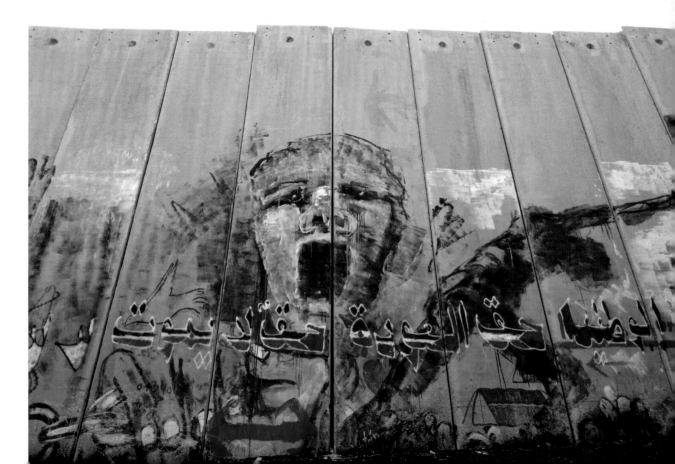

Pictured here are Said Eid Zwahra, his wife, Fatima, and one of their grandchildren, also named Said. Said was born in this modest home in 1938, ten years before the State of Israel was created. In 1993, Israeli officials came to photograph Said's home –there are 2 bedrooms, as well as an expansive cave that they utilise. He has since been forbidden to make any additions or renovations to his home – if he does he will be fined, a demolition order will be issued, and Said will get a bill for the demolition when it's carried out. As a result, they've built 'temporary' rooms, ones without fixed roofs, which evade demolition regulations. The house is home to 36 members of this family, including 15 children.

Opposite their home (main photo, opposite), however, is the rapidly growing Israeli colony of Har Homa, built on Jabal Abu Ghneim, south of Jerusalem, in the occupied West Bank and in violation of international law. It is home to about 15,000 Jews. While Said is denied the right to build onto his home or the 28 dunams of land he owns, the colony has confiscated five dunams of his land for its own expansion. A legal case to have his land returned was on-going at the time of writing, although construction had begun.

To make matters worse, behind Said's home is the Wall, cutting them off from their community in nearby Beit Sahour. This means that Said and his family must apply for permits every six months to travel from their home to school, medical facilities and extended family in Beit Sahour, all within the West Bank. 'We are forbidden from bringing meat, eggs and milk from Beit Sahour,' he says – 'We can only bring fruit and vegetables, and these are restricted to 3 kilograms.' Their permits to enter Jerusalem are called 'Humanitarian' permits – they are barred from driving and working in Jerusalem, but they are permitted to buy higher priced chicken and lamb there, and can travel in taxis, though they can't afford them.

Palestinian communities enjoy tight-knit bonds. Relatives and friends in Beit Sahour are no longer able to visit Said and his family. If Said and family want to see their friends and extended family, they have to take a taxi, which costs 70 NIS (£6.50) and they cannot afford to do this often. Because of the taxi cost, the 15 children and their mothers rent a house in Beit Sahour so the children can get to school relatively cheaply and without the ordeal they would face daily at the checkpoint. They return home only one day a week.

Said has been offered money by Jewish authorities to move. 'We'll never sell, not even if it means the only thing we have to eat is the sand,' he says adamantly.

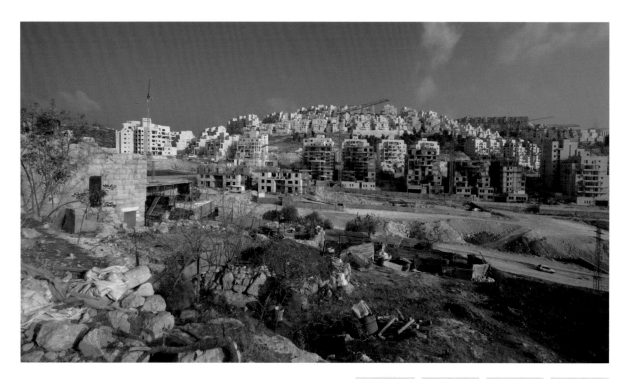

The property developer's sign reads: 'The Dutch Village, Jerusalem: view of a mountain, atmosphere of a village.' I expressed interest in buying property to one property agent. Their glossy brochure showed landscaped parkland that extended into Said's property – his home and land simply didn't exist. I asked about the legal status of this colony, feigning concern that they might not be a sound investment. The agent replied: 'Who knows what a peace settlement will involve. But we have every indication [from the Israeli government] that these will stay.'

Artwork on the Wall in Abu Dis showing Israel's voracious consumption of Palestinian land (green) over six decades. The occupied Palestinian Territory (West Bank and Gaza) comprises only 22 per cent of historic Palestine and the Palestinian Authority controls only part of this – Israel has effective control over 90 per cent of historic Palestine

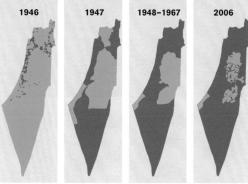

Palestinian land

Israel (or Jewish land pre-1948) – military and civil control

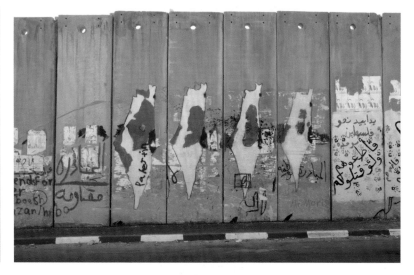

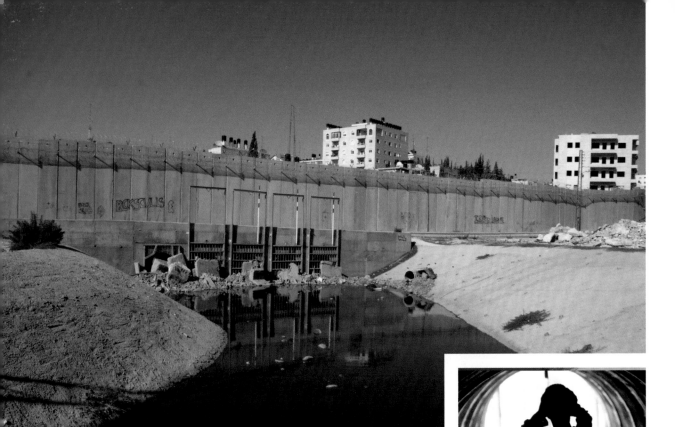

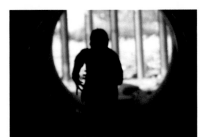

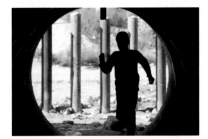

As I photograph the stagnant water, a boy's voice calls: 'Hello! Hello! Sawwer! ['Take a photo!'].' I can't see him. There's silence, then moments later, 'Hello!' again, this time from under the door in the Wall. He peeks underneath, smiling. 'Ismi Mohammad' ['My name is Mohammad'] he says. 'Ana William,' I reply. Then he's off again. A moment later: 'William!' he calls. He comes through the huge storm drains. 'Come!' he beckons. The smell is revolting. His playground is this tunnel filled with fetid sewage.

The apartment buildings here – once

convenient and inexpensive locations for commuting into Jerusalem – are largely empty. A man whose house is directly on the other side of this Wall shows me where the sewage floods his home during storms. His grape vines create a canopy of shade, but they cannot eat the grapes because they are contaminated.

Storm drains like these have served as a passage for Palestinians to get round the Wall to enter Jerusalem to earn money, pray or visit family. All around the Wall are improvised ladders made out of rope, fence, discarded pallets – whatever their ingenuity can put to use.

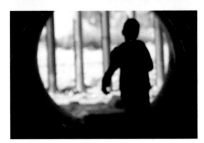

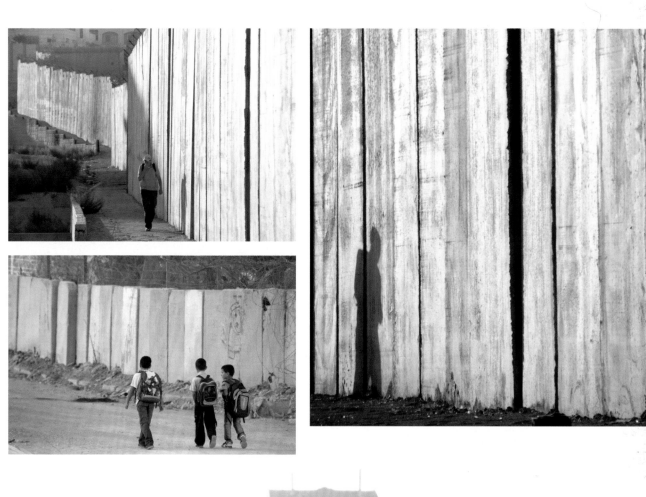
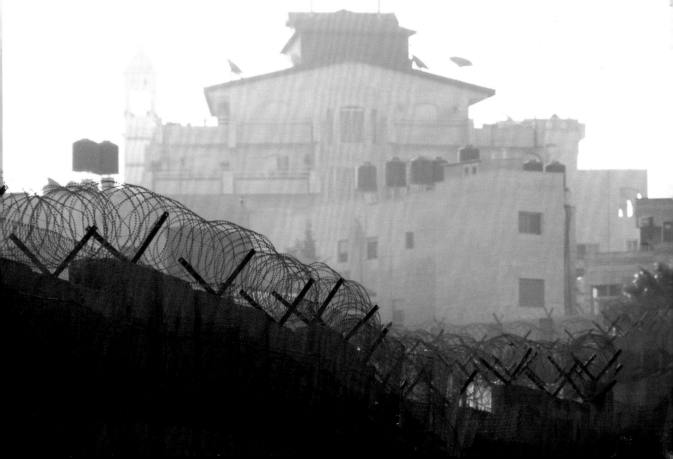

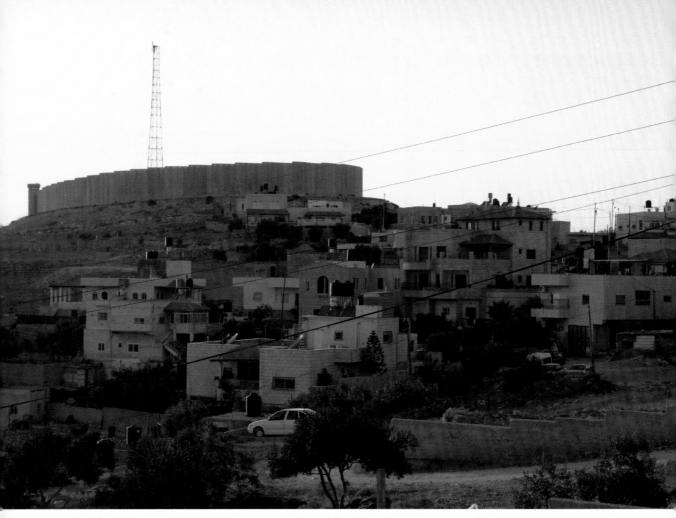

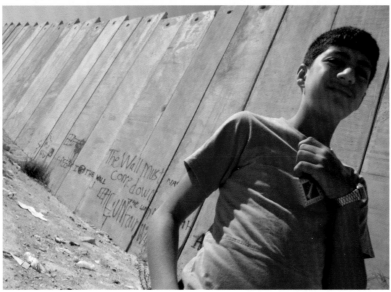

TOP
The Wall cutting off Abu Dis from Jerusalem. A surveillance camera is mounted on a tall pole to monitor activity for miles around.

RIGHT
Three young boys stop collecting bits of metal and discarded aluminium cans when they see my camera. They pose in front of the wheel barrow they are pushing. '*Sawwernah! Sawwernah!*', they shout – 'Take a photo of us!'

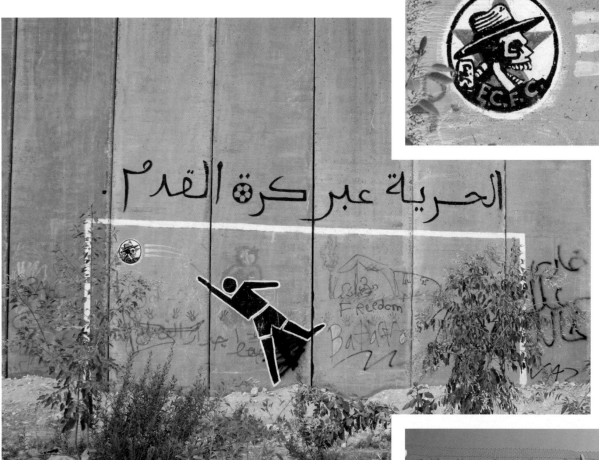

الحرية عبر كرة القدم.

TOP
'Freedom through football,' the graffiti reads on this section of wall in Abu Dis, with a detail of the ball (inset).

ABOVE
Dangling football boots and the Wall, like a surreal still life, in Abu Dis.

RIGHT
Graffiti in Jerusalem, near the Zeitoun checkpoint that isolates Al 'Ezariya from Jerusalem.

Playing football in Abu Dis, with Jerusalem in the background. The land belongs to Abu Dis University, which fought a hard-won but spirited legal battle to stop the Wall from encroaching even deeper onto the campus. Students and faculty set up makeshift classrooms and camped on the land in peaceful defiance when Israel first set out to snatch more Palestinian land for the route of the Wall. Despite this 'triumph', the university lost a third of its land to the Wall and is now separated from East Jerusalem.

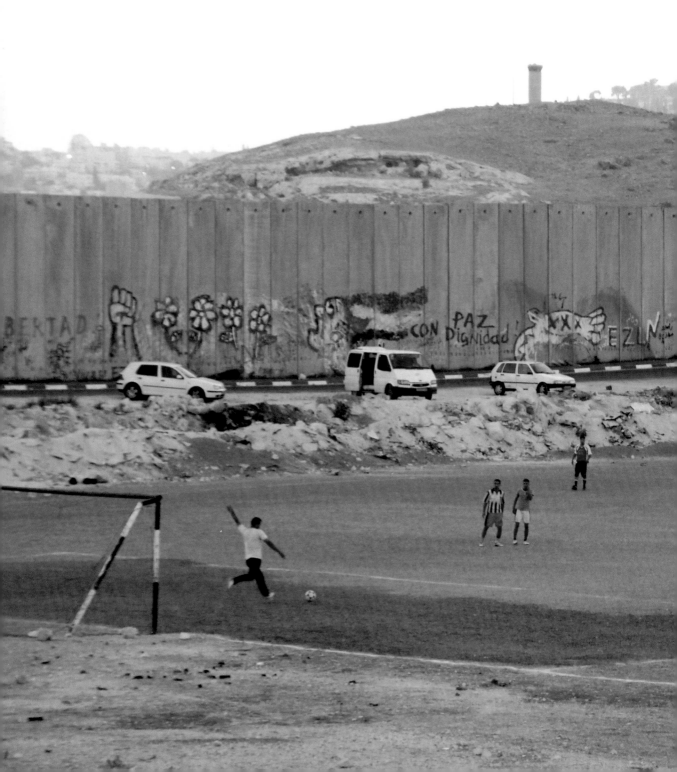

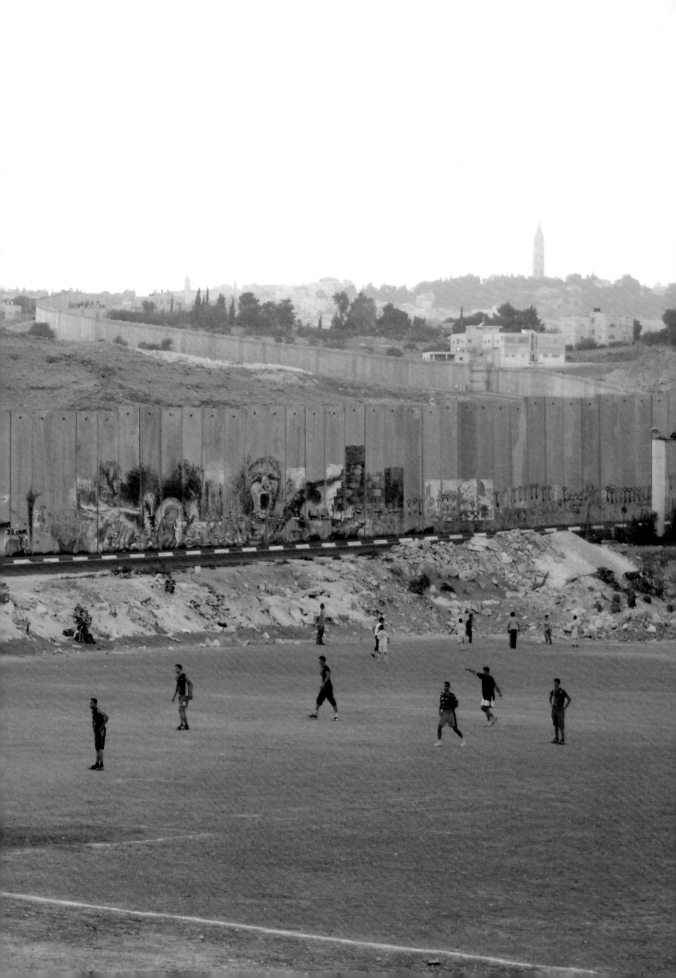

Nu'man is a small Palestinian village between Jerusalem and Bethlehem, with about 200 residents. They have lived here for generations, but the village's future is being systematically strangled. In 1967, Israel illegally annexed this area and included it within the Jerusalem municipality – but the residents of Nu'man were not given the status of Jerusalemites, nor were they provided with municipal services. Israel regards the residents of Nu'man as West Bankers living illegally in Israel and has implemented a raft of measures to ensure that the village cannot survive, amounting to 'forced transfer', the residents allege.

Students walk two kilometres to their school in the neighbouring village of Al-Khas because school buses can no longer enter their village. Like all of Nu'man's residents, students are subjected to Israeli 'security' searches as they leave and enter their village. Residents, including school kids, regularly report harassment, humiliation and intimidation by soldiers, as well as severe delays due to movement restrictions. For a university student travelling to Abu Dis, the journey that

once took 20 minutes now takes three hours.

Friends and relatives, medical facilities, shops, schools, places of worship – all are outside the village. Many of Nu'man's residents curtail their movement due to the harassment and humiliation they've come to expect from the soldiers. As in other Palestinian villages 'seamed in' by the Wall, soldiers regulate what food Nu'man's residents can bring back, confiscating amounts they deem 'excessive'.

Residents cannot build new homes or additions to existing homes. There is an Israeli-imposed ban on all construction to stifle any growth – Palestinian growth, that is. While much of Nu'man's land has already been appropriated for the military checkpoint and the Wall, an additional 530 dunams belonging to Nu'man is earmarked for a significant extension of the Israeli Har Homa colony, to create another 12,000 homes for Jews.

This means that younger generations cannot build a home and will have to leave Nu'man to build in neighbouring West Bank villages. As they leave, they and their offspring will no longer be permitted to return to Nu'man to visit their relations – not without obtaining a visitor permit from the Israeli authorities. The village is becoming increasingly isolated.

Twice the village has petitioned the Israeli Supreme Court – most recently in 2007 – for the village to be recognised as part of the West Bank, and for the Wall to be re-routed, or for its residents to receive Jerusalem ID cards and municipal services. The latest case was on-going at the time of writing.

PHOTOS:

All school children from Nu'man return from school in neighbouring Al-Khas in this way, having to go through a checkpoint, where their names are checked against a list and their possessions are searched. The main photo shows the checkpoint, which regulates traffic to and from Nu'man towards Jerusalem and towards Hebron.

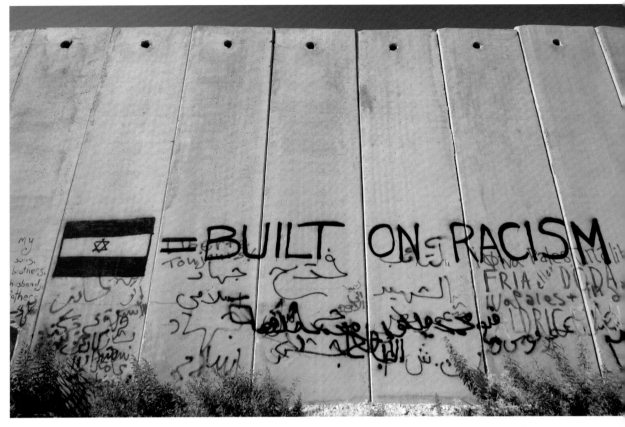

The first time I attempted to photograph the school children of Nu'man crossing this checkpoint – on occupied West Bank land – an aggressive, armed Israeli supervisor from the Border Police (BP) came running towards me, shouting to stop taking photos. I showed him my press card and a photocopy from the Israeli Defense Forces (IDF) handbook about photos being permitted at checkpoints. Over the course of several minutes, we had this exchange:

BP: Delete those photos, you are not permitted to take photos here.

ME: Why not? I am press, I have these [handing him the photocopy and press card].

BP: This is for the IDF. We are the Border Police. You need to get permission first to photograph here. Delete the photos.

ME: Okay, I will phone the Border Police now and get permission [start calling].

BP: You can't do it here. Do it over there [pointing down the road, in what he regards the West Bank].

ME: [Pointing towards road leading up to Nu'man] Okay, I'll phone from just over there.

BP: No, that is still Israel. Phone from over there.

ME: This land is part of Israel?

BP: Yes

ME: And the people who live there are Israeli citizens, Jerusalemites?

BP: No, they are West Bankers.

ME: So why can't I call from here then? They are West Bankers over there and they are West Bankers here. Is this the West Bank or Israel?

BP: Israel.

ME: So why aren't these people also Israeli citizens?

BP: [Frustrated] You can't call from here, you're too close to the checkpoint. Phone from over there. I hope you understand. And delete the photos.

RIGHT
The graffiti in Arabic, written for Israelis, reads: 'The Wall is in your head.'

Graffiti from Abu Dis.

The artwork on the right shows the Dome of the Rock and Jerusalem as the heart of Palestine. The poetry reads:

How many stabs has she endured from you / that cause her wounded heart to bleed? / Is there anyone to wipe her tears / or stop her bleeding?

BELOW

In the foreground is a demolished Palestinian home in Nu'man – built illegally and without permission, according to Israel, which illegally occupies this section of the West Bank. In the distance, the Israeli colony of Har Homa, built illegally on Palestinian land, is set to engulf more as it expands towards Nu'man.

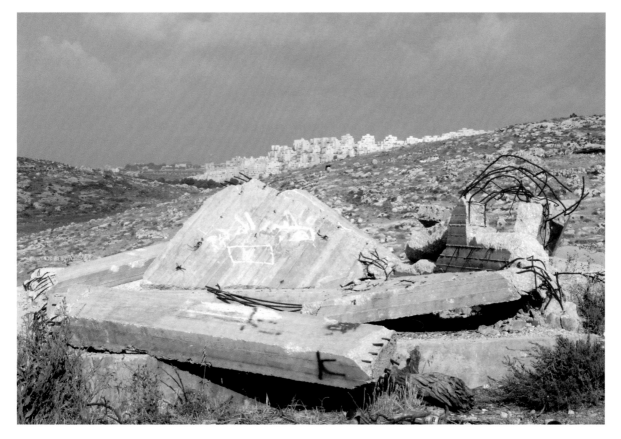

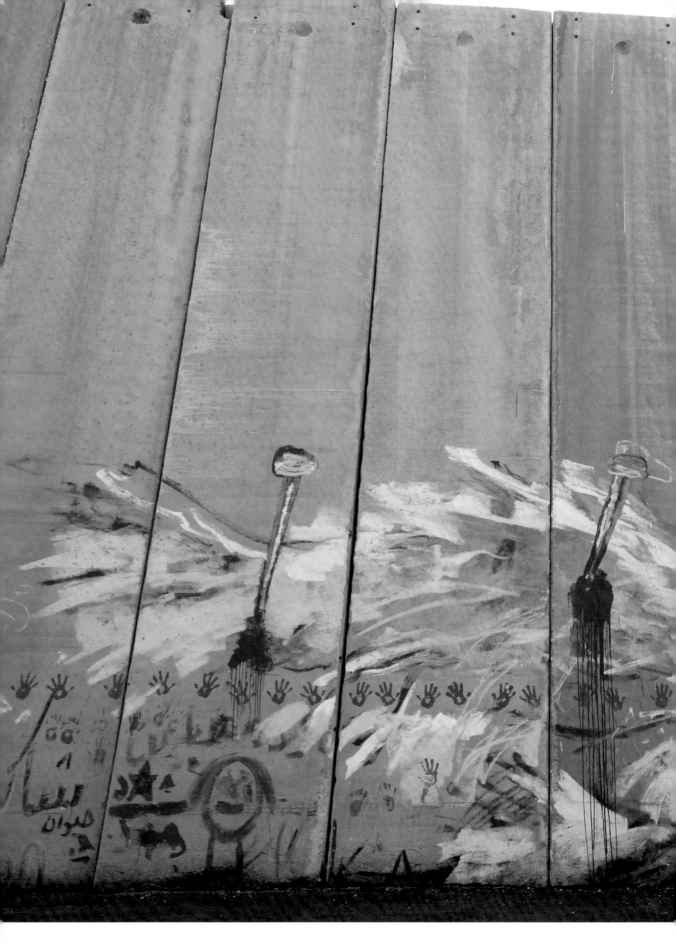

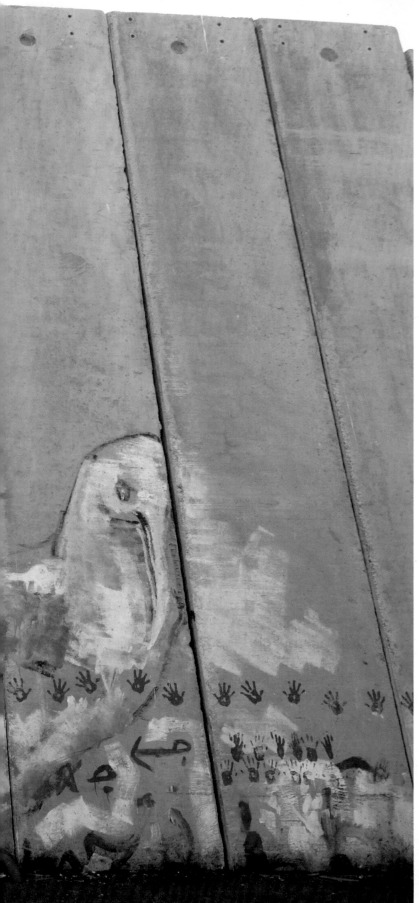

Artwork on the wall in Abu Dis.

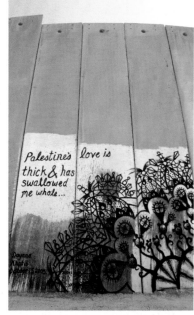

Palestine's thick & has swallowed me whole... love is

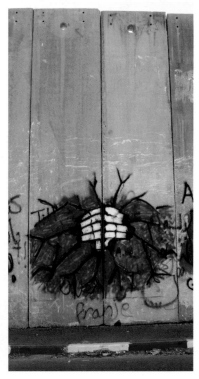

Studying against a backdrop of the Wall, Abu Dis University.

Several students walk me around this campus of 8,000 students and describe how the Wall affects their lives. They come from areas inside Jerusalem and from neighbouring towns and villages in the West Bank, and study a range of subjects – English literature, political science, dentistry, law and medicine. Mu'ayyad, who is studying to be a medical technician, lives nearby but on the other side of the Wall. 'It used to take two minutes to get here. Now I take two buses and go through one checkpoint, and that

usually takes 90 minutes,' he says.

Everything depends on the mood of the soldiers at the checkpoint, they say. 'Some days your journey has the usual hassles and humiliation; some days there's more of it than usual; and some days staff and students can't get through,' says Husam, from Silwan in Jerusalem.

Another student, Martin, describes how the Wall has divided the family home: he and his father have Jerusalem ID cards and must live in Jerusalem or they will lose the right to reside there, while his mother and siblings have West Bank IDs and cannot enter the city. Martin and his

father go to the family home over the weekend. While Jews from around the world can emigrate to Israel, millions of Palestinians who were made refugees when Israel was created cannot return to their homes, and Palestinians in Israel and occupied East Jerusalem do not qualify for family unification if they want to live in Jerusalem with family members from the West Bank and Gaza Strip. It's down to demographics: official government policy is to maintain a Jewish majority in both Jerusalem and Israel. Palestinians assert that these are racist, apartheid policies.

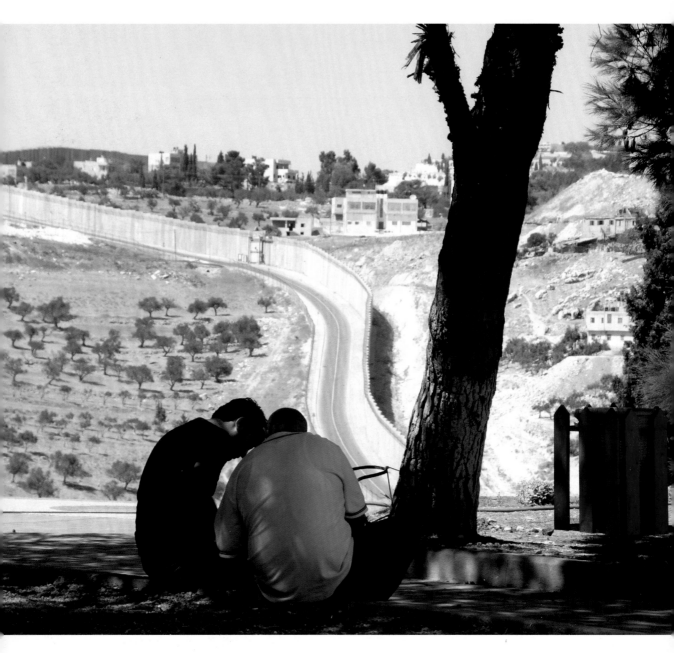

RIGHT, TOP
An olive tree with historical Palestine at its centre. One half is dead, the other is healthy.

RIGHT, MIDDLE
A Palestinian flag and a call for national unity amidst the struggle.

RIGHT, BOTTOM
The graffiti reads: 'Return' [i.e. of Palestine's 7 million refugees to their homeland]

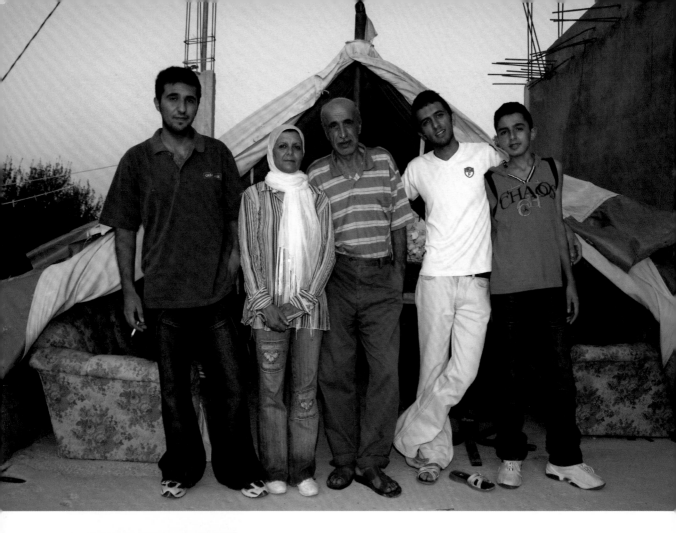

ABOVE

The Salim family in Al Walaja: Al-Motasim, Seham, Mundeer, Ahmad and Mohammad.

It's hard to be sanguine when your house is set to be demolished for a third time, but somehow the Salim family maintain an upbeat, united and strong front.

Their home was demolished twice – with no prior warning of the day – in 2006 for being built without permits in this village of Walaja, located between Jerusalem and Bethlehem. Israel claims the area is within the municipality of Jerusalem, but regards the people as West Bank Palestinians. 'We aren't even allowed into Jerusalem to submit the paperwork,' Mundeer, 53, says cynically. Even if they could, permits would be refused.

This time, their house is in the way of the Wall's planned route – as are 45 neighbouring homes also with demolition orders hanging over them. (Three dozen homes and agricultural buildings, along with two cisterns, were recently destroyed here so Israel could build a by-pass road.) Al-Motasim, the eldest son, a civil engineer, shows me videos of the first two demolitions. It's a bizarre experience to watch these traumatic images with the family. They are stoic about it. This is reality TV.

The family have owned land in the village of Walaja for generations – long before the State of Israel was created. The original village was depopulated and destroyed by Jewish militias in 1948. Six decades on, Israel is trying once again to depopulate the 'new' Walaja of its 2,000 residents: land confiscation, house demolitions, a ban on building, road closures and the prospect of being cut off from Beit Jala and Bethlehem are designed to force the residents of Walaja to abandon their land. With their schools, shops, medical facilities and extended communities all in Beit Jala and Bethlehem, residents of Walaja will find it increasingly difficult to go about their daily lives once the Wall has encircled their land.

From the Salim home, you can see the

three expanding Jewish colonies of Gilo, Har-Gilo and Giv'at Yael, all built illegally on confiscated Palestinian land. 'There,' points Al-Motasim, beyond the rubble of their former home, 'that's Gilo.'

The Salim family are as prepared as they can be – they've kept the tents that they lived in after the previous demolitions. It's taken its toll on the family in many ways – financially, academically, emotionally and psychologically.

Seham, mother to the three boys and a remarkably strong woman who always manages to smile and put on a brave face, admits, however: 'You go to bed every night not knowing if you'll wake up and still have your home. You have no security.'

South Africans like Bishop Desmond Tutu say that Israel exercises a system of apartheid more diverse and violent than what they experienced in recent decades in South Africa. In April 2009, Farid Esack, a South African peace activist, anti-apartheid campaigner and gender equality commissioner for Nelson Mandela's government, wrote the following letter to the Palestinian people. It was painted on the Wall in Ar-Ram by a charitable organisation called Sendamessage (www.sendamessage.nl). At 1,998 words, Esack's letter is written along 2.6 km of the Wall and is apparently 'the world's longest letter.' On their website, Sendamessage state: '[W]e are not after a world record. This is about justice for the Palestinians. After 62 years of neglect, oppression and dispossession they deserve a message the world will not readily forget.'

It is reproduced here in its entirety.

Farid Esack: Open Letter, 2009

My dear Palestinian brothers and sisters, I have come to your land and I have recognized shades of my own. My land was once one where some people imagined that they could build their security on the insecurity of others. They claimed that their lighter skin and European origins gave them the right to dispossess those of a darker skin who lived in the land for thousands of years. I come from a land where a group of people, the Afrikaners, were genuinely hurt by the British. The British despised them and placed many of them into concentration camps. Nearly a sixth of their population perished.

Then the Afrikaners said, 'Never again!'. And they meant that never again will harm come unto them with no regard to how their own humanity was tied to that of others. In their hurt

they developed an understanding of being's God chosen people destined to inhabit a Promised Land. And thus they occupied the land, other people's land, and they built their security on the insecurity of black people. Later they united with the children of their former enemies – now called 'the English'. The new allies, known simply as 'whites', pitted themselves against the blacks who were forced to pay the terrible price of dispossession, exploitation and marginalization as a result of a combination of white racism, Afrikaner fears and ideas of chosenness. And, of course, there was the ancient crime of simple greed.

I come from Apartheid South Africa.

Arriving in your land, the land of Palestine, the sense of deja vu is inescapable. I am struck by the similarities. In some ways, all of us are the children of our histories. Yet, we may

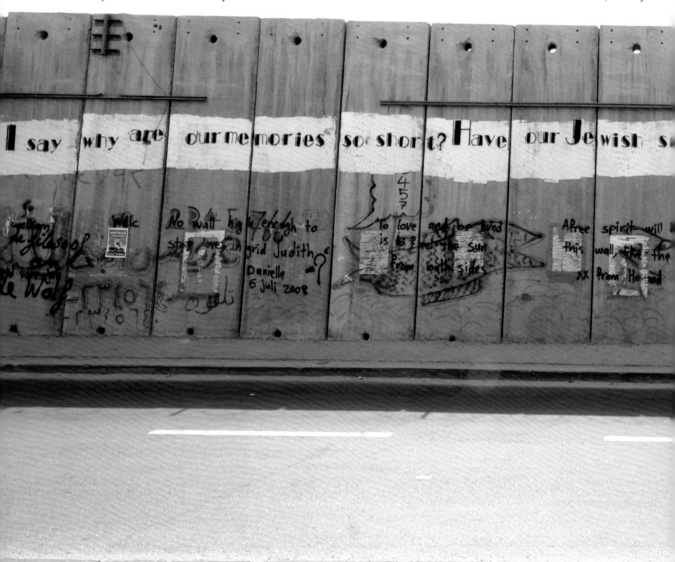

also choose to be struck by the stories of others. Perhaps this ability is what is called morality. We cannot always act upon what we see but we always have the freedom to see and to be moved.

I come from a land where people braved onslaughts of bulldozers, bullets, machine guns, and teargas for the sake of freedom. We resisted at a time when it was not fashionable. And now that we have been liberated everyone declares that they were always on our side. It's a bit like Europe after the Second World War. During the war only a few people resisted. After the war not a single supporter of the Nazis could be found and the vast majority claimed that they always supported the resistance to the Nazis.

I am astonished at how ordinarily decent people whose hearts are otherwise 'in the right place' beat about the bush when it comes to Israel and the dispossession and suffering of the Palestinians. And now I wonder about the nature of 'decency.' Do 'objectivity,' 'moderation,' and seeing 'both sides' not have limits? Is moderation in matters of clear injustice really a virtue? Do both parties deserve an 'equal hearing' in a situation of domestic violence – wherein a woman is beaten up by a male who was abused by his father some time ago – because 'he,' too, is a 'victim'?

We call upon the world to act now against the dispossession of the Palestinians. We must end the daily humiliation at checkpoints, the disgrace of an Apartheid Wall that cuts people off from their land, livelihood, and history, and act against the torture, detention without trial, and targeted killings of those who dare to resist. Our humanity demands that we who recognize evil in its own time act against it even when it is 'unsexy' to do so. Such recognition and action truly benefits our higher selves. We act in the face of oppression, dispossession, or occupation so that our own humanity may not be diminished by our silence when some part of the human family is being demeaned. If something lessens your worth as a human being, then it lessens mine as well. To act in your defense is really to act in defense of my 'self' – whether my higher present self or my vulnerable future self.

Morality is about the capacity to be moved by interests beyond one's own ethnic group, religious community, or nation. When one's view of the world and dealings with others are entirely shaped by self-centredness – whether in the name of religion, survival, security, or ethnicity – then it is really only a matter of time before one also becomes a victim. While invoking 'real life' or realpolitik as values

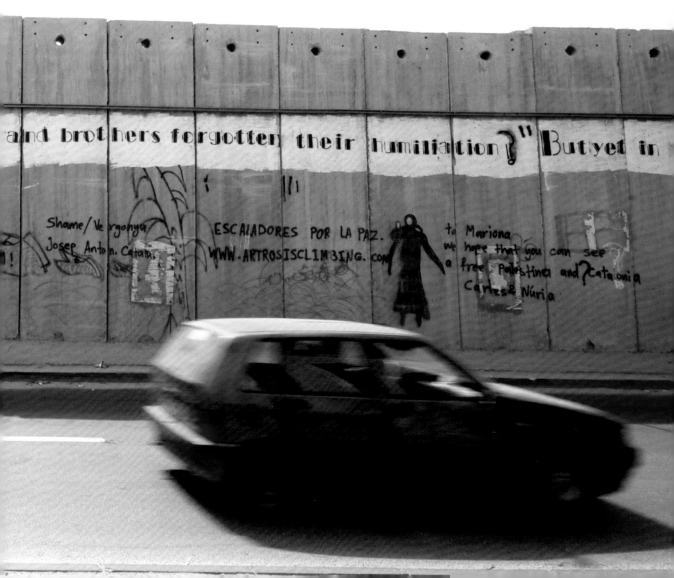

themselves, human beings mostly act in their own self–interest even as they seek to deploy a more ethically based logic in doing so. Thus, while it is oil or strategic advantage that you are after, you may invoke the principle of spreading democracy, or you may justify your exploitation of slavery with the comforting rationalization that the black victims of the system might have died of starvation if they had been left in Africa. Being truly human – a mensch – is something different. It is about the capacity to transcend narrow interests and to understand how a deepening of humanness is linked to the good of others. When apartness is elevated to dogma and ideology, when apartness is enforced through the law and its agencies, this is called Apartheid. When certain people are privileged simply because they are born in a certain ethnic group and use these privileges to dispossess and discriminate against others, then this is called Apartheid. Regardless of how genuine the trauma that gave birth to it and regardless of the religious depth of the exclusivist beliefs underpinning it all, it is called Apartheid. How we respond to our own trauma and to the indifference or culpability of the world never justifies traumatizing others or an indifference to theirs. Apartness then not only becomes a foundation for ignorance of the other with whom one shares a common space. It also becomes a basis for denying the suffering and humiliation that the other undergoes.

We do not deny the trauma that the oppressors experienced at any stage in their individual or collective lives;

we simply reject the notion that others should become victims as a result of it. We reject the manipulation of that suffering for expansionist political and territorial purposes. We resent having to pay the price of dispossession because an imperialist power requires a reliable ally in this part of the world.

As South Africans, speaking up about the life or death of the Palestinian people is also about salvaging our own dream of a moral society that will not be complicit in the suffering of other people. There are, of course, other instances of oppression, dispossession, and marginalization in the world. Yet, none of these are as immediately recognizable to us who lived under, survived, and overcame Apartheid. Indeed, for those of us who lived under South African Apartheid and fought for liberation from it and everything that it represented, Palestine reflects in many ways the unfinished business of our own struggle.

Thus I and numerous others who were involved in the struggle against Apartheid have come here and we have witnessed a place that in some ways reminds us of what we have suffered through. Archbishop Desmond Tutu is of course correct when he speaks about how witnessing the conditions of the Palestinians 'reminded me so much of what happened to us black people in South Africa… I say why are our memories so short? Have our Jewish sisters and brothers forgotten their humiliation?' But yet in more ways than one, here in your land, we are seeing something far more brutal, relentless and inhuman than what we have ever

seen under Apartheid. In some ways, my brothers and sisters, I am embarrassed that you have to resort to using a word that was earlier on used specifically for our situation in order to draw attention to yours.

White South Africa did of course seek to control Blacks. However it never tried to deny Black people their very existences or to wish them away completely as we see here. We have not experienced military occupation without any rights for the occupied. We were spared the barbaric and diverse forms of collective punishment in the forms of house demolitions, the destruction of orchards belonging to relatives of suspected freedom fighters, or the physical transfer of these relatives themselves. South Africa's Apartheid courts never legitimized torture. White South Africans were never given a carte blanche to humiliate Black South Africans as the Settlers here seem to have. The craziest Apartheid zealots would never have dreamt of something as macabre as this Wall. The Apartheid police never used kids as shields in any of their operations. Nor did the Apartheid army ever use gunships and bombs against largely civilian targets. In South Africa the Whites were a stable community and after centuries simply had to come to terms with Black people. (Even if it were only because of their economic dependence on Black people.) The Zionist idea of Israel as the place for the ingathering for all the Jews – old and new, converts, reverts and reborn is a deeply problematic one. In such a case there is no sense of compulsion to reach out to your

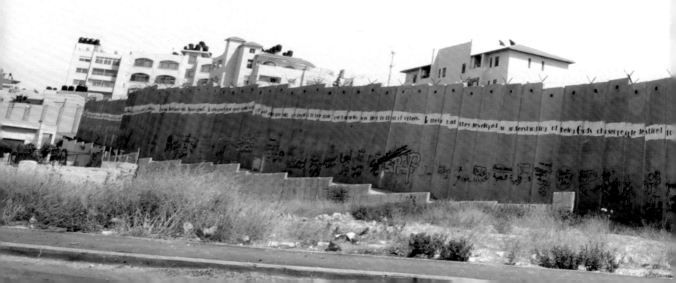

neighbour. The idea seems to be to get rid of the old neighbours – ethnic cleansing - and to bring in new ones all the time.

We as South Africans resisting Apartheid understood the invaluable role of international solidarity in ending centuries of oppression. Today we have no choice but to make our contribution to the struggle of the Palestinians for freedom. We do so with the full awareness that your freedom will also contribute to the freedom of many Jews to be fully human in the same way that the end of Apartheid also signaled the liberation of White people in South Africa. At the height of our own liberation struggle, we never ceased to remind our people that our struggle for liberation is also for the liberation of white people. Apartheid diminished the humanity of White people in the same way that gender injustice diminishes the humanity of males. The humanity of the oppressor is reclaimed through liberation and Israel is no exception in this regard. At public rallies during the

South African liberation struggle the public speaker of the occasion would often call out: 'An injury to one?!' and the crowd would respond: 'Is an injury to all!' We understood that in a rather limited way at that time. Perhaps we are destined to always understand this in a limited way. What we do know is that an injury to the Palestinian people is an injury to all. An injury inflicted on others invariably comes back to haunt the aggressors; it is not possible to tear at another's skin and not to have one's own humanity simultaneously diminished in the process. In the face of this monstrosity, the Apartheid Wall, we offer an alternative: Solidarity with the people of Palestine. We pledge our determination to walk with you in your struggle to overcome separation, to conquer injustice and to put end to greed, division and exploitation.

We have seen how yesterday's oppressed – both in Apartheid South

Africa and in Israel today – can become today's oppressors. Thus we stand by you in your vision to create a society wherein everyone, regardless of their ethnicity or religion, shall be equal and live in freedom.

We continue to draw strength from the words of Nelson Mandela, the father of our nation and hero of the Palestinian people. In 1964 he was found guilty on charges of treason and faced the death penalty. He turned to the judges and said: 'I have fought against white domination, and I have fought against black domination. I have cherished the ideal of a democratic and free society in which all persons live together in harmony and with equal opportunities. It is an ideal which I hope to live for and to achieve. But if needs be, it is an ideal for which I am prepared to die.'

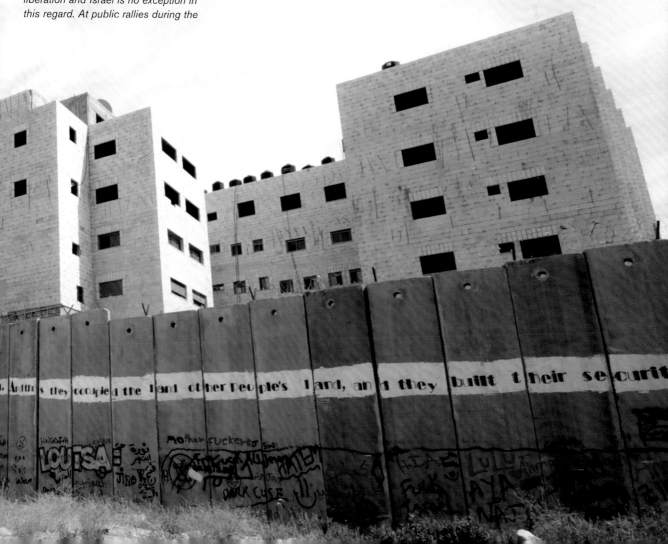

Qalandia checkpoint is a main point of access into Jerusalem from north West Bank. Like the checkpoint at Bethlehem, several thousand Palestinian workers, desperate for an income, queue daily from before dawn in degrading conditions, typically for about two hours.

Like Bethlehem, there is the inevitable pandemonium that occurs as workers compete, cheek by jowl, for a place in the metal corridors in the rush to get to work. It is pathetic and heart wrenching to witness.

This is the first stage of their checkpoint ordeal. Once through the electronic turnstile, they then queue for another turnstile. Beyond this, their belongings are x-rayed and their permits, IDs and biometric details are checked by surly Israeli soldiers. Mohammad, a father of two in his early thirties, works in ceramics. As we speak, his hands are clasped to the entrance of the corridor, his shoulders and back pressed tightly against several other men. He maintains this frozen position for five minutes until the line moves forward, then squeezes himself into the corridor entrance. 'Why?' he asks me. 'Why treat us like animals? They could process us without this degrading treatment, and quicker. It's to break us. Look at everyone here. Look at their faces.'

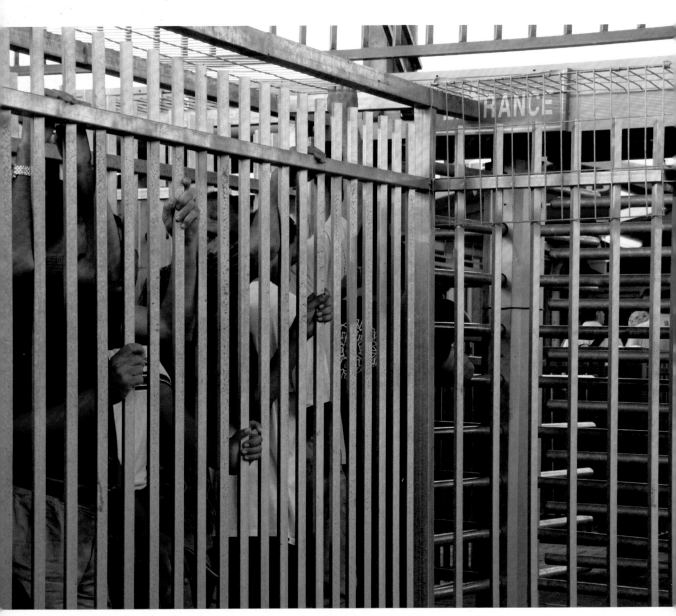

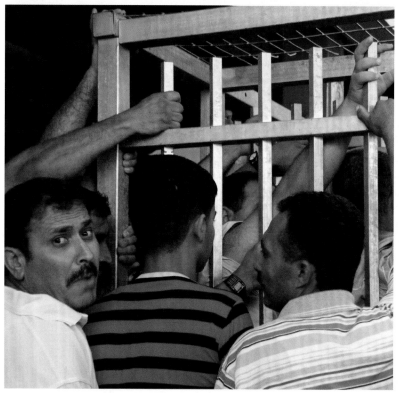
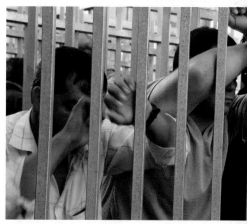
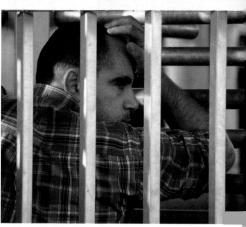

CTRL+ALT

rgive what you have done?

Breath
Freedom

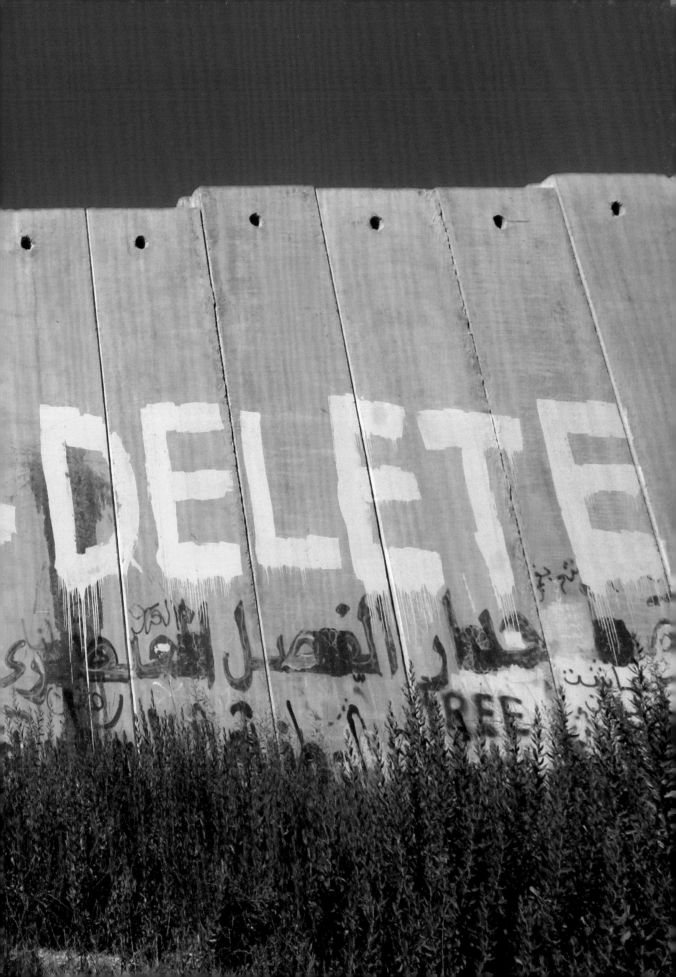

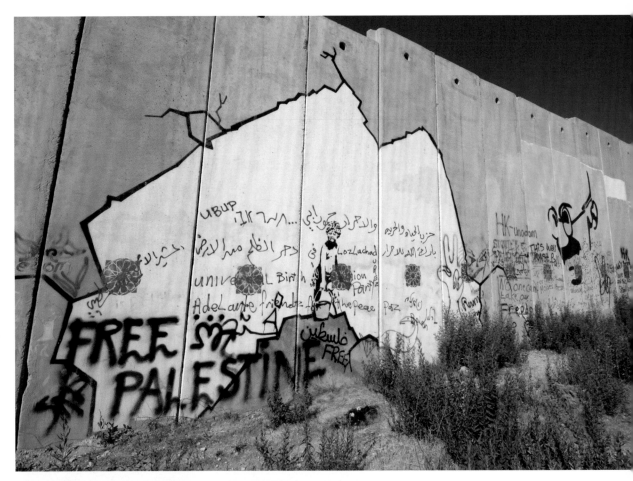

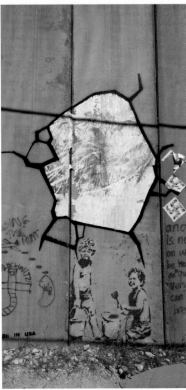

Cracks in the wall:

ABOVE AND FAR LEFT
Banksy's boy with a sand bucket near Qalandia checkpoint and Bethlehem, drawing attention to the brutality of the Wall.

LEFT
Near Qalandia checkpoint

OPPOSITE PAGE
Graffiti in Qalandia (above), Dome of the Rock mosque artwork in Abu Dis (inset) and in Jerusalem (below).

PREVIOUS PAGE
Near Qalandia checkpoint

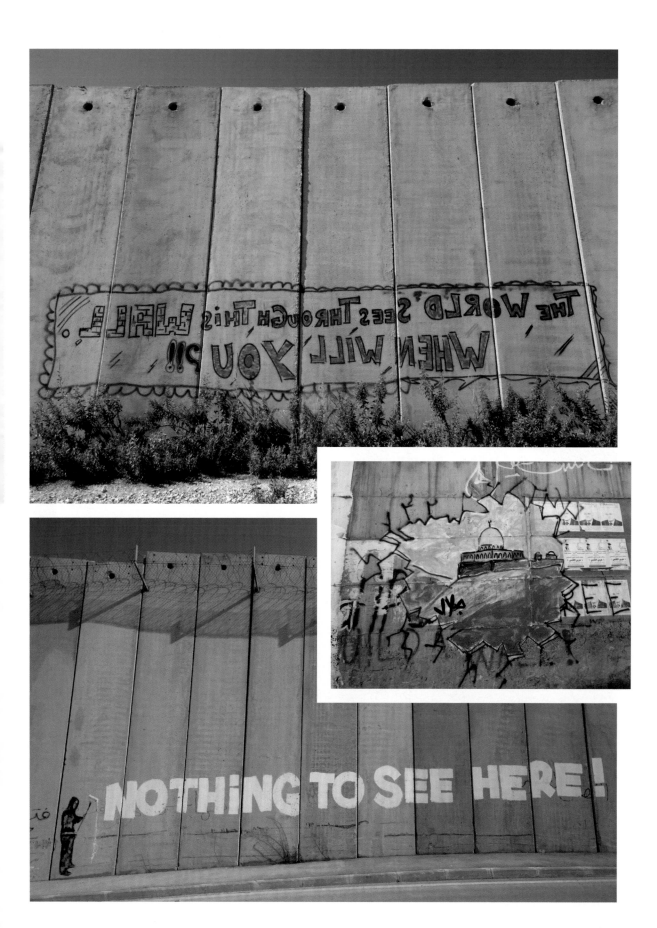

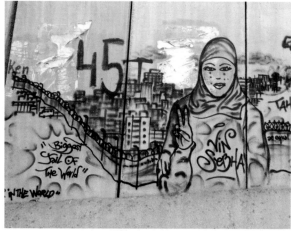

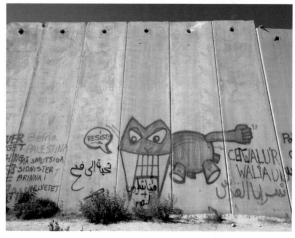

Jerusalem is a holy city for Muslims, Christians and Jews that attracts millions of religious and non-religious visitors from all over the world. In the Old City, groups of Catholic pilgrims carrying water bottles, rosaries and a cumbersome, large crucifix, amble along the Via Dolorosa, reciting the rosary; Jews and non-Jewish tourists don kippas and approach the Wailing Wall; others enjoy the exquisite beauty of the Dome of the Rock.

At Qalandia and Bethlehem checkpoints, each about 10 km from Jerusalem's Old City (one to the north, the other to the south), Muslim pilgrims trying to access Al-Aqsa mosque during the holy month of Ramadan experience a very different reality.

Pilgrims start arriving at dawn to queue to get through the Wall for prayers that begin around noon – men to one side, women to another. Thousands endure the fierce summer sun – as it's Ramadan, without food or water – and compete in surging crowds to reach the first of many Israeli barriers they will pass through, if they are lucky. Many are children, or elderly and infirm – the Israelis do nothing to make their passage easier.

For Ramadan prayers, the Israelis restrict access for West Bank Palestinians to children, men over 50 and women over 45. Many from these categories are still turned away.

The frontline is a stand-off between desperate, tired worshippers and gun-toting Israeli soldiers. The atmosphere is tense, volatile. Some people try to circumvent the barrier. There are violent confrontations. Soldiers roughly push women back, some fall, some snag their dresses on the barbed wire fence; one soldier shouts orders through his loudspeaker directly into people's ears. A Palestinian man argues with a soldier. He is forcefully pushed, he protests, there is shouting, then several soldiers grab him and forcibly lead him into an army vehicle and he is taken somewhere.

As prayer time approaches, those stranded plead with the soldiers for access. More shouting, pushing. Women holding children remonstrate at the soldiers' heavy-handedness, their children screaming, the soldiers simply kicking the barriers deeper into the crowd. Lines of soldiers run to the front as shouting swells, sound bombs and tear gas are fired, the crowd retreats, the media follow behind. Eventually, in peaceful protest, groups of men form lines and begin praying outside the Wall. Soldiers look on, bemused.

Back in the Old City, tourist dollars are exchanged for Last Supper pens, olive wood icons and crucifixes, menorahs, t-shirts and spices as the call to prayer from Al-Aqsa blurs into the soundscape.

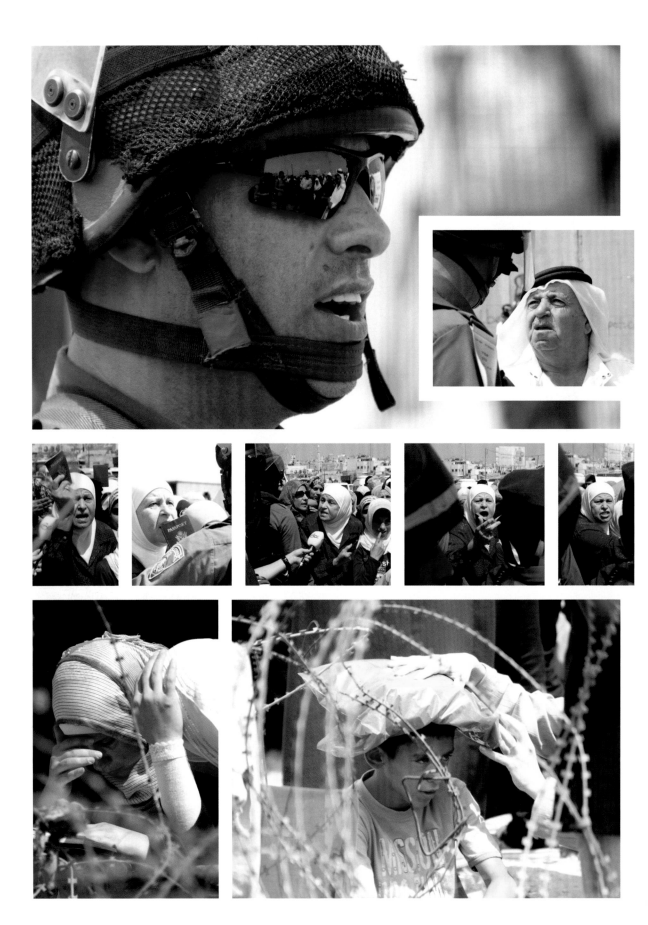

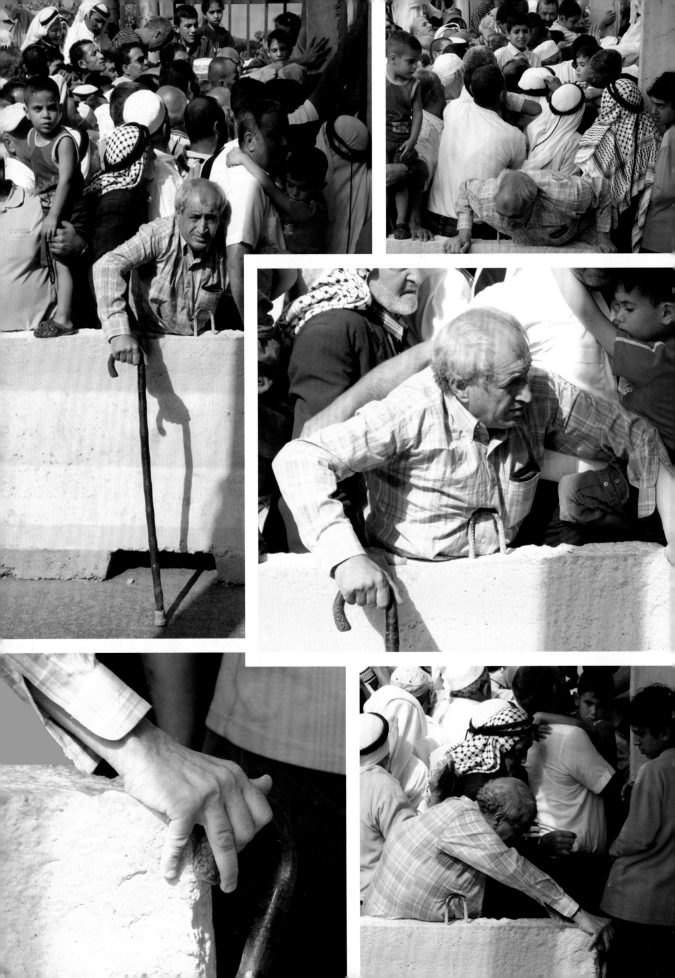

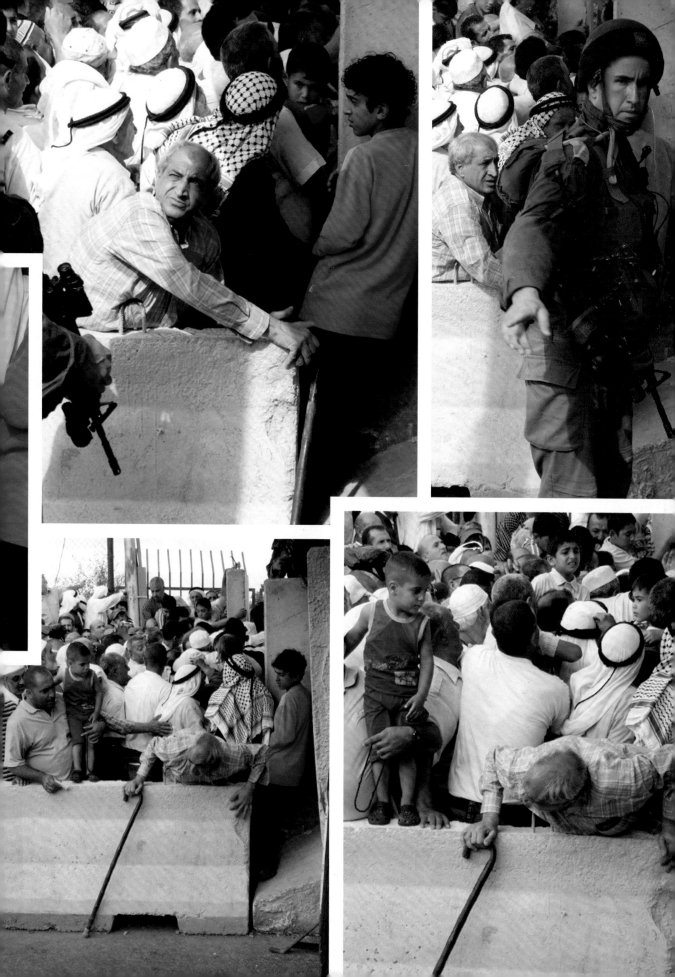

Donne nous la gare
centrale de Ramallah
ou pars!

Veolia give us
Ramallah Central
station or
fuck off

as! Arrête
illegale

Help us out no more
illegal investment in
East Jerusalem light
Rail, Stop VEOLIA

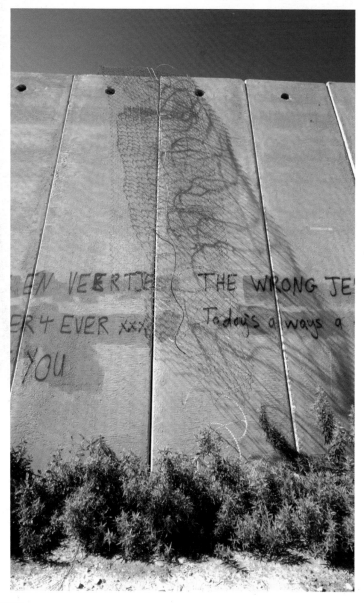

There are both real, makeshift ladders and painted ladders along parts of the Palestinian side of the Wall. The ones drawn by children are particularly sad and thought-provoking. One child has written: 'I'm not a mouse, I'm a human being just like you.'

In the Jerusalem suburb of Al Judeira, a once busy road now comes to a dead end at the Wall. There is still a trickle of traffic, however: a regular stream of taxis drops men off beneath billboards advertising businesses that must surely have relocated or gone bust. The men shuffle off out of sight.

There is one mechanics' shop and a metal workers' business operating: all of the other businesses – clothing shops, grocery stores, restaurants, offices – have shut down. Apartment blocks are largely abandoned. It reminds me of photos of Chechnyan neighbourhoods, only this one isn't bombed out, just ringed by a concrete noose.

A local man directs me towards the Wall. 'Go look,' he says. The men from the taxi are there, looking cagey. They will attempt to cross over the Wall in search of work. There are several ladders made out of chairs and wood from pallets. 'What would you do?' one asks me. 'There is no work. My children need to eat, they need clothes. We need to live.'

I stand on top of a building with a man in his late twenties named Amr, who holds his baby boy, Rafiq. I watch a dozen workers below jump the Wall from two locations into what looks like a cement factory. The men range in age from about 15 to 55. Those waiting to jump look out for soldiers.

Suddenly to the right, two soldiers come over a hill and catch two of the workers. One soldier slips and, as he gets to his feet, whacks one of the Palestinian men across the head. The other workers over the Wall scatter and hide behind a shed and under a cement truck. A third soldier arrives and looks for the others. He finds three under the truck, rounds them up at gunpoint and kicks one hard in the side. Support comes and they lead the workers away. Those who legged it through the other gap in the Wall are all through.

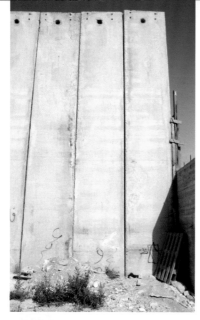

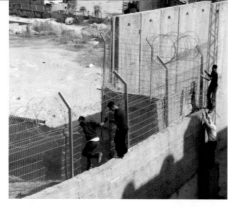

Amr shows me Al Judeira from the rooftop of his building. It's deserted, abandoned, dead. As we go down the stairs he tells me to look through a broken window into a flat. Sunlight streams into it. It is empty apart from two children's toy bikes. Outside the front door, 'Allah' [God] is spray painted on the wall and a bouquet of plastic roses is tied to the door handle.

An Israeli armoured personnel carrier has entered the area and rounded up more men waiting to jump the Wall. The head of the unit tells me: 'These men are heading to Jerusalem to carry out terrorist acts.' They blindfold several of the men – one is from the northern city of Nablus, I'm told. While Amr loads his car, Rafiq watches this scene unfold. The mechanic tells me that this happens daily. 'It's hell here,' he says.

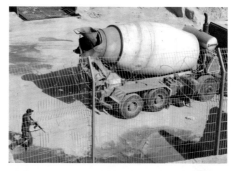

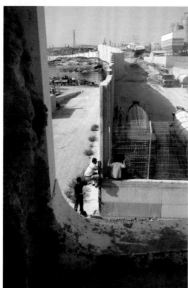

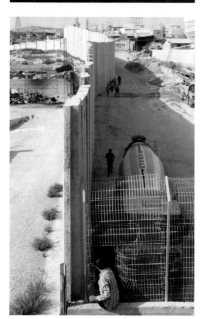

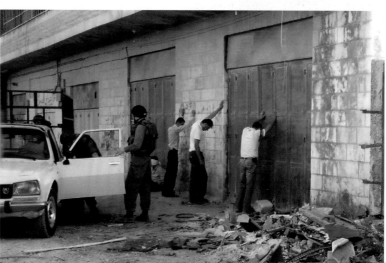

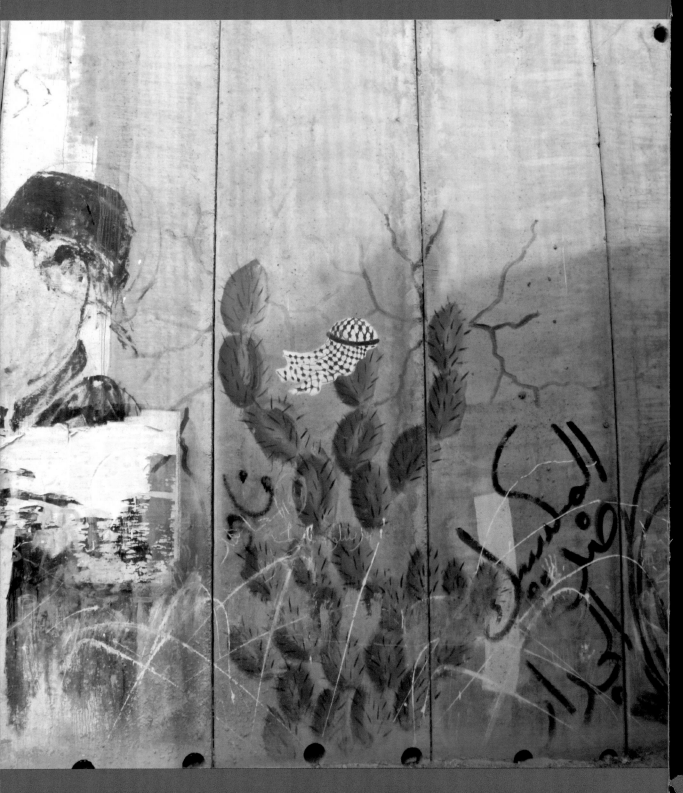

EPILOGUE

The sabra, or prickly pear cactus ('sabr' means patience), has come to symbolise Palestinian steadfastness and resistance. The cactus is able to survive the harshest conditions and it re-grows if cut. In the Palestinian villages that the Israelis depopulated and destroyed in 1948, often the sabra cacti are all that remain – the cacti were used to protect against trespassers and to demarcate borders around homes. Jewish militias demolished many of the buildings but the sabra remain, revealing the boundaries of the homes of the dispossessed.

Ni'lin, a traditional agricultural village of 4,700 inhabitants, lies a half-hour drive north-west of Jerusalem. It is one of several Palestinian villages at the forefront of the struggle to resist the construction of the Wall on stolen Palestinian land.

Before the State of Israel was created, Ni'lin was 58,000 dunams (580 hectares) in size. Over the decades huge amounts of its land have been expropriated and annexed by Israel, particularly in 1948 and 1967. Today, it is bordered to the southwest by the Jewish colonies of Hashmon'im, Modi'in Illit, and Mattityahu, home to 40,000 Jews who live on 8,000 dunams of Ni'lin's land.

Ni'lin will lose another 2,500 dunams to the Wall – 40 per cent of it will be built on farmland – and another 150-200 dunams for a tunnel that the Israelis will use to divide the village into two and to control the movement of its residents.

This will leave Ni'lin with just 7,300 dunams, according to the Palestinian Grassroots Anti-Apartheid Wall Campaign. Ni'lin will have lost a staggering 87 per cent percent of its land to Israel in just over six decades.

How do you expect us to respond? What would you do?

They are questions I am asked by people like Mohammad Amira, a teacher from Ni'lin, who has lost 250 dunams of agricultural land, as has his brother.

It's a composite dialogue that's presented to me in each village I visit, with the same conviction, the same frustration, the same sense of injustice – and the same determination to resist and to struggle for justice.

We see Israel's expanding colonies on our shrinking horizon. Built on Palestinian land, they become huge fortresses that exploit our resources, trample our rights and threaten our existence. They multiply. Their growth is Palestine's demise. For the exclusive rights of Jewish settlers in the West Bank, Israel imposes punitive measures that severely undermine our human rights, our liberty and our quality of life in equal measure. It's apartheid. It's ethnic cleansing.

And now they're taking more of our land to build the Wall that will further choke our community, and all of the communities within Palestine. The noose is tightening.

Now we find our village on the frontline. Our legal battles in the Israeli Supreme Court have largely been a charade – what did we expect, justice from a country that has ignored international law and UN Security and General Council resolutions for decades when they pertained to Palestinian rights? The Wall is coming. We see the convoys of bulldozers and trucks, protected by the Israeli army, move in and start the destruction, the theft of our land. We watch our land and olive groves – our source of income, heritage, our inheritance and our children's inheritance – being appropriated and uprooted, threatening our family's future. Five thousand olive trees in Ni'lin alone have been uprooted.

Several Palestinian villages – Ni'lin, Bi'lin, Jayyous and others – are at the forefront of this popular struggle to oppose the continued construction of the Wall on their land. Non-violent anti-wall demonstrations are organised by local committees, often by the village youth. In Ni'lin, these demonstrators consist mainly of local men and boys, international activists and some left-wing and anti-Zionist Israelis. Demonstrations vary in size from a few dozen to a few hundred people, depending on the significance of the occasion and the level of emotion. Flags, banners, t-shirts expressing solidarity, chants, loudspeakers, video cameras and the spirit of defiance and resistance – these are what they bring to the frontline.

The Israeli response, especially in a village like Ni'lin, largely sealed off from outsiders by the Israeli Border Police, is predictable: repression, exercised through disproportionate and often deadly force. The blocking of bulldozers and chanting for justice are met with the crack of baton on bone, high velocity tear gas canisters and gunfire.

Israeli violence invariably provokes a reaction. Prepubescent kids and teenagers with catapults, their faces concealed, hurl stones at the soldiers and take cover behind sabra cacti and walls. It's a David and Goliath battle. Severe injuries and fatalities occur, which go unreported in the West until a Westerner or an Israeli is critically injured or killed. At the time of writing, four residents of Ni'lin had been killed by live ammunition, including a 10 year old boy shot in the forehead. Another was killed when shot with rubber coated steel bullets, and an American activist remained in critical condition after being struck in the head by a 40 mm tear gas canister.

It is not just the demonstrators that face Israeli brutality. These defiant, non-violent demonstrations often result in collective punishment. There are comprehensive incursions into the towns – often in the middle of the night – with scores arrested and detained without charge, curfews imposed for days, and beatings. Schools are turned into interrogation centres and Israeli soldiers ransack private and public property. It is part of a coordinated Israeli tactic to crush these shows of popular resistance in villages throughout the West Bank, say local activists.

No Israeli soldiers have been killed in these confrontations, while 19 Palestinians have died – the average age of the victims is 19. Some 1,500 Palestinians have been injured since 2004, according to the Palestinian Grassroots Anti-Apartheid Wall Campaign. No Israeli soldiers or their superiors have been charged by the Israeli military for these deaths. Al-Haq, a Palestinian human rights organisation, attributes this to 'a pervasive culture of impunity among the ranks of the Israeli military establishment'. B'tselem, an Israeli human rights groups, says that this sends the message to Israeli soldiers and their superiors 'that Palestinian lives are cheap; it creates an atmosphere of immunity from prosecution'.

Muhammed Jayyousi is the youth coordinator of the Stop the Wall campaign in Jayyous. Like Ni'lin, Jayyous has faced brutal Israeli reprisals for the demonstrations the town has organised weekly since autumn 2008, when more of their land and fruit trees were threatened by the Wall. Despite Israeli threats and violence, Muhammed says the demonstrations will, and must, continue. 'To resist is to exist or we will lose more of our land,' he says. 'We need to come back for as long as it takes to show Israel that we won't accept the Wall, we won't live in a ghetto, we won't be refugees in our own land. It's our only choice.'

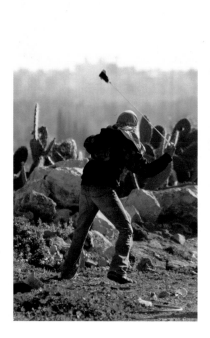

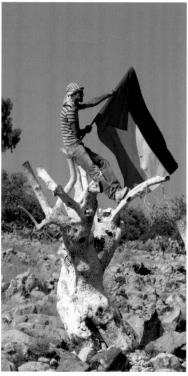

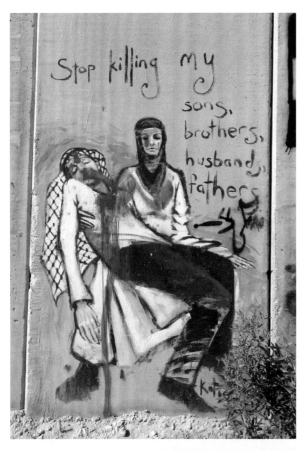

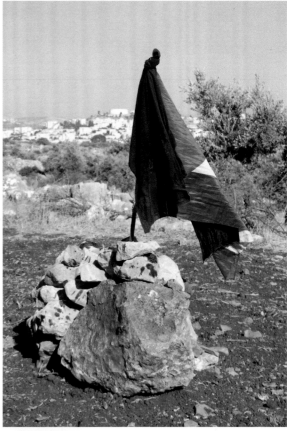

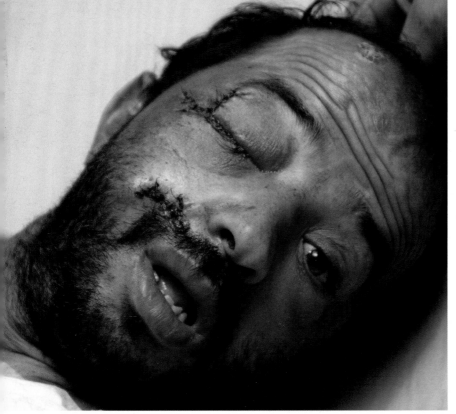

ABOVE

A memorial to Ahmed Moussa, aged 10, who was shot in the head with live ammunition by an Israeli soldier in July 2008. Friends who witnessed his murder tied his blood-stained shirt to a Palestinian flag. An Israeli colony built on Nil'in land is visible in the background.

LEFT

Awwad Srour, age 40, from Ni'lin, was shot with rubber coated steel bullets, reportedly from a distance of just seven metres, when he attempted to stop Israeli soldiers arresting his brother, Aqel, at their home in the middle of the night. Awwad was shot three times: one bullet entered his eye socket and was lodged in his brain; another entered his cheek; a third entered his chest. Israeli officials stopped Awwad from receiving specialist eye treatment at St John's hospital in East Jerusalem – the only specialised eye hospital available to the Palestinians – following the shooting. He was left blinded in his right eye.

Aqel, who was 34 at the time, was arrested, severely beaten and held for

The following Palestinians have been killed by the Israeli military while protesting against the appropriation of their land for the construction of the Wall:

Basem Abu Rahmeh, age 31
Mohammad Khawaja, age 20
Arafat Khawaja, age 22
Youssef Ahmed Younes Amirah, age 17
Ahmed Husan Youssef Mousa, age 10
Mahmoud Muhammad Ahmad Masalmeh, age 15
Muhammad Elias Mahmoud 'Aweideh, age 15
Taha Muhammad Subhi al-Quljawi, age 16
Jamal Jaber Ibrahim 'Asi, age 15
U'dai Mufid Mahmoud 'Asi, age 14
'Alaa' Muhammad 'Abd a-Rahman Khalil, age 14
Islam Hashem Rizik Zhahran, age 14
Diaa' A-Din 'Abd al-Karim Ibrahim Abu 'Eid, age 23
Hussein Mahmoud 'Awad 'Alian, age 17
Muhammad Da'ud Saleh Badwan, age 21
Abdal Rahman Abu 'Eid, age 17
Muhammad Fadel Hashem Rian, age 25
Zakaria Mahmoud 'Eid Salem, age 28
Yousef Akil Srour, age 35

a month in an Israeli detention centre. An organiser of Ni'lin's non-violent demonstrations, Aqel was a target for Israeli intimidation and threats, locals say.

According to Al Haq, on 5 June 2009 Aqel attended an anti-wall demonstration. After the crowd had dispersed, he walked through the field towards the village. He heard a gunshot. He turned to see that a 16 year old boy, Mohammed

Moussa, had fallen, shot in the abdomen by an Israeli Border Policeman. Aqel ran to the boy's aid. As he did, the Border Policeman then shot Aqel in the chest. Mohammed and Aqel were rushed to Ramallah Hospital. Aqel, who was married with three children, was pronounced dead. Mohammed survived but with spinal injuries and, at the time of writing, may be permanently paralysed.

OVERLEAF

A boy waves a Palestinian flag as night falls in a field in Ni'lin in September 2008, following a huge Ramadan dinner held in the fields near where construction of the Wall was taking place. It was attended by scores of locals, international activists and the media.